FIBER ART TODAY

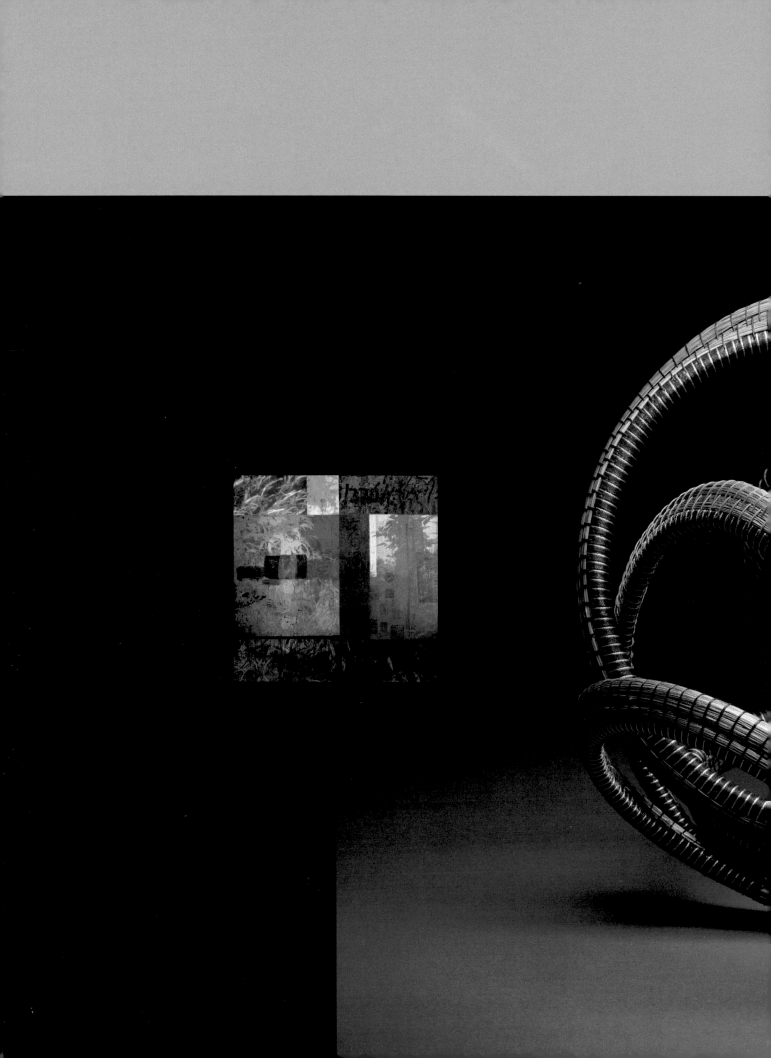

FIBER ART TODAY

Carol K. Russell

Schiffer Publishing Ltd

4880 Lower Valley Road · Atglen, Pennsylvania 19310

Title page:
Debora Muhl; *Chaos #1310*

Michael James; *The Concept of Qi*

This page:
Seamus McGuinness; *21g*

Last page:
Riitta-Liisa Haavisto; *Wait*

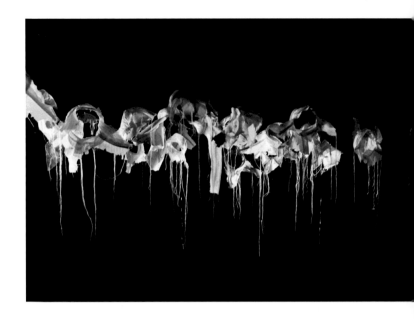

Published by Schiffer Publishing Ltd.
4880 Lower Valley Road
Atglen, PA 19310
Phone: (610) 593-1777; Fax: (610) 593-2002
E-mail: Info@schifferbooks.com

We are always looking for people to write books on
new and related subjects. If you have an idea for a
book please contact us at the above address.

Schiffer Books are available at special discounts for bulk purchases for sales
promotions or premiums. Special editions, including personalized covers,
corporate imprints, and excerpts can be created in large quantities for special
needs. For more information contact the publisher:

For the largest selection of fine reference books on this and
related subjects, please visit our website at
www.schifferbooks.com

This book may be purchased from the publisher.
Include $5.00 for shipping.
Please try your bookstore first.
You may write for a free catalog.

In Europe, Schiffer books are distributed by Bushwood Books
6 Marksbury Ave. Kew Gardens, Surrey TW9 4JF England
Phone: 44 (0) 20 8392 8585; Fax: 44 (0) 20 8392 9876
E-mail: info@bushwoodbooks.co.uk
Website: www.bushwoodbooks.co.uk

Other Schiffer Books By The Author:
Tapestry Handbook: The Next Generation.
ISBN: 9780764327568. $59.95

Other Schiffer Books on Related Subjects:
Color and Fiber. Patricia Lambert,
Barbara Staepelaere, and Mary G. Fry.
ISBN: 0887400655. $49.50

Fiber Expressions: The Contemporary Quilt.
Quilt National.
ISBN: 0887400930. $12.95

Copyright © 2011 by Carol K. Russell

Library of Congress Control Number: 2011920969

Designed by Rosemary Shillingford
Type set in Bembo Std/Adobe Garamond Pro

ISBN: 978-0-7643-3777-2
Printed in Hong Kong

Creating this collection of art treasures has been an enlightening adventure to say the least. Intriguing ideas for this and future publications have revealed themselves throughout my travels. The results of poking around at galleries and exhibitions to see artwork in person, of meeting and sharing thoughts with icons in the field are all embedded on these pages. As advocates for the arts, galleries, and museums struggle to survive difficult economic times, yet they have reached out generously during the past year in collegial exchange and a sincere desire to continue the promotion of our field in this most challenging of eras.

All those at Snyderman-Works Galleries in Philadelphia have my admiration and gratitude for their kind assistance to a writer/researcher seeking kindred spirits. Rick Snyderman of the Snyderman Gallery has shared greatly of his expertise and resources for this publication as has Director Bruce Hoffman and Assistant Director Kathryn D. Moran. As well, Ruth Snyderman of The Works Gallery and Frank Hopson, Director have been most helpful during visits there along my pathway to publication.

To Matthew Hall of Galerie Besson in London I shall always be grateful for facilitating the Peter Collingwood image that illustrates better than any words the elegance of art expressed in woven structures. Implicit in this rare treasure is the hand of a significant early visionary in the métier set forth in this book but moreover his profound contributions to provenance throughout a much celebrated life as artist, teacher, and writer.

Tai Gallery in Santa Fe has brought to the attention of American museums and collectors the art of highly esteemed Japanese masters. Sharing generously their research and curatorial perspective, Everett Cole and Koichi Okada at Tai Gallery have made it possible to present on these pages the magnificent examples of Japanese bamboo sculpture.

Judy Chicago and Audrey Cowan have contributed over the years not only images of textile art for my publications but the vital aesthetic and human values we foster. Others deserving of acknowledgement are: Hans Krondahl, artist, advisor, and much admired teacher, who continues to educate by keeping us connected to successive generations of creativity from Sweden; Helga Berry who shares her international network with graciousness, wisdom, and diplomacy and Camille Cook of Friends of Fiber Art International who promotes our art to collectors worldwide.

If this book seems heavy, consider that it has been carried forth upon the shoulders of giants.

ACKNOWLEDGEMENT

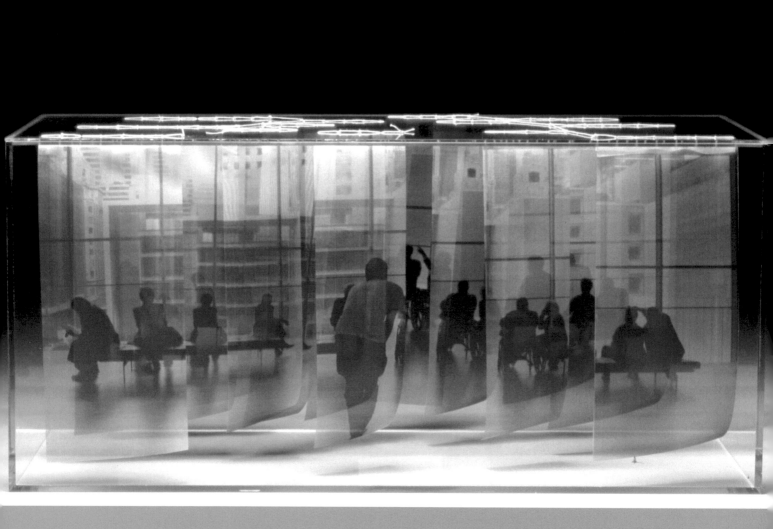

Katherine D. Crone; *dialogue on Art*; Digitally altered
photograph, archival ink-jet printing, sewn with alternating
hitch bookbinding stitch; acrylic plastic, silk organza, linen
thread; 11 x 24 x 10" (27.5 x 60 x 25cm); photo: D. James Dee.

CONTENTS

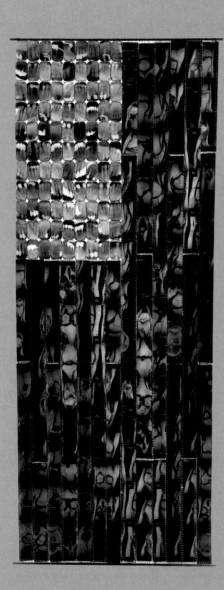

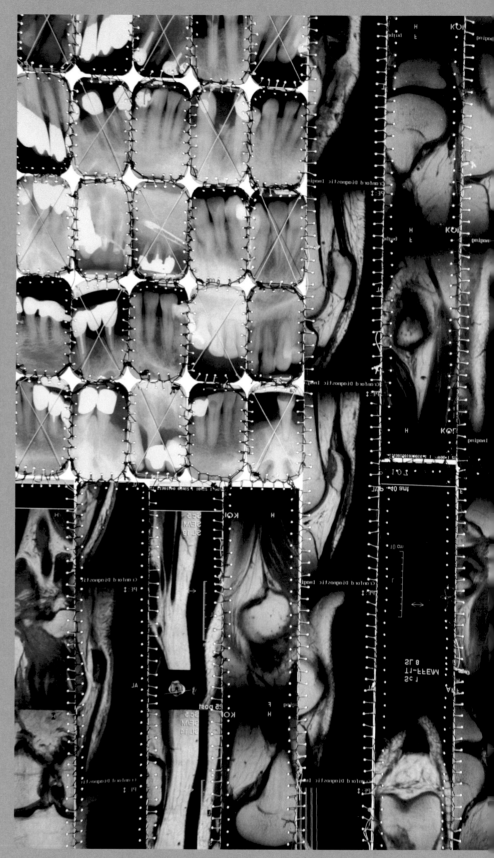

Joan L. Dreyer; *Flag*; mixed media; dental film, cotton, thread; 44 x 17" (110 x 42.5cm); photo: courtesy of Snyderman-Works Galleries.

▶*Flag* (detail)

Sometime in 1997, our long-time Gallery Director Bruce Hoffman and I were having a conversation as we looked at images of contemporary fiber sculptures in a magazine article. We were both becoming increasingly disenchanted with the state of things in contemporary American glass, an area in which our gallery had specialized for more than a decade, and which now seemed more interested in skill than soul. Technique isn't enough to sustain art. Take a look at Maxfield Parrish's Arts and Crafts Period glass mosaic at the Curtis Center in Philadelphia. It's exquisite – and boring. Then take a look at Judith Schaechter's stained glass panels from the early 1990s. You won't need any expertise to sort out why one elicits powerful emotions, while the other just sits there.

When things become formulaic, it's time to move on.

I'm often asked to critique student work. My inclination is to tell them to look at everything other than work in their chosen field. The iconic Philadelphia architect Robert Venturi titled his first important book, published in 1966, *Complexity and Contradiction in Architecture* and that succinctly sums up what really makes it all interesting. And that's what Bruce and I were seeing in fiber: Work that was fresh, original, and complex. The question we asked ourselves was: Why wasn't all this getting more attention?

Our conclusion was, as in so many other areas of the arts, the easy way out was to create categories, and by so doing, turn what had been spontaneous into something generic. Quilt-makers showed in quilt shows, basket-makers showed in basket shows, weavers showed in weaving shows.

But people like Sheila Hicks didn't. Neither did Lenore Tawney, nor Faith Ringgold or Elizabeth Scott. Claus Oldenburg's soft sculpture of the 1950s and '60s didn't move towards the world of craft fairs. It moved into the world of sculpture, because it wasn't just about the materials. It was also about the ideas.

But at some point, there was a disconnect. The ideas became trapped in an intellectual Sargasso Sea. Art moved away from the passion of the hand – and let's make no mistake about it – whether you are looking at gorgeous Berber kilims and hand-hammered silver, wood, and woven traditional neckpieces in Morocco, or an El Anatsui tapestry at the Met – that passion is how human beings have communicated and learned from before the dawn of literate cultures.

What Bruce and I were seeing was the passion of the hand, but a hand that didn't want to be tethered to a 'category'. Our response was that he agreed to organize an exhibition, subversively calling it 'fiber art' but intending to assemble work by artists whose processes and ideas pushed the limits of their chosen materials, yet honored and respected the long history of applied techniques, and evidenced a deep and scholarly knowledge of that history. It was complexity *and* contradiction in action.

So when the exhibition opened in 1998, there was an enormous amount of enthusiasm on the part of artists – and a fair amount of confusion on the part of the public. What did Dominic DiMare's sublime horsehair, bone, and linen totems have to do with Nancy Koenigsberg's New York City-tough pieces of woven copper and steel wire, or Yvonne Bobrowicz's exquisite languorous tangles of fishing line tipped with gold leaf?

What indeed! Linked by that ancient bond I spoke about above, it fulfilled all the possible expectations we had hoped for. People who 'got it' were wildly enthusiastic and wanted to know if we could mount an exhibition like this again the following year. We said: *Are you nuts? We'd love to do it again, but this was an insane amount of curatorial work. Maybe we could put another together in two years.*

Thus was born our International Fiber Biennial, which just completed its 7th iteration with works by more than 60 artists from six countries.

In all fairness, I recognize the importance of exhibitions focused on one particular textile area, but I would be remiss if I didn't point out how more visually interesting those exhibitions are now because of the new life being breathed into these traditional forms by a rich new cross-pollination of materials and process.

At the same time, there is still the need to draw the broader public into this dialogue. It will not be an easy job. Traditions are comfortable, and in these uncomfortable times, it's fairly

WHAT HAPPENED...

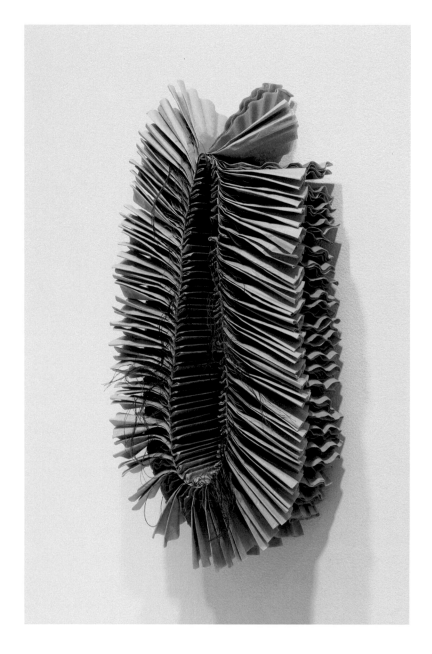

understandable that many people cling to the sense of security and stability that tradition provides. There is no easy solution or pathway. But in fact, the greater danger is in succumbing to the status quo.

What makes all this so much fun is the constant stream of new invention and fresh talent. Newcomers such as Joan Dreyer and her work with photo-weaving; Adam Cohen's Lichtenstein-influenced camo-embroideries; C. Pazia Mannella's delicate necklaces of woven coffee filters. ***Coffee filters***! Amy Orr's pop-art portraits made from cut-up and woven credit cards. They are all part of a new wave of playful, yet masterful practitioners.

So, one might look at this book as a disparate collection of unrelated works, and indeed it is. One could equally see it as an effort to perform the all but impossible task of organizing, in one volume, the diverse world of artists who travel through this realm, some only tangentially. Both views would be correct.

Intended as a broad survey, its very existence is evidence of the growing interest in examining, documenting – ***and challenging*** – the changes underway. As further evidence, a small but growing coterie of astute young curators is now playing an increasingly important role in assembling collections at institutions throughout this country and abroad.

Venturi put it this way in his book: "I am for richness in meaning rather than clarity of meaning." That certainly conveys my feelings perfectly.

And this book offers the viewer the opportunity to examine that issue.

Rick Snyderman
Snyderman-Works Galleries June 2010

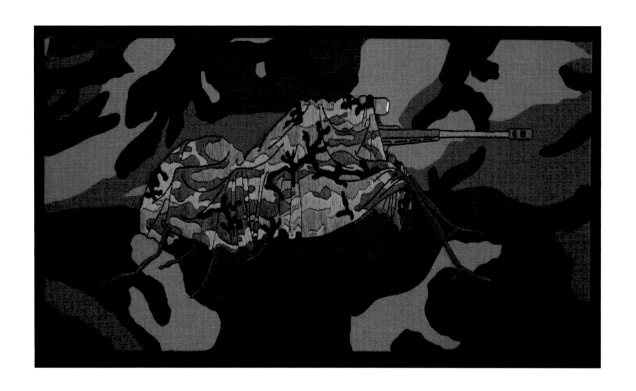

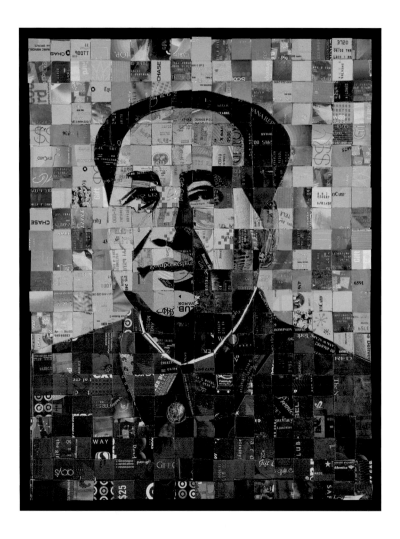

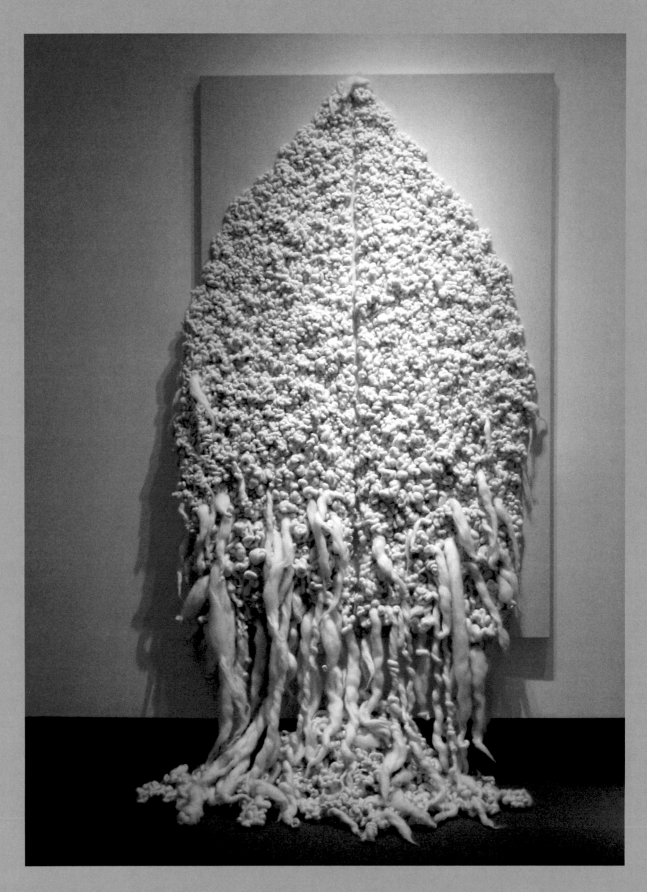

Karen Ciaramella; *Centered*; sculpture; wool, canvas; 83 x 45"
(132.5 x 112.5cm); photo: Karen Ciaramella.

Is it possible in our rapidly expanding information universe to summarize or provide an overview of the field we refer to as *textile* or *fiber art*? Probably not—it is too vast and too diverse. It spans past, present, future, and is growing in directions that not too long ago would have been unforeseeable. Are there topics of interest and trends worth perusing? Absolutely. Impossible as it is to accommodate the profusion of recent and current developments in this multitudinous field, one may pick particular aspects to examine, to use as platforms for inquiry and observation. As observers, each of us comes with built-in predilections, interests, and gaps in what we know or care about. Each view is inevitably skewed, as in the old tale of blind men feeling an elephant; what you think it is may depend on which part you are touching. As an art historian and curator, I admit to preferences shaped by, on one hand, a very long view chronologically speaking, and on the other hand, a very short view based on the frequently frenetic pace of bringing together exhibitions under severe limitations of time and money. Several years ago I emerged from studies of very ancient arts that often depended on stratigraphy rather than written records or critical theory for their history; i.e., material culture, in which information about cloth might be extrapolated from less perishable materials, although actual textile remains, when found, were often technically and esthetically sophisticated. The outcome (at least for this writer) was that a division between art and craft was never relevant. Without the intervention of the European Renaissance when such distinctions arose, antiquity had no concern over what was art and what was craft. A copper needle in an Early Bronze Age pot clearly indicated sewing; basketry patterns were impressed several millennia ago in clay. Fleece and fabric clothing is depicted in ancient Mesopotamia and Egypt; apron-like garments are seen on much, much earlier prehistoric figurines. Wool, fur, and leather garments, colorful decorative felt, and remnants of finely knotted carpet came from second and first millennium BC tombs in the Altai Mountains of Siberia.

Such a random glance at the past reminds us that textiles have always had much to tell us. Think of the many inexpensive versions of African royal *kente* cloth for sale today, or the folk and ethnic patterns for needlework that have been appropriated for our pleasure. Appropriation of form and content continues to be a strong trend in the arts; e.g., Jeff Koons, Robert Rauschenberg, and countless others. From a historical perspective, Rome appropriated Greek art; famous Renaissance artists were reproduced in paintings and prints by their contemporaries; Duchamp appropriated "readymades," etc. Easily transportable, textiles have long been, and continue to be both transmitters and innovators of the cultural and visual information they carry. Interest in art of another time and place can morph into inspiration resulting in contemporary work of great originality, as in the hands of Ed Bing Lee. His appreciation of the traditional Japanese *Chawan* produced a glorious series of knotted vessels that, upon reflection, the artist realized were *new creatures*. (1)

Textile and *fiber art*, terms used to embrace the entire field, may be considered old-fashioned and lack marketplace cachet in today's world of sound bites. But perhaps it indicates that they no longer adequately describe what was previously acceptable without question. *Textile* is a noun or adjective, not a process. An artist may be a textile maker, a weaver, a basket maker or, in today's world, even a fiber or textile nanoengineer. *Fiber* relates more easily to process by shifting our minds back to the sources of *textile*. But today, fiber can refer to material that carries light or sound, and textiles can be made of petroleum, steel, carbon, or materials as yet uninvented. Who knows what new space age technologies are undergoing experimentation? Names for new materials may surface, but does it make sense to circumvent the familiar terms we know and use? Not really—besides, as yet there do not seem to be suitable substitutes that encompass these disciplines. It would be far more useful to educate a broader public to fuller awareness and understanding of what the terms may reference. Hopefully, communication about a sphere of activity so integral to both human history and contemporary creative exploration will occur both inside and outside the usual institutions of the field.

Our relationship with the environment is a complicated issue of interest and concern. Currently, a proposal for a huge river-covering project by Christo and Jeanne-Claude (d.2009) is undergoing unending governmental review of its potential impact on the

TEXTILES—and Other Thoughts

environment. Their much publicized *The Gates* in Central Park NYC (2005) also aroused controversy. On a much more modest scale, the materials and techniques traditionally associated with the field of textiles have hazards both to artists and their surroundings. We all know some of the problems, and it is incumbent upon artists to educate and protect themselves and the environment. In a reversal of historical usage, techniques used in the textile industry are increasingly available for studio use, making precautions important. Several publications provide information about safe and acceptable practices; e.g., books by Monona Rossol and bulletins published by the Surface Design Association and other organizations.

Many studio textile artists are rightfully worried about how their work affects our already challenged ecosystem. A number of artists, among them Abigail Doan, are committed to using their materials and the environment gently. Carol Westfall, whose work has long been concerned with social and environmental issues, expresses her thoughts about the fragility of the world's water supply in comments accompanying her work. One hopes that growing awareness will be addressed not only by individuals, but also in workshops, schools, and universities. We probably will never achieve a perfect record, but we ought to know where the stuff we pour in the sinks is going, and where it came from. Even the harmless act of knitting uses wool that was dyed somewhere. The repurposing of materials (the term used to be *recycling*!) is a valuable attempt to limit discard. For textile and fiber artists it also hearkens back to economic responsibility, to the ethic of *waste not, want not* that has generated centuries of quilts and all manner of contemporary work composed of cast-off and found materials. The art of John Garrett includes masterful examples of such recycling. Artists have long known how to manipulate and incorporate natural and manufactured materials into their work. However, the age we live in has added to the repertoire of manufactured materials, ranging from components of electronics, metal and plastic wire and thread, polymers (e.g., polyester and polyamides—even as phosphorescent yarn!), and microfibers approaching 1/200 the width of a human hair. Whether these materials were *born* in environmentally pure circumstances is another question.

The debate that continues over distinctions between art and craft is both interesting and tiresome—interesting because it provides insights into what we presume artists are doing; tiresome because it is not necessarily relevant to what artists are actually doing. Yet it goes on, and with some consequences that have wider impact than one might assume. The American Craft Museum in 2000 became the Museum of Arts and Design, obviously deciding that *craft* as a component of its name did not fully illuminate the Museum's mission. Whether one agrees or disagrees with that decision, the Museum of Arts and Design has been and continues to be a preeminent presenter of innovative art in textile and other crafts, including *Slash* (2009-10), and *Radical Lace and Subversive Knitting* (2007). A succinct and thoughtful exploration of the art/craft "dilemma" has been written by Bean Gilsdorf in the *Surface Design Journal*. Gilsdorf states: "Today, the idea that such an opposition as 'art versus craft' exists in regard to medium is a well-worn fiction….objects made in any medium exist

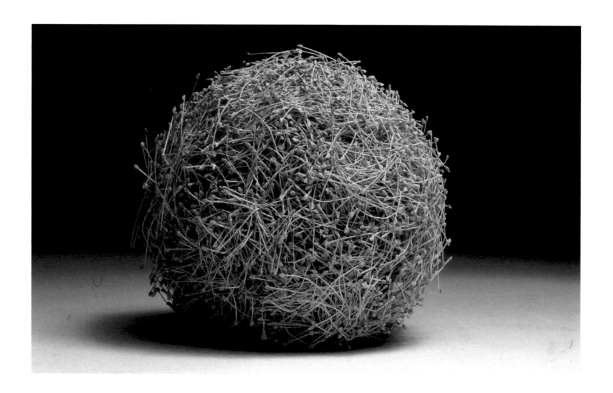

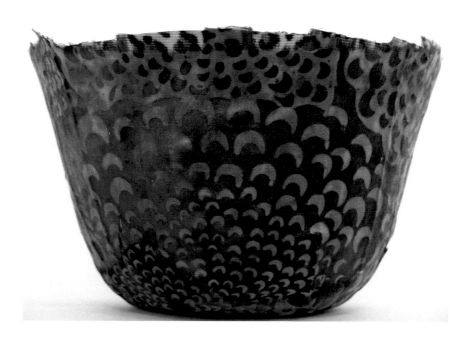

▲▲**Carol Westfall**; *This Crowded Planet (one of a series)*; mixed media; compressed weaver's knots; 5" diameter (12.5cm); photo: D. James Dee.

▲**Pamela Becker**; *Penelope*; sculpture; cotton and silk fabric, ribbon, varnish; 5.25 x 5.25 x 3.25" (13.125 x 13.125 x 8.125cm).

along a continuum of identity, from art to craft..." (2) Bean mentions some of the many artists, e.g., Ann Hamilton, Polly Apfelbaum, and others whose work completely disregards the imaginary boundary. To that can easily be added artists such as Sabrina Geschwandtner, whose art incorporates knitting, film, performance, and audience participation.

Many artists no longer want to be identified by medium or technique. Nonetheless, artists who achieve fame in the so-called "fine arts" are not normally known as "craft" artists although they use and incorporate materials and techniques, especially of textile and fiber arts, in their work. This writer recalls the dilemma of Robert Forman: When earlier in his career he sought gallery representation for his highly original compositions of inlaid thread, art galleries found his work too embedded in craft, while craft galleries considered it painting that happened to be thread. Although the art vs. craft syndrome has relaxed somewhat, it still characterizes an art world in which galleries seek to establish specific identities based on who and what they present.

Museums and other art venues, however, are discovering growing interest in arts that are less off-putting for audiences than some recent conceptual art trends. The materials and handwork that have characterized craft and thereby, textile identity, open avenues of access and approachability for the viewing public. But it is the artists themselves who have obliterated the supposed demarcation through their work. Leslie Pontz clearly identifies her work as fiber sculpture and uses found and fabricated iron along with crocheted fiber and metal to create large and small sculptures. In addition she and Ruth Borgenicht, a ceramic sculptor, have cooperated on work that uses both of their materials. Such "crossover" art is no longer an anomaly in the textile/fiber field and has many manifestations. Nor are there limitations within particular practices. Pamela Becker, known for ingenious layered, printed, and painted fabric wall pieces, is also the creator of singular baskets in wrapped coil technique, as well as a repertoire of collaged fabric vessels adorned with a variety of materials. Patricia Malarcher incorporates metallic Mylar into modular collage and stitchery compositions; a recent work consists of 100 components that can be rearranged depending on the context. Pat Hickman and Kiyomi Iwata are each finding new ways to use formerly discarded or overlooked components of silk cocoon processing in mixed media artworks. There are literally no frontiers limiting exploration by contemporary textile artists.

How do those who are curators, writers, art historians, critics, deal with the immense body of studio textiles and fiber arts? While roles may overlap, each implies a particular area of interest and responsibility. The obligations of a museum and its curators are determined by the mission of museums in general and by the special interests of a particular museum. Museums, in the broadest sense, collect, preserve, and interpret; but every museum has its own focus on whether, and how, it participates in those activities. Obviously, interpretation includes education. Curatorial responsibilities may cross into several areas of museum operations, but the most visible role is that of interpretation through the planning and development of exhibitions. Even in the best of all possible worlds, reality intrudes in many forms: Does an exhibition reflect the museum's stated mission? Will it interest and bring in an audience? Will it generate income? Will it generate programs? Does it require financing

Abigail Doan; *Crocheted Snow 01*;
installation: Tencel fiber, branches,
ice, snow; 60 x 3" (150 x 7.5cm);
photo: Abigail Doan.

outside of the existing budget? The concerns to be addressed far exceed this brief list. In museums of modest size and budget (which means most museums!), the labor is intense to attract visitors, funding, good press, and public relations. Few museums have the finances for major—or even minor—publications without seeking outside funds. However, for both the museum and the exhibited artists, once a show has closed, documentation in the form of a catalog or brochure is a valuable—and often the only record. For the developing artist it is career enhancement; for an established artist it is validation of a continuum of creative accomplishments. For many, being chosen for a museum show adds particular luster to a resume. Certainly, inclusion in publications brings an artist's work to a much broader audience.

For a curator, once an exhibition concept has been approved, the real pleasure consists of selecting artists and work. It can be important to have artists of note to attract an audience of knowledgeable practitioners and devotees of the field. For this curator/writer it is a personal obligation to include "emerging" artists in exhibitions for a number of reasons: It is difficult for a worthy developing artist to have work put before a museum audience, and important for institutions to bring fresh talent and ideas to public and critical interest. For a recent exhibition, this curator chose the work of Karen Ciaramella, who creates sculptures of thick knotted white wool and whose work is gaining attention. For a curator, describing work in an exhibition can become a complicated maneuver: "Mixed media" or "own technique" in an artist's description of his or her piece may be accurate but not necessarily informative. The amount of information a curator provides is often a judgment call, somewhere between the briefest identification and a longer didactic label. Should there be short—or long explanatory text on walls or in handouts? Even decisions that seem perfunctory are rooted in serious questions about how viewers perceive and respond to art. How much—and what—should come between a viewer's personal response to a work and explication of it? I.e., what is the role of interpretation? Although expanding the frame of reference of the viewer is the surest way to create an informed audience (especially for mind-stretching art), it may not always be appropriate or enjoyable to load that into the viewing experience.

An exhibition is frequently planned to include workshops and other educational programs, in hopes that these will enhance knowledge of textile arts through hands-on activities and contacts with artists—and will, at the same time attract a broader audience. The greatest problem in the arts today, including theater, music, and dance, is audience development—especially audiences of young people. Huge amounts of time and energy are being devoted to this. And for those who might think that art jumps up on the walls or pedestals without human intervention, a recent museum show from discussion to presentation took at least three years to implement, not at all an unusual span of time for the process. Many museums, and therefore curators, are committed to exhibition schedules several years ahead.

As we sail (or perhaps lurch!) into an unclear future, there is, as the saying goes, good news and bad news. Good news is that the field of textile and fiber arts is vibrant and eclectic. Good news is that computers and the internet are extraordinarily useful for artists, curators, historians, critics, students, and the merely curious, providing instant access to all kinds of information. Good news is that artists and the rest of us can manipulate, print, and publicly post information and imagery in ways previously unimagined. Bad news is the proliferation of an enormous amount of work (increasing exponentially!) of dubious quality. On the other hand, good news is access to some of the best work in the world. Websites for artists, galleries, and museums are good news, but bad news is the cyber cosmos of all of us trying to be seen, heard, and read. And for those of us who must attempt to sort our way through this plethora of material, bad news is that it is inordinately difficult to develop agreed-upon critical standards for art in an era of pluralism and relativism. But fortunately, *very* good news is the innovative, daring, and exciting work being created today by artists. While we may refer to it as textile and fiber art, this is art that challenges preconceptions and defies easy categorization.

Hildreth York
Curator of Art and Design,
Hunterdon Art Museum, Clinton, New Jersey

Notes:

1. See the statement by Ed Bing Lee that accompanies his work.

2. Bean Gilsdorf, "Sticks and Stones: Craft's Identity Battle with Art and Itself." *Surface Design* 24: 3 (Spring 2010) p. 49 ff.

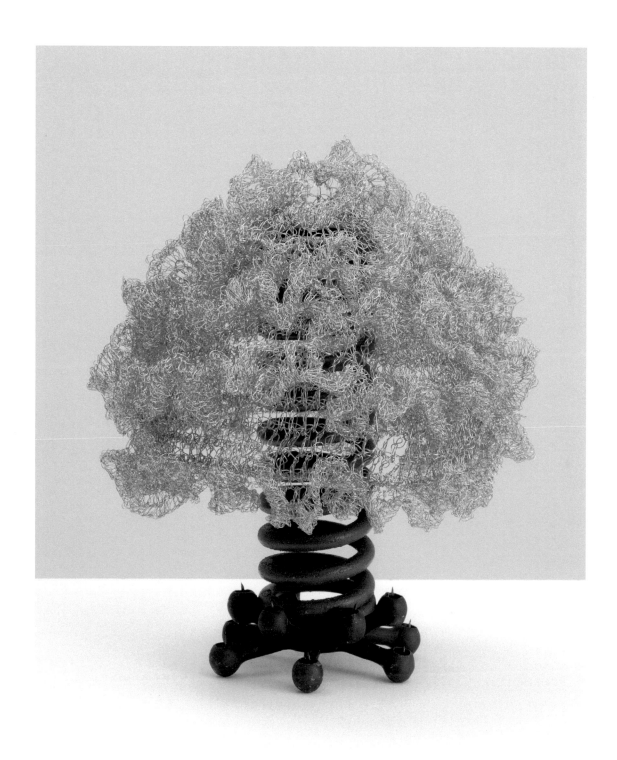

Leslie L. Pontz; *Sketch 2*; Sculpture; crocheted
wire, iron, paint; 9 x 7.5 x 8" (22.5 x 18.75 x
20cm); photo: John Carlino.

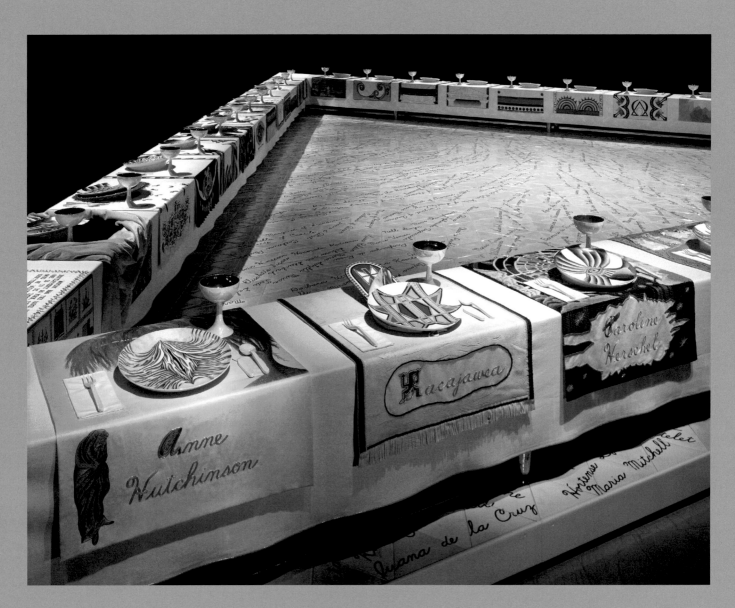

▲Installation view, Wing Three, featuring Anne Hutchinson, Sacajawea, and Caroline Herschel place settings
from *The Dinner Party*
© Judy Chicago, 1979
Embroidery on linen and china paint on porcelain
Elizabeth A. Sackler Center for Feminist Art
Collection of the Brooklyn Museum
Photo © Donald Woodman

▶PETER COLLINGWOOD (1922-2008)

Macrogauze M63, no.9, 1970s
Natural linen, steel rods
69 x 25 inches

© ESTATE OF THE ARTIST
Image Courtesy of Galerie Besson

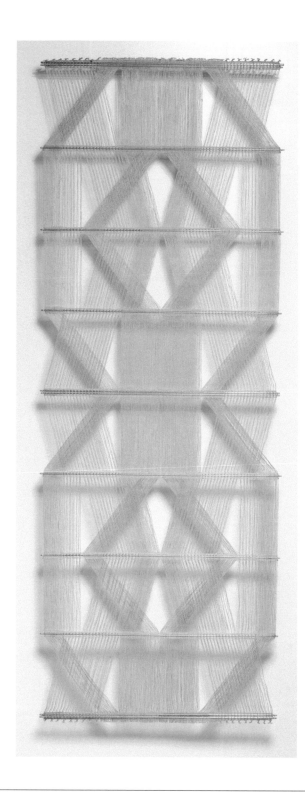

by Carol K. Russell

A work of art is the trace of a magnificent struggle
Robert Henri

As submissions for this book landed here in graceful flocks, not unlike herons and egrets floating homeward toward the New Jersey wetlands, scores of artists shared their *magnificent struggles*. With respect for their trust and immense pride in their efforts, this New Jersey writer sends forth their art into a world of readers they may never meet except in spirit.

Again Henri asserts, *Art after all is but an extension of language to the expression of sensations too subtle for words*. Sensations may indeed be too subtle for spoken or written words but the visual vocabularies of the artists on these pages impart layers of meaning far beyond any written text. All have presented compelling creative inquiries for documentation in published form at this point in time. Each artist has developed a distinctive synthesis of form and content. Many have pursued successfully the scrutiny of the international hierarchy of contemporary textile art exhibitions. Tossing off any ballast of an art/craft dichotomy, today's artists create material relevance in the international markets for contemporary wall art, sculpture, vessels, and installations. Traced herein are the magnificent triumphs of sixty-one artists from more than ten countries and cultures.

Museums, galleries, curators, and their audiences respond eagerly to artists working in whatever media best express an idea, theme or mood. The viewing public in New York's Central Park was exhilarated strolling in droves through Christo and Jeanne-Claude's utterly transforming twenty-three miles of *Gates*. This unprecedented interim of urban joy could not have been realized in a medium other than saffron colored cloth dancing against the clear blue winter sky. At the Brooklyn Museum, Judy Chicago's richly constructed and exhaustively researched *Dinner Party* could never assert on flat canvas its powerful reconsideration of women's roles in history. Whether in post 9-11 New York City or in antiquity, the sympathetic voices of textiles lend contextual critique to humankind's epic.

INTRODUCTION

Christo and Jean-Claude (1935-2009); *The Gates* (23 miles of walkways lined with saffron-colored fabric *Gates*; installed throughout Central Park, New York City February 2005); photo by Carol K. Russell.

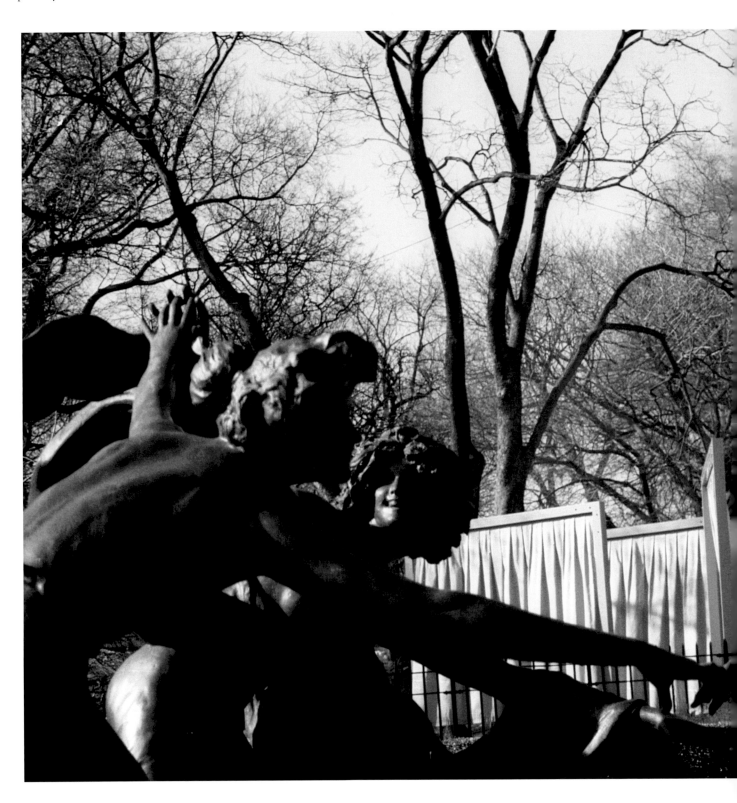

In the past century, artists sought to expand the vocabulary of art into imagery achievable only through the use of textiles and their physical properties. In his attempts to escape the picture space, abstract expressionist Robert Rauschenberg bridged the gap between art and life with cloth and cloth-like forms. Then as now, tangible materials appropriated from life provide both gesture and a means toward abstraction. As enunciation of social practices, Miriam Schapiro's etchings of lace doilies symbolized the anonymous nature of women's handwork while influencing the subversive *Pattern and Decoration* art current of the 1970s. Rauschenberg and Schapiro arrived from opposite directions to discover common cloth as bearer of concepts impossible to convey in other media.

Integration of thought with physical form is a process of mediation, explored on these pages by artists skilled in the rhythms of textiles as discipline and mindful of the rhythms of life as metaphor. Cloth, threads, and the methods employed to build forms from them necessitates a fractional approach to fulfilling one's concept. Distinct rhythms of process are often obvious though in themselves may not be artistically expressive. The magic occurs as dynamic design tension and evidence of inner conflicts coexist with and are supported by the artist's hand wrought efforts.

As with painters, ceramists or printmakers, textile artists exploit the expressive range of their materials while respecting any physical restraints. In this book are art works not merely created in textile media but conceived therein. This was an editor's greatest joy: presenting artists positive and secure in the *whys* of their media. Why Ferne Jacob's distinctive vessels have greater impact molded with threads than with clay. Why the disarming lightness of Norma Minkowitz' crocheted baby blanket lures us headlong into a scary bedtime story. Why our threatened environment finds advocacy in Carol Westfall's fragile fabrics and intricate embroidery. Why Seamus McGuinness' torn shirts matter.

As we learned years ago from master weaver Peter Collingwood, our textile structures and materials cannot and more importantly, need not impersonate paint or marble. Rather, we explore and exploit our own distinct voices, mindful that beyond the realm of purely visual pleasures lies a world of ideas expressed best in textiles or textile references. Between the covers of this book are the contemporary perspectives of three generations of fiber artists. May the tracings of their times inspire the *magnificent struggles* of a fourth generation.

THE ARTISTS

ADELA AKERS ▸ Guerneville, CA USA

browngrotta arts

Adela Akers's beautiful large-scale weavings can be as purely abstract as the mathematics that inspires them. Trained in science as well as art, Akers brings to her work a formal discipline derived from math, which results in works whose repetitive geometric structures recall ancient pre-Columbian tapestries as well as contemporary art works inspired by modes of industrial production. She shares concerns with some of the most influential artists of her generation. During the late 1960s and early 1970s in the United States, the minimalists and postminimalists also worked with repetitive, highly simplified form. Akers's 1972 Ceremonial Wall brings to mind the felt pieces of Robert Morris, but the stronger relationship is with those women artists, such as Eva Hesse, who revolutionized contemporary art practice by mixing references to the body, and a hitherto unacceptable sense of the handcrafted, with a rigorous minimalist practice. Akers's more recent works are just as ambitious as her early art but more refined.

Quoted from the catalog: Flintridge Foundation Awards for Visual Artists 2005-2006, essay by Lynn Zelevansky, The Henry J. Heinz II Director of The Carnegie Museum of Art since 2009. She formerly served as the Terri and Michael Smooke curator and department head, Contemporary Art, Los Angeles County Museum of Art and as curator in the department of painting and sculpture at the Museum of Modern Art in New York.

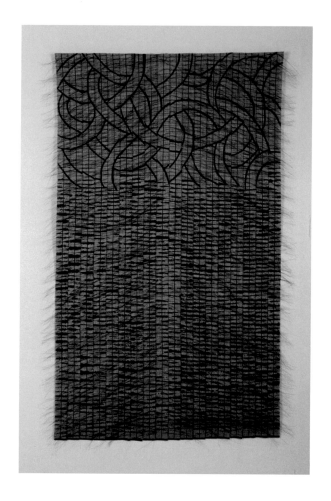

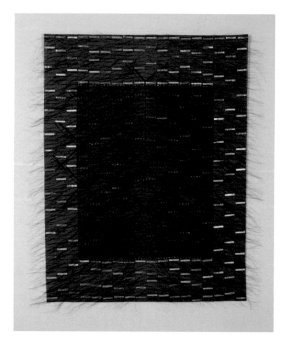

▲ **Adela Akers**; *Broken Circle* (from series of designs involving resist patterns); weaving, supplementary weft, warp painting, resist dyeing; linen, horsehair, paint, ink; 35 x 31" (87.5 x 77.5cm); photo: Bob Stender.

◀ **Adela Akers**; *The Grid* (from the *Window* series); weaving, stitching, supplementary weft, warp painting; linen, horsehair, metal foil, paint; 43 x 29" (107.5 x 72.5cm); photo: Bob Stender.

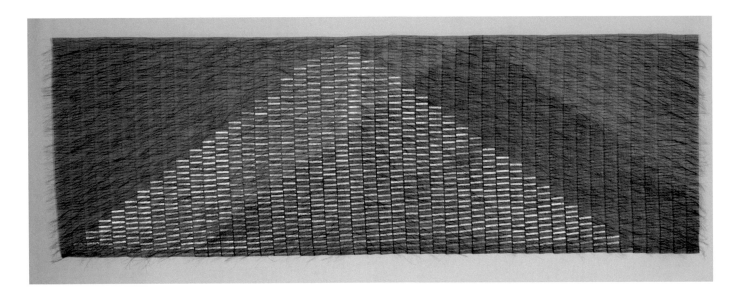

Adela Akers; *Casting Shadow* (from the *Pyramid* series); weaving, supplementary weft, stitching; linen, horsehair, metal foil; 30 x 95" (75 x 237.5cm); photo: Bob Stender.

Adela Akers; *Final Search* (from the *Drawing* series); weaving, supplementary weft, warp painting; linen horsehair, paint; 35 x 31" (87.5 x 77.5cm); photo: Bob Stender.

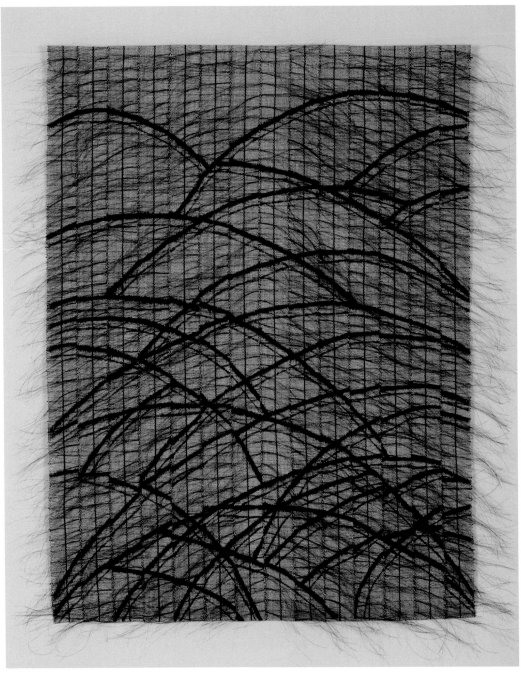

LANNY BERGNER ▸ Anacortes, Washington USA

Snyderman-Works Galleries

A viewer wants to wander around Lanny Bergner's sculptures; to superimpose one transparent form upon another; to experience its aspects from all points of view but mostly, to observe the inner relationships move toward then away from each other. Though ethereal in delivery, Bergner's artistic acts invite earthly responses. Here is reality not in the material sense but between indistinct forces captured in a still moment but poised for activity.

Following through with the eclecticisms of the latter half of the twentieth century, Bergner continues to experiment with industrial metals, free formed with his direct hands-on process using only a scissors for mesh cutting and pliers for connecting the frayed mesh. This artist seeks to "... *engage the viewer with glimpses into a primordial genesis where nature and industry coalesce. The work ultimately celebrates the delight, mystery and wonder of it all.*" He has met with appreciative audiences in prestigious exhibitions at the Central Museum of Textiles in Lodz, Poland, The Textile Center in Minneapolis, and the Museum of Art and Design in New York.

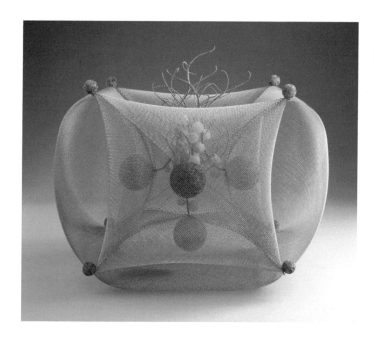

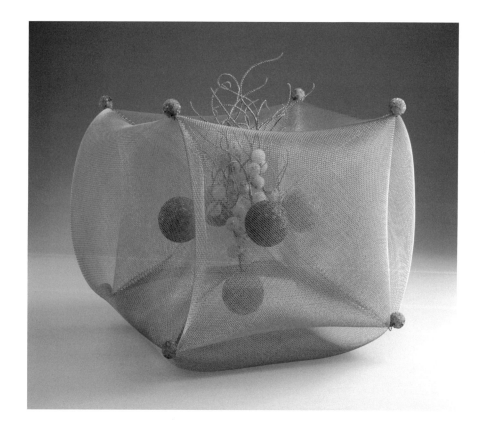

▲**Lanny Bergner**; *Space Botanical* 4; sculptural basketry; bronze mesh, wire, glass frit; 15.5 x 17 x 17" (32 x 38 x 38cm); photo: courtesy of the artist.

◀*Space Botanical* 4 (alternate view).

▶**Lanny Bergner**; *Portal*; sculptural installation; bronze and brass mesh, wire, glass frit; 68 x 50 x 24" (173 x 127 x 61cm); photo: courtesy of the artist.

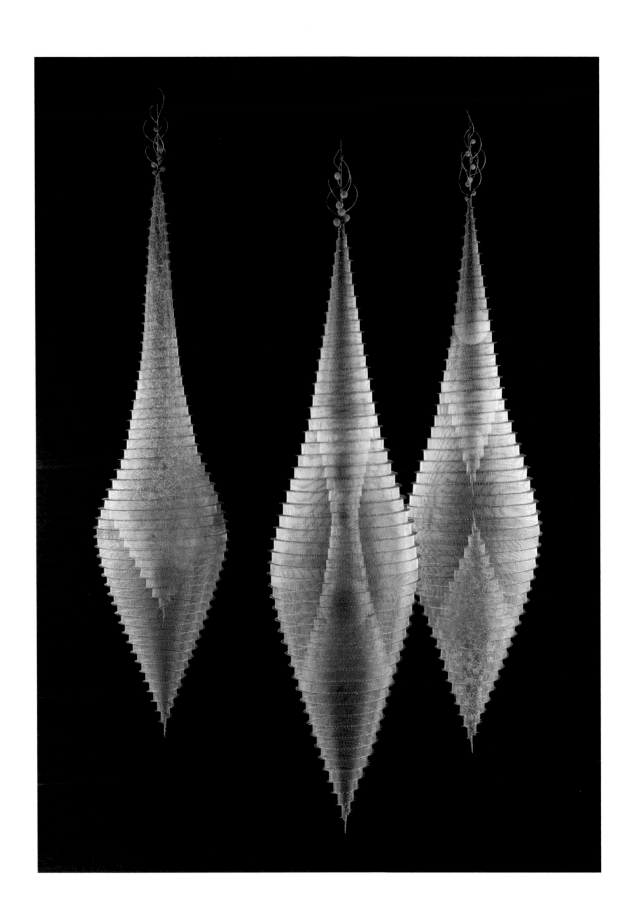

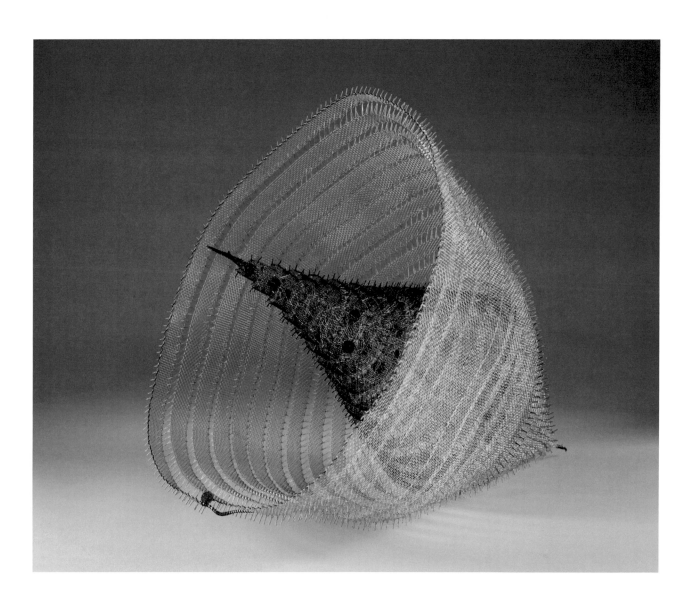

Lanny Bergner; *Red Bud*; sculptural basketry; bronze, black anodized aluminum and brass mesh, wire, glass frit; 13 x 13 x 16" (33 x 33 x 40.5cm); photo: courtesy of the artist.

Lanny Bergner; *Blue Bud*; sculptural basketry; black anodized aluminum and brass mesh, wire, glass frit; 13 x 13 x 17" (33 x 33 x 43cm); photo: courtesy of the artist.

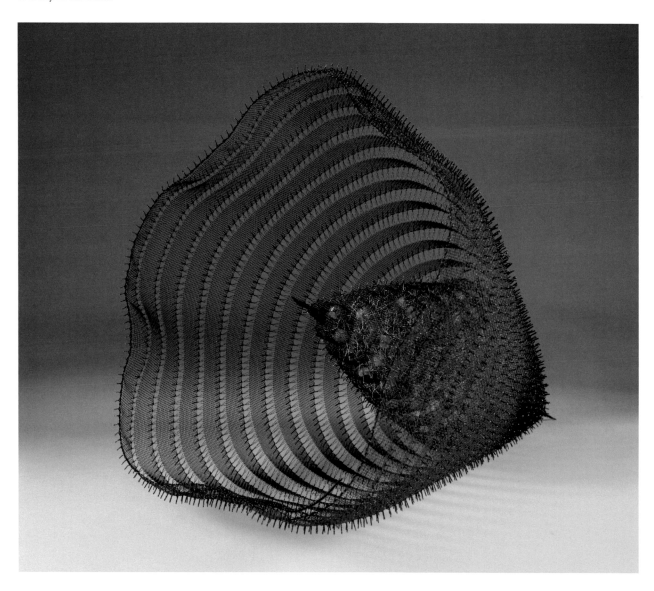

MARY BERO ▶ Madison, Wisconsin USA

Hibberd McGrath Gallery

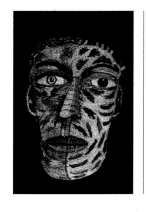

Mary Bero; *Stuffed Head: Self-Portrait*; stitched portrait, stuffed head; cotton fabric, silk and cotton thread, polyfil; 6 x 4.5" (15 x 10 x 1.25cm); photo: Jim Wildman.

Composing thousands of dense stitches into emotional abstractions is Mary Bero's own quiet, introverted affair with art but one that draws the attention of an international following. Often referred to as an outsider artist, Bero's work has found its way inside museums and major art collections throughout the United States and Europe.

Incorporating traditional and non-traditional needlework techniques with painting and other media, Mary Bero's work defies categorization. Never conforming to rigid, predictable conventions, she challenges her audience to see things—or themselves—differently.

Usually intimate in scale to command close attention, Bero's freely embroidered faces appear chaotic but with an artist's internal order. Disconcertingly naïve faces, actively marked with strokes of conflicting colors, implore viewers to look behind the hypnotic mismatched eyes. *Dare to come inside*, challenges the outsider artist.

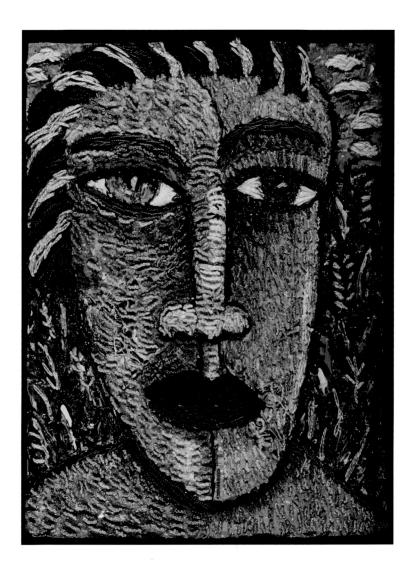

▲**Mary Bero**; *Parallel Zone*; painted, hand and machine stitched; canvas, rickrack, textile inks, threads (silk, cotton, rayon); 10 x 8.5" (25 x 21cm); photo: the Artist.

◀**Mary Bero**; *Blue Nude*; painted, stitched, knotted; rag paper, a/c, cotton and silk thread; 6 x 4.5" (15 x 11cm); photo: Jim Wildman.

HELGA BERRY ▶ Anchorage, Alaska USA

I had been a passionate tapestry weaver for almost thirty years when I began to feel strangled by the slow process of creating. Still, I looked forward to documenting the many wonderful chapters of my life while exploring new ones. This was when India came to my rescue. In India I found beautiful hand-woven, hand-printed, hand-painted, hand-embroidered, and hand-stitched fabrics in the vibrant colors I love and have woven into my tapestries. In India everyone embraces brilliant colors and glitzy elements—even the men!

Today, I recycle silk sari fabrics into wall hangings or baskets reflecting my travels and my life in Alaska. I even make use of wrinkled or torn discards showing the wear and tear I myself have felt.

Life changes. I have turned a page.

Helga Berry 2010

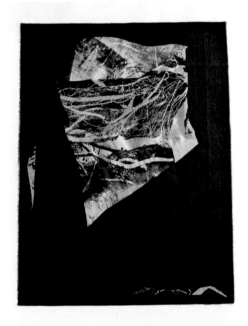

▲ **Helga Berry**; *Moonlit Trail*; fused fabrics; silk, silk organza, silk/metallic organza; 43 x 33" (110 x 84cm); photo: Chris Arend Photography.

◀ *Moonlit Trail (detail).*

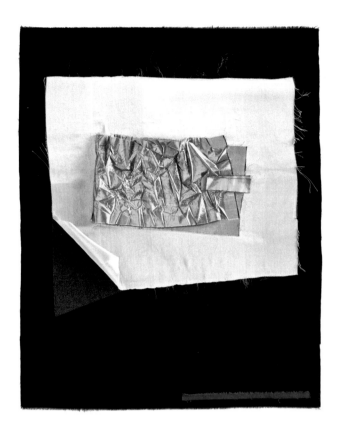

Helga Berry; *Turning A New Page*; fused fabrics; silk, silk organza, silk/metallic organza; 37 x 29" (94 x 74cm); photo: Chris Arend Photography.

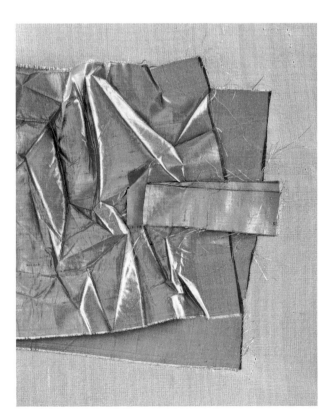

Turning A New Page (detail).

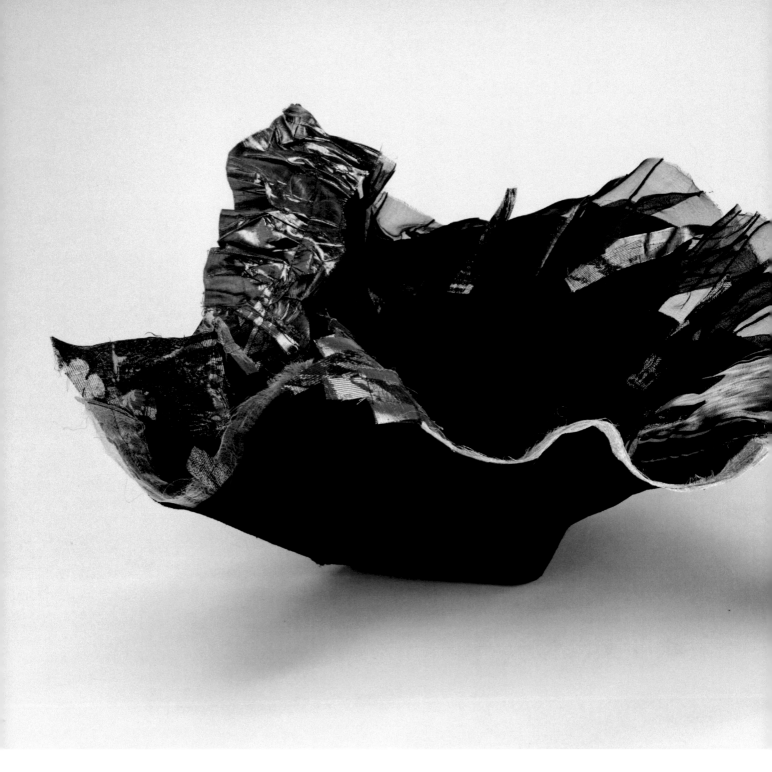

Helga Berry; *Black and Gold Basket*; fused and stitched fabrics; silk, silk organza, silk/metallic organza; 24 x 12" (61 x 31cm); photo: Chris Arend Photography.

Black and Gold Basket (alternate view).

Black and Gold Basket (detail).

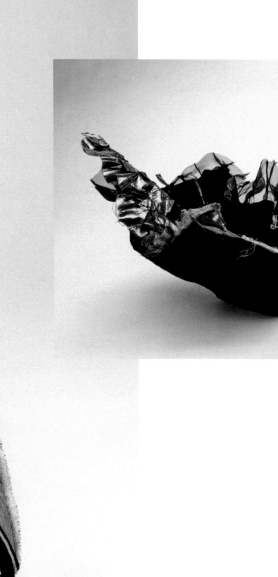

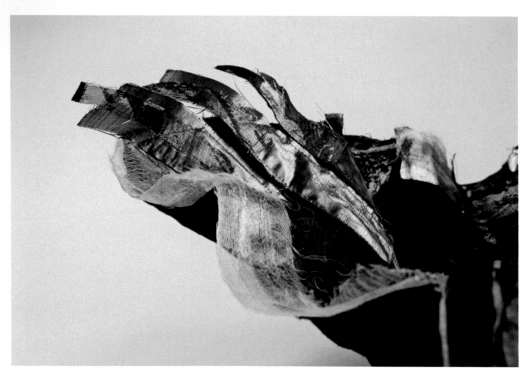

JAPPIE KING BLACK ▸ Brockport, New York USA

The intersection of glorious nature with an outdoor sculpture bearing the unmistakable evidence of human hands creates a curious reality in New York's Hudson Valley. Closer inspection poses many questions yet offers few answers.

Artist Jappie King Black weaves and manipulates grape vines into ghostly forms for her large scale, site-specific installations. From a distance, relationships amongst all the organic elements come into view, entice visitors of all species into an art park, change with the seasons, and eventually decay.

Continuing her theme of nature, metamorphosis, loss, and the handmade object, the artist sculpts intricate hand stitched and coiled baskets. Cast in bronze using the lost wax method, her handworks become one of a kind vessel fragments for the ongoing series *Burnt Offerings*.

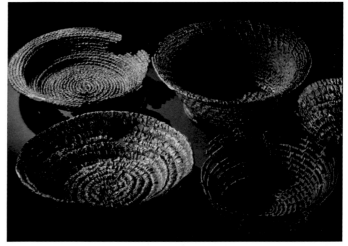

▸**Jappie King Black**; *Burnt Offerings Series*; bronze, lost wax castings; cast from coiled and stitched baskets.

▾**Jappie King Black**; *Lace Weave*; bronze basket from the *Burnt Offerings* series; bronze, lost wax casting; one of a kind cast from coiled and stitched basket; 2 ½ height x 9 ½" diameter (5.5 x 23cm).

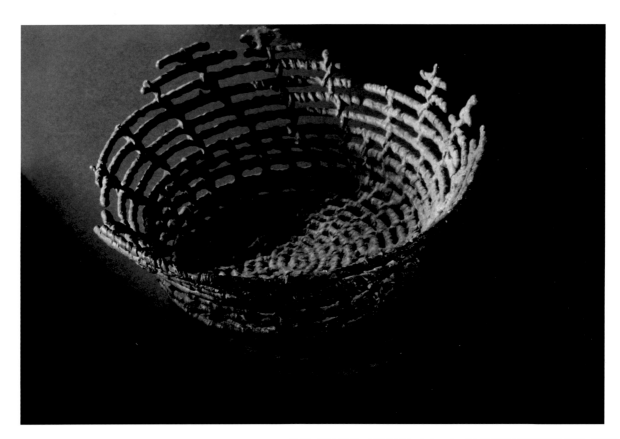

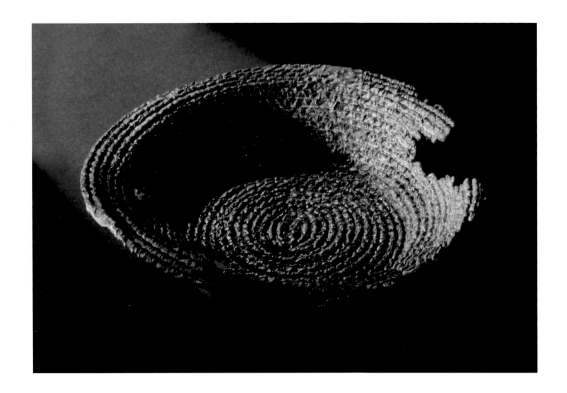

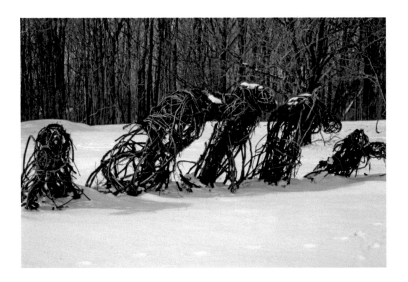

Jappie King Black; *Blue Patina*; bronze basket from the *Burnt Offerings* series; bronze, lost wax casting; one of a kind cast from coiled and stitched basket; 2 ½ height x 9 ½" diameter (5.5 x 23cm).

Jappie King Black; *Evolving (winter)*; Temporary site-specific sculpture at Stone Quarry Hill Art Park, Cazenovia, New York; grapevine and metal; 8 x 20 x 10' (2.5 x 6 x 3m); photo: J. K. Black.

Jappie King Black; *Regeneration (spring)*; Temporary site-specific sculpture at Brydcliffe Arts Colony, Woodstock, New York; grapevine and metal; 8 x 20 x 10' (2.5 x 6 x 3m); photo: Richard W. Black.

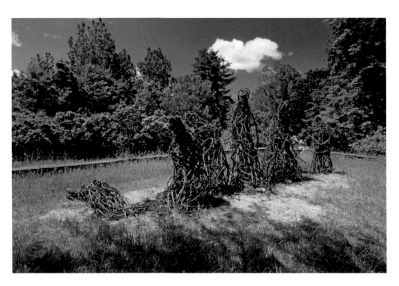

TANABE CHIKUUNSAI III ▸ Osaka, Japan

TAI Gallery / Textile Arts

Tanabe Chikuunsai 3rd, whose given name is Hisao, was born in city of Sakai, Osaka on March 6, 1940. Through his elementary school years, he made baskets with bamboo strips discarded by his father, Chikuunsai 2nd. His favorite time of the day was spent splitting bamboo and plaiting bamboo with his father's students.

After graduating from high school, he learned bamboo art from Okubo Shochikusai, who was Chikuunsai 1st best student. Later, Chikuunsai 3rd attended department of industrial craft design at Musashino Art University where he focused on design. Upon graduation from Musashino Art University, he returned to Sakai City and seriously studied bamboo art under Tsukayoshi Tadayoshi, who was another top student of Chikuunsai 1st.

He was given the name of Syochiku by Chikuunsai 2nd in 1969. In 1974, his Nitten piece titled "Ho", "Square", was purchased by the Tokyo National Museum of Modern Art. He has actively exhibited at the Japanese Modern Industrial Arts Exhibition, Nitten, Osaka Industrial Arts Exhibition and All Kansai Art Exhibitions. In 1991, at the age of 51, he assumed the name of Chikuunsai 3rd. Now, he wants to create a traditional style of bamboo art for the modern age, while utilizing the skills of the previous Chikuunsai generations.

Courtesy of TAI Gallery/Textile Arts

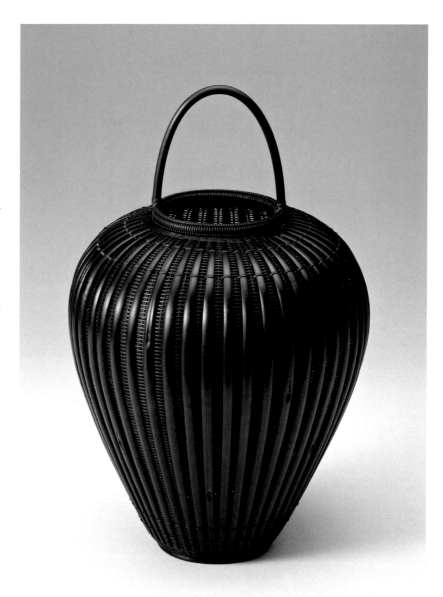

Tanabe Chikuunsai III; *Lady*; technique: gozame, yoroigumi; material: madake, yadake, rattan; 15 x 10" diameter (37.5 x 25cm); photo: Gary Mankus.

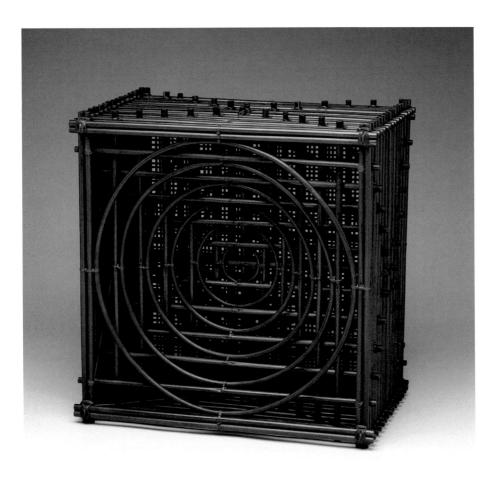

◀**Tanabe Chikuunsai III**;
Double Layers; technique:
kumimono; material: yadake,
rattan; 17.5 x 17.5 x 10.5"
(43.75 x 43.75 x 26.25 cm);
photo Gary Mankus.

▼**Tanabe Chikuunsai III**;
Ancient Wind; technique:
gozamezashi; material: madake,
yadake, rattan; 11 x 24 x 7
(27.5 x 60 x 17.5cm); photo:
Gary Mankus.

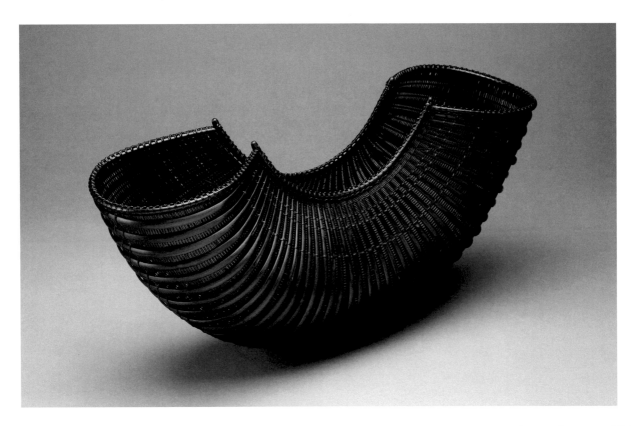

KYOUNG AE CHO ▸ Milwaukee, Wisconsin USA

Born in South Korea, achieving her MFA from Cranbrook Academy of Art in Bloomfield Hills, Michigan, Kyoung Ae Cho has achieved prominence through shows at museums and galleries in both countries. Her visual conversations with nature are the result of gathering and collecting natural materials and objects often dismissed as having low value or worthy only of being discarded. Finding beauty in the intricate patterns, shapes, textures, and colors of her environment, the artist collaborates with the rhythms of nature as they reflect our world's ever-evolving society of humankind.

As a child in Korea, Kyoung Ae Cho was taught to sew by her grandmother but also to appreciate beauty in small natural treasures collected and examined with a young artist's eyes. She sought to understand a twig that she might understand branches that she might understand a tree to understand nature itself. Today she finds symbols of strength in cross sections of pine, a wood often regarded as *soft*. As with bits of cloth organized into the recognizable patterns of quilts, a visual and material unity emerges from the dramatic strokes of a tree's life span. In this way the artist combines her love of sewing and of wood. Kyoung Ae Cho writes: "*I want to have my work carry the beauty and the power that I see and feel in nature.*"

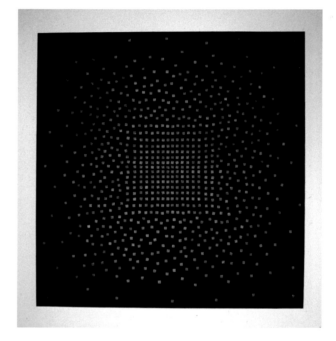

▸**Kyoung Ae Cho**; *Chaos* II; woodworking; wood, nails, paint; 10 x 10' (305 x 305cm); photo: Kyoung Ae Cho.

▾**Kyoung Ae Cho**; *Untitled*; woodworking; wood: 11.75 x 29.75 x 2.75" (29.9 x 75.6 x 7cm); photo: Kyoung Ae Cho.

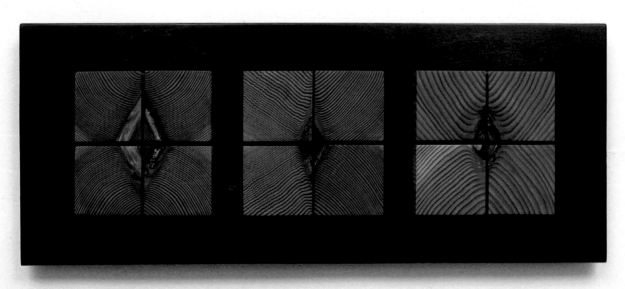

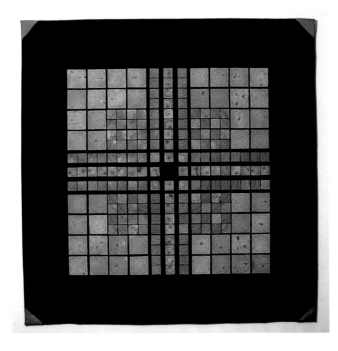

△ **Kyoung Ae Cho**; *Quilt?!*; woodworking, hand and machine stitching; wood, waxed linen cord, fabric, thread; 54 x 54" (138 x 138cm); photo: Kyoung Ae Cho.

▶ *Quilt?!* (detail).

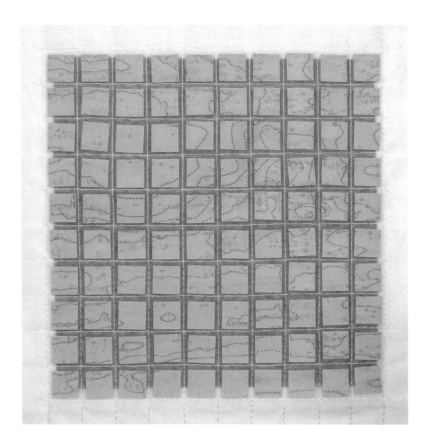

▶ **Kyoung Ae Cho**; *Inner Scape VI*; woodworking, hand stitching, burn marks; wood, thread, silk organza, silk satin organza; 30 x 30" (76 x 76cm); photo: Kyoung Ae Cho.

KATHERINE D. CRONE ▸ New York, NY USA

Snyderman-Works Galleries

These works are visual journals. The images are transparent and ephemeral but are captured in book forms and rendered in photographs with sculptural dimension. My subject matter is quotidian—light and shadows, water, reflections, architectural details, panoramic landscapes—but like the daily life captured by a written journal it brings with it accumulated meaning and emotion. Does the work trigger personal associations? Is it meditative? Even though each piece may have a personal back-story for me, the viewer's reaction is what validates my intent.

Many things influence me: the landscape and light on the East End of Long Island; my travels, especially to Japan; a Yale education; and my late husband's rigorous, Bauhaus-influenced approach to design. Indirect influences come from the work of the Japanese artists, photographers, and architects; Hiroshige, Hokusai, Naomi Kobayashi, Hiroshi Sugimoto, and Tadao Ando.

Katherine D. Crone

▸▸**Katherine D. Crone**; *Wanderer*; digitally altered photograph, archival ink-jet printing, sewn with Saddler's Harness Figure 8 bookbinding stitch; acrylic plastic, silk organza, nylon monofilament; 4 x 6 x 4" (10 x 15 x 10cm); photo: D. James Dee.

▸ *Wanderer* (alternate view).

◂**Katherine D. Crone**; *Flutter in the Wind (from the Haiku series), Author, Masaoka Shiki;* digitally altered photograph, archival ink-jet printing, laser engraving; acrylic plastic, silk organza, linen thread; 6 x 5.75 x 2.75" (15 x 13.25 x 6.25cm); photo: D. James Dee.

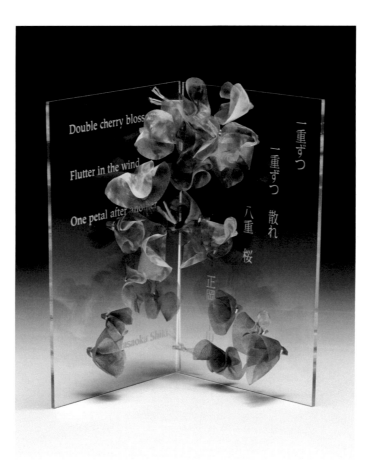

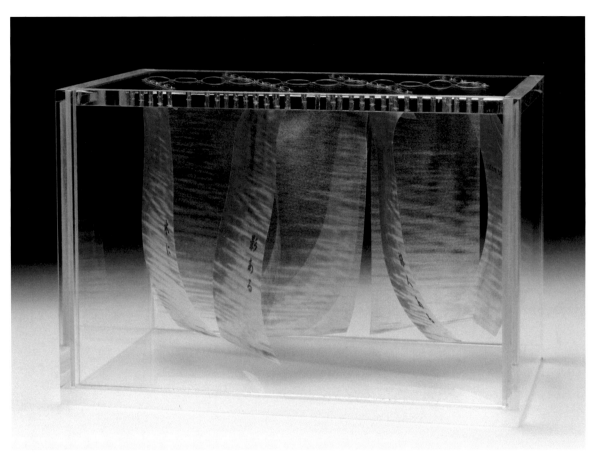

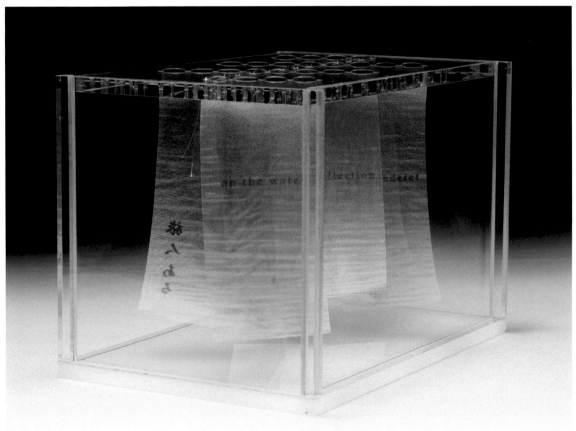

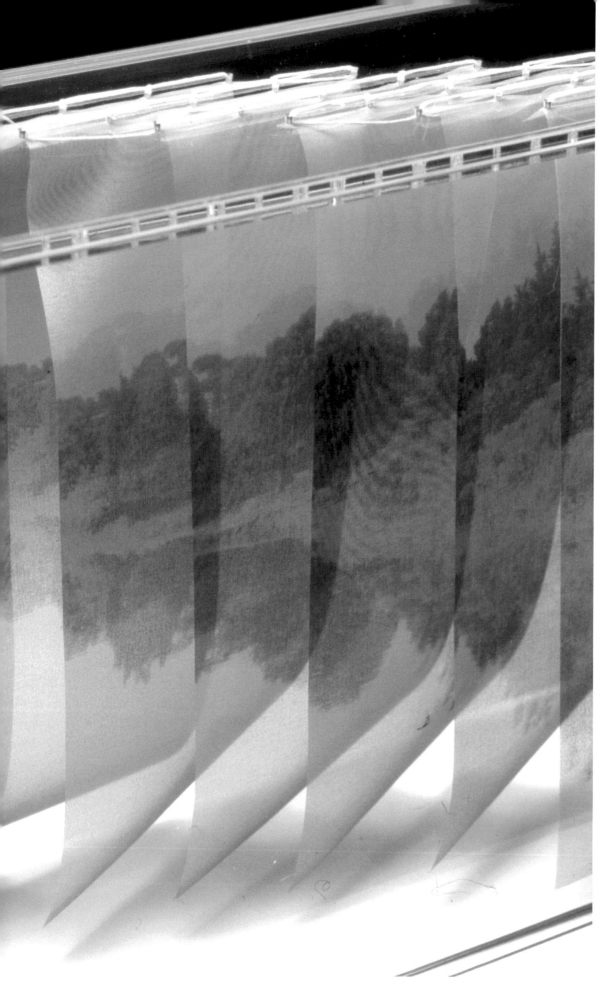

▶**Katherine D. Crone**;
Bridge at Pussy's Pond;
digitally altered
photograph, archival
ink-jet printing, sewn
with alternating hitch
bookbinding stitch; acrylic
plastic, silk organza, linen
thread; 8.75 x 23.5 x 4.75"
(21.25 x 58.75 x 12cm);
photo: D. James Dee.

◀*Bridge at Pussy's Pond*
(detail).

▶**Katherine D. Crone**;
Reflecting Pool; digitally
altered photograph, archival
ink-jet printing, sewn with
Saddler's Harness Figure 8
bookbinding stitch; acrylic
plastic, silk organza, nylon
monofilament; 4 x 6 x 4"
(10 x 15 x 10cm); photo:
D. James Dee.

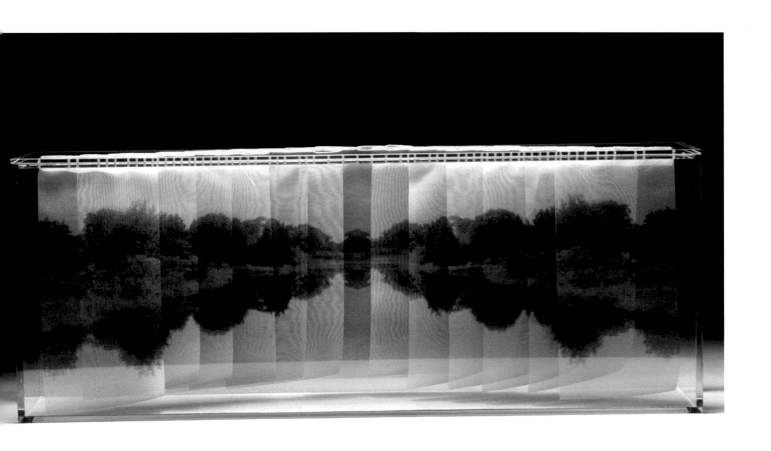

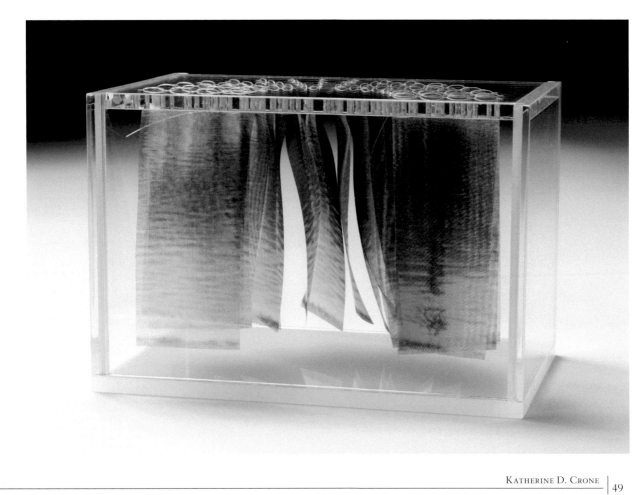

HELEN DAHLMAN ▸ Göteborg, Sweden

Though not the first artist to endow animals with human-like feelings, intellect, and experiences, Helen Dahlman's luscious embroidery first disarms the viewer then lends structure and equilibrium to her turbulent tales. In *Flicken och Björnen (The Girl and the Bear)* a slender girl stands before a thickly embroidered bear. Her subsequent experiences convey feelings rather than rational thoughts. The brief story illustrates universal human struggles with authority and vulnerability, violence and protection, power and subjugation. Through silver, gold, and silken stitches, we absorb this artist's complexity and power.

The artist's second tale examines volatile relationships between men and women, compressed here into four frantic weeks in the life of an attractive, high-spirited hare.

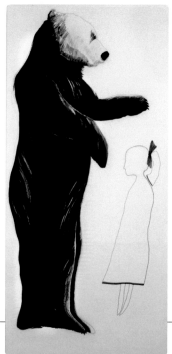

◂**Helen Dahlman**; *The Girl and the Bear* (embroidered installation at Göteborg Art Museum); embroidery on silk; 88 x 44" (220 x 110cm); photo: Johan Wingborg.

▸**Helen Dahlman**; *The Girl and the Bear* (detail of embroidery).

▸▸**Helen Dahlman**; *Her Hands* (from *The Girl and the Bear* installation); gold embroidery on Plexiglas; 22 x 12" (55 x 30cm); photo: Johan Wingborg.

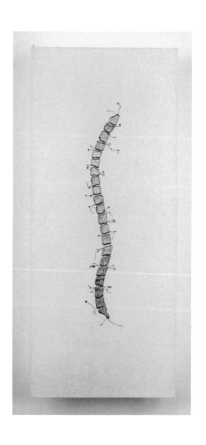

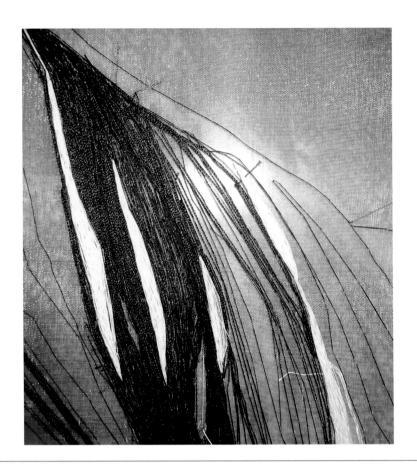

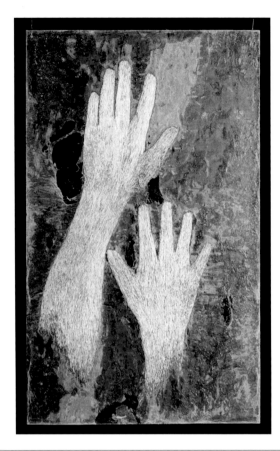

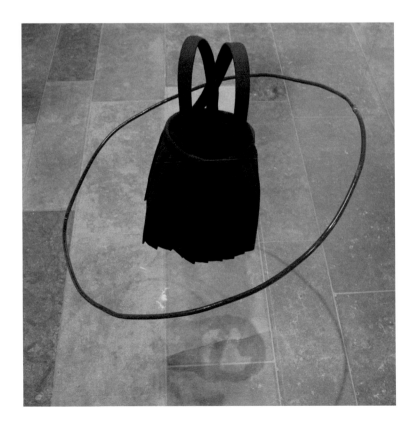

◀◀◀**Helen Dahlman**; *Her Spine* (from *The Girl and the Bear* installation); gold embroidery on Plexiglas; 26 x 12" (65 x 30cm); photo: Johan Wingborg.

◀◀**Helen Dahlman**; *She pretends she has a door* (from *The Girl and the Bear* installation); embroidery on wood; 30 x 30" (75 x 75cm); photo: Johan Wingborg.

◀**Helen Dahlman**; *Her Place* (from *The Girl and the Bear* installation); skirt with rubber ring; 16 x 20" (40 x 50cm); photo: Johan Wingborg.

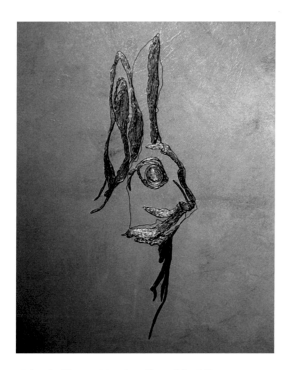

Helen Dahlman; *Moonhare* (first of the following embroidered series: *4 Weeks in a Hare's Life*); silver embroidery mounted on Plexiglas; 24 x 16" (60 x 40cm).

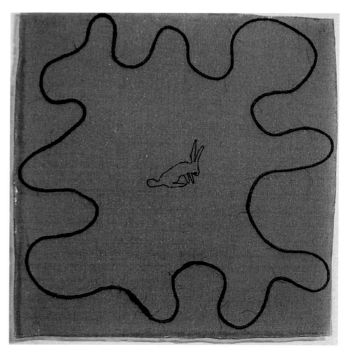

Helen Dahlman; *In Love*; embroidery mounted on Plexiglas; 4.5 x 4.5" (12 x 12cm).

Helen Dahlman; *She is Cold*; embroidery mounted on Plexiglas cube; 2.5 x 1.5 x 1.5" (6 x 3 x 3cm).

Helen Dahlman; *Shit, What a Wind*; embroidery mounted on Plexiglas; 4.5 x 4.5" (12 x 12cm).

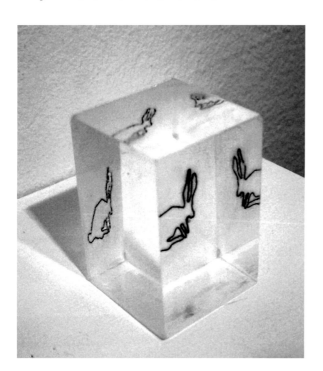

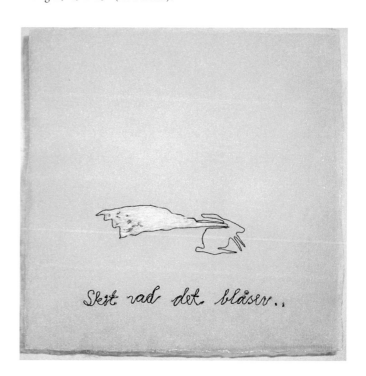

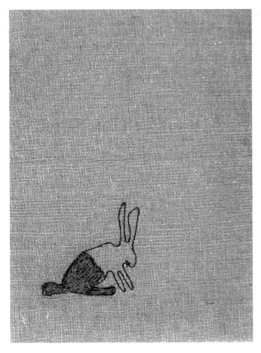

Helen Dahlman; *Once a Month Pants*; embroidery mounted on Plexiglas; 4.5 x 4.5" (12 x 12cm).

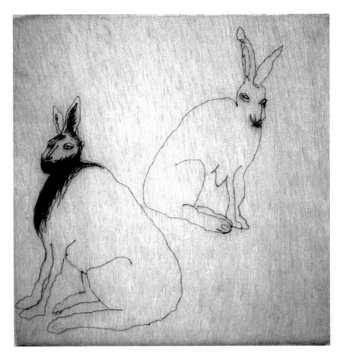

Helen Dahlman; *Marriage*; embroidery mounted on Plexiglas; 4.5 x 4.5" (12 x 12cm).

Helen Dahlman; *Her Escape in Slow Motion*; embroidery mounted on Plexiglas; 20 x 1.5" (50 x 2cm).

Helen Dahlman; *Party Girl*; embroidery mounted on Plexiglas; 4.5 x 4.5" (12 x 12cm).

ANN FAHY ▸ Galway, Ireland

Ann Fahy's fine art quilts have become essential threads connecting Ireland's ancient land and culture to its artistic present. In luxuriously embellished silks and linens the artist keeps alive traces of Ireland's oldest form of communication—the Ogham alphabet. Ogham markings, carved upon megaliths still standing throughout Ireland, were comprised of lines and notches with the lines representing consonants and the notches vowels. The name of the language references Ogmios, the Celtic God of speech and oral learning.

Viewed flat Burren House might be an open book or ancient scroll displaying its prehistoric message. Reading from bottom to top, the Ogham letters translate into modern Irish as *Fado, Anois, Amarach* meaning *Yesterday* (or long ago), *Today, Tomorrow.* Tied up as a sculpture, the piece becomes one of a series of quilted houses. In cloth and thread, Fahy tells ancient archaeological tales told through the fossils, dolmen, and passage graves along Ireland's vast limestone Burren—stretching miles along Ireland's western edge between the Atlantic Ocean and Galway Bay. Where the sides of the house join, the Ogham reads *Boireann* (or *Burren*) meaning great rock.

> *And the end of all our exploring*
> *Will be to arrive where we started*
> *And to know the place for the first time.*
>
> T. S. Eliot

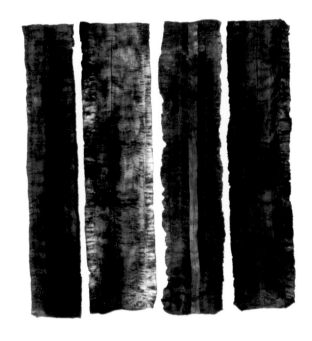

⌃**Ann Fahy**; *Four*; pleating, dyeing, quilting; linen; 48 x 48" (120 x 120cm).

▸▸*Four* (detail).

▸*Four* (detail).

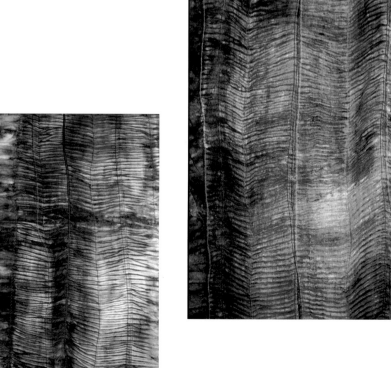

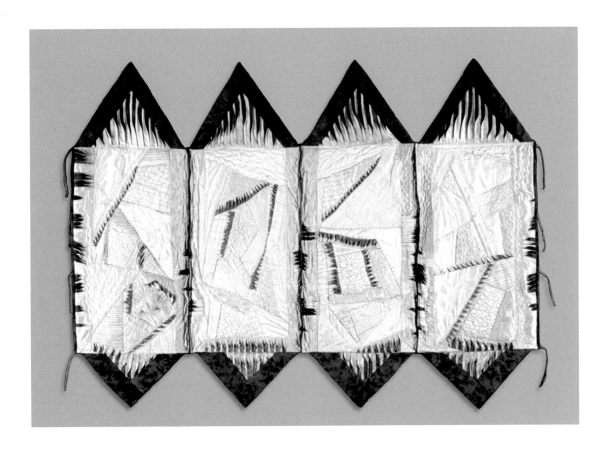

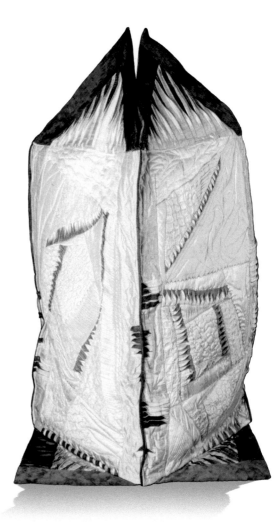

▲▲**Ann Fahy**; *Burren House*
(as wall hanging); fabric
manipulation, piecing, quilting,
machine embroidery; silk; 48 x
68" (120 x 170cm).

▲ *Burren House* (detail).

▶*Burren House* (as free standing
sculpture); 48 x 17 x 17" (120 x
42.5 x 42.5cm).

ROBERT FORMAN ▸ Hoboken, New Jersey USA

Francis M. Naumann Fine Art

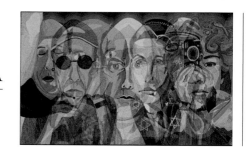

Robert Forman; *Self Portrait Six*; thread glued to board; cotton, linen, silk, rayon; 24 x 40" (60 x 100cm); photo: Jeff Goldman

Robert Forman's urban observations intentionally fool the viewer's eye while confronting conventional expectations of fiber art. This artist sees his world in layers of semi-transparent images piled one upon another or in fleeting glimpses of people passing each other in space or time. Details emerge so complex they could only have been created with marks of impossibly fine threads. With masterful integration of image and materials, Forman leads his audience beyond any curiosity about threads into fast-paced New Jersey and New York scenes. Always with an eye toward wit, irony, and metaphor the artist fakes even the complex fabrics in his interior scenes with a distinctive impressionistic style.

Forman calls his work *thread painting*, an accurate though too general a characterization of laying down fine threads in a single layer. Early experiments in the technique lured him to Mexico to explore its cultural roots. A Fulbright Fellowship allowed him to live and study with Huichol Indians in the Sierra Madre mountains. There, traditional yarn paintings reflect the indigenous peoples' natural surroundings and religious life. Forman's Huichol colleagues referred to their art as *permanent prayers*. The Jewish artist from New Jersey returned home with enriched perceptions to inspire the art of his people, his prayers, and his place in the world.

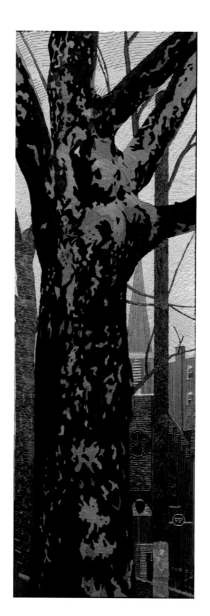

▸**Robert Forman**; *Hoboken Station*; thread glued to board; cotton, linen, silk, rayon; 30 x 40" (75 x 100cm); photo: Jeff Goldman.

▸▸**Robert Forman**; *Tunnel*; thread glued to board; cotton, linen, silk, rayon; 36 x 40" (90 x 100cm); photo: Jeff Goldman.

▸**Robert Forman**; *Monkey*; thread glued to board; cotton, linen, silk, rayon; 40 x 30" (100 x 75cm); photo: Jeff Goldman.

◂**Robert Forman**; *Tree*; thread glued to board; cotton, linen, silk, rayon; 48 x 16" (120 x 40cm); photo: Jeff Goldman.

JOHN G. GARRETT ▸ Albuquerque, New Mexico USA

As an archaeologist visualizes associations amongst his finds, so might sculptor John Garrett organize concepts in materials and objects imbued with heavy experience. His copper, steel, wire, and other materials are compelled to refer at various stages to the orders of the woven grid. This simple mathematical constant supports a free and energetic sculpting style. Though for all its implied clarity, the underlying geometry seems more a source of poetic mystery. References to the patterns of stitching, knotting, crochet, and riveting join the layers of mystery with their own abstractions.

With characteristic lucidity and precision, Garrett's wall art engages viewers with objects taken directly from the stream of life. His rhythmic, slightly varied surface structures suggest an ongoing mental process in which the physical becomes metaphysical.

The stronger elements of his vessels favor the deep dimensions and entrapped implications even as they express softer, cloth-like surfaces and stitched joins. Little exists here of the traditional roles of metal and thread, yet their universally understood principles have been endowed with fresh aesthetic viability.

▲**John G. Garrett**; *New Age Basket No. 2*; stitching, crochet; steel armature, fabric, wire, beads, found steel, manipulated copper, rivets; 12.5 x 12 x 12" (31.25 x 30 x 30cm); photo: Margot Geist.

▸**John G. Garrett**; *New Age Basket No. 4*; stitching, crochet; steel armature, found steel, manipulated copper, wire, beads, rivets; 20.5 x 15 x 15" (51.25 x 37.5 x 37.5cm); photo: Margot Geist.

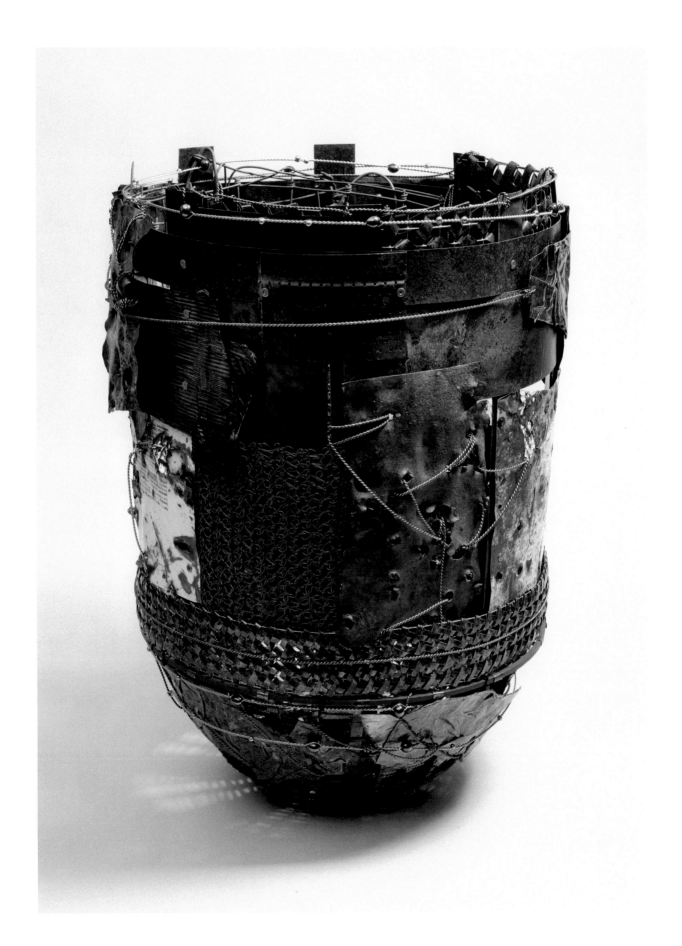

▶**John G. Garrett**;
Journeyman's Quilt; painting, papermaking, collage, riveting, needlepoint stitching, crochet, weaving, printing; copper, steel, aluminum, paint, handmade and commercial paper, photographs, drawings, linoleum, compact discs, wire, yarn, thread, fabric, buttons; 71.5 x 70.5" (178.75 x 176.25cm); photo: Margot Geist.

▼*Journeyman's Quilt* (detail).

John G. Garrett; *Sandman Diptych*; stitching, knotting; hardware cloth, copper strips, waxed linen string, beads, buttons, shells, paper, hardware, paper on wood panel; each panel: 24.5 x 11.5" (61.25 x 28.75cm); photo: Margot Geist.

John G. Garrett; *Rainman Diptych*; stitching, knotting; hardware cloth, aluminum strips, nylon string, beads, buttons, hardware, paper on wood panel; each panel: 24.5 x 11.5" (61.25 x 28.75cm); photo: Margot Geist.

ANNA-RIITTA HAAVISTO ▸ Helsinki Finland

Second generation Finnish artist Anna-Riitta Haavisto has exhibited her work both independently and in concert with that of her mother, the late Riitta-Liisa Haavisto. Finnish girls are expected to learn and eventually pass on to their daughters the skills of weaving, embroidery, sewing, and knitting. With tradition as the point of departure, the Haavistos set free the threads and structures of handcrafted textiles to assume deeper metaphors and meanings as fine art. Galleries in London, St. Petersburg, Berlin, Paris, Philadelphia, and New York responded enthusiastically.

Anna-Riitta Haavisto's taut, focused fiber sculptures reflect an inner consonance with our unpredictable and often discordant universe. Inspired by the iconic box of chocolates from the film *Forrest Gump,* her work *Sweet Times* contains similar layers of possibilities and surprises. With her experimental inclination coupled with the aesthetic influences of the cubists and the Bauhaus, the artist vents personal or societal realities through the orderly visual languages she was taught as a child.

▶**Anna-Riitta Haavisto**;
Black Coral I; mixed
technique; stainless steel,
rubber, plastic; max 15.74
x 3.93" (max 40 x 10cm);
photo: Matti Huuhka.

◀*Black Coral I* (detail).

▼**Anna-Riitta Haavisto**;
City Chick's Cot; mixed
technique; stainless steel
wire, plastic; max 5.90"
(15cm); photo: Matti
Huuhka.

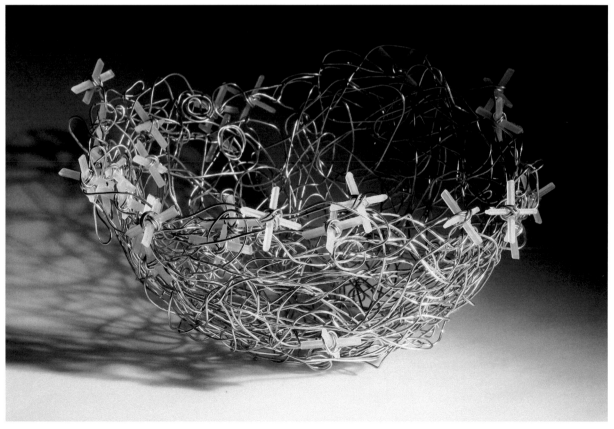

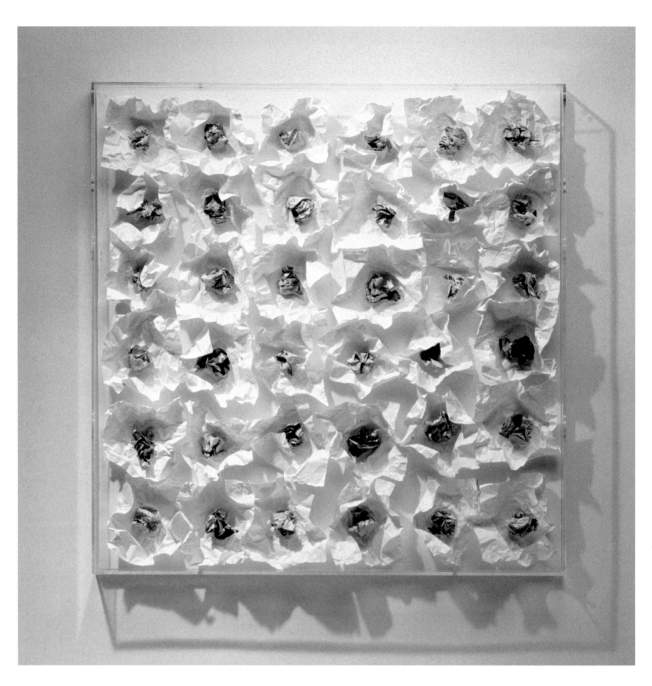

▲**Anna-Riitta Haavisto**; *Sweet Times*; mixed technique; paper, newsprint (*Financial Times*); 19.68 x 19.68 x 1.57" (50 x 50 x 4cm); photo: Matti Huuhka.

▶**Anna-Riitta Haavisto**; *Pills of Joy I & II*; mixed technique; pill containers, cotton; each piece 1.96 x 1.96 x .78" (5 x 5 x 2cm); photo: Matti Huuhka.

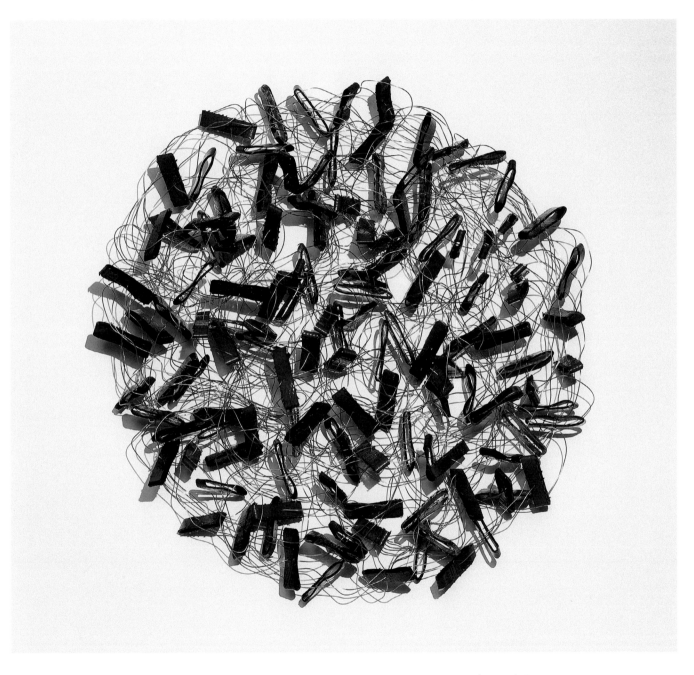

Anna-Riitta Haavisto; *Blue Puzzle I*;
mixed technique; stainless steel, coated
rubber; max 17.71 x 2.75" (max 45 x
7cm); photo: Matti Huuhka.

RIITTA-LIISA HAAVISTO ▸ Helsinki, Finland
1930-2009

One of Finland's most highly regarded embroidery artists, Riitta-Liisa Haavisto will long be remembered for her elegant abstractions stitched with an uninhibited style. In layers of impossibly fine threads, she suspends her audience somewhere between recognition and sensation. Her designs were inspired by people, of whom she made piles of sketches or by childhood imaginings of hobgoblins and fairies inhabiting the Finnish forests. Enigmatic subjects, portrayed with minimal but convincing expression are intensified by potent elements such as negative space and deep mysterious backgrounds. Yet, nothing seems willed here. It is as if each form or color reveals the next logical note in the music of her personal sphere. Present always though is the unmistakable equilibrium of a master conductor.

Amongst her many awards, Riitta-Liisa Haavisto has been honored with the Nordic Designer Award by the (Swedish) Karin and Bruno Mathsson Foundation.

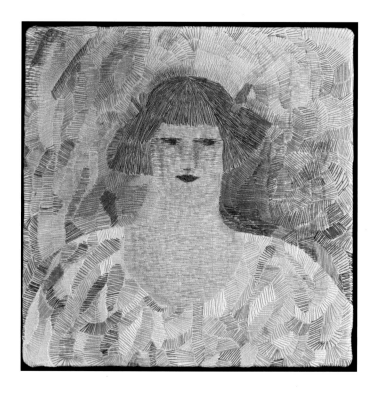

▲**Riitta-Liisa Haavisto**; *Summer Girl*; hand embroidery; silk, viscose, cotton; 9.05 x 9.05 x 0.6" (23.5 x 23.5 x 1.5cm); photo Matti Huuhka.

▸**Riitta-Liisa Haavisto**; *Awakening City*; hand and machine embroidery/stitching; cotton, linen silk, viscose; 20.86 x 20.07 x 0.78" (53 x 51 x 2cm); photo Matti Huuhka.

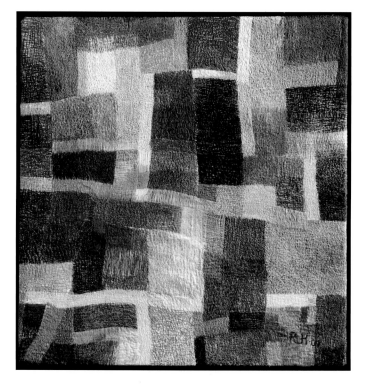

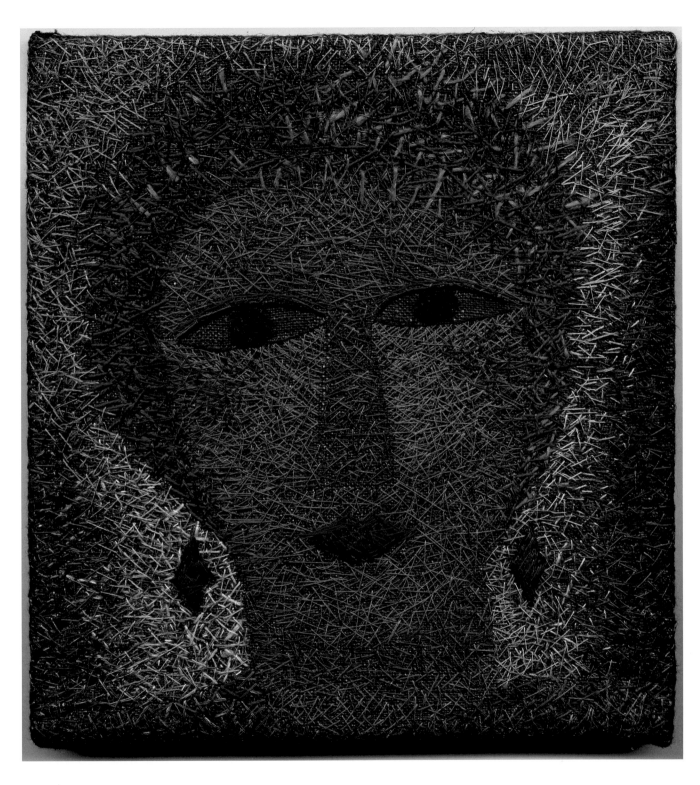

Riitta-Liisa Haavisto; *Blues*; hand
embroidery; linen, cotton, silk;
7.48 x 7.08" (19 x 18 x 1cm);
photo: Matti Huuhka.

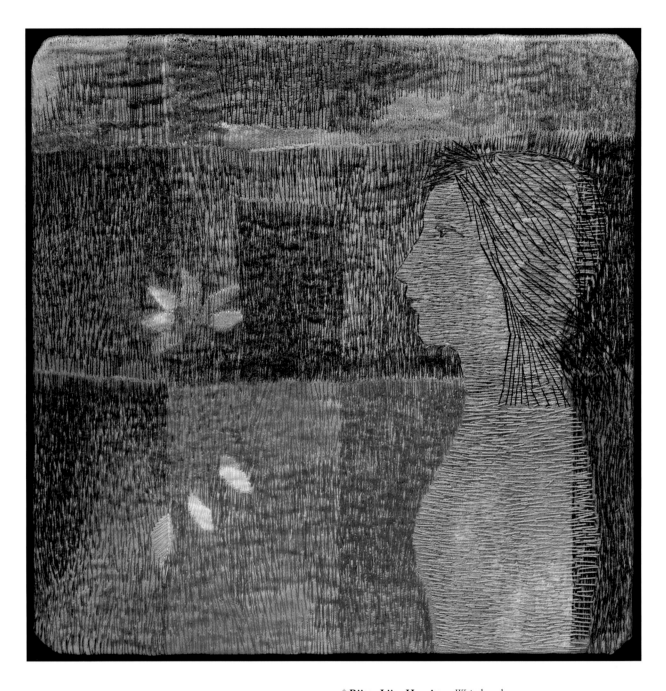

▲**Riitta-Liisa Haavisto**; *Wait*; hand embroidery; silk viscose, cotton; 9.05 x 9.05 x 0.6" (23.5 x 23.5 x 1.5cm); photo Matti Huuhka.

▶**Riitta-Liisa Haavisto**; *Distant Memories*; hand embroidery; cotton, silk, viscose; 9.05 x 9.05 x 0.6" (23.5 x 23.5 x 1.5cm); photo Matti Huuhka.

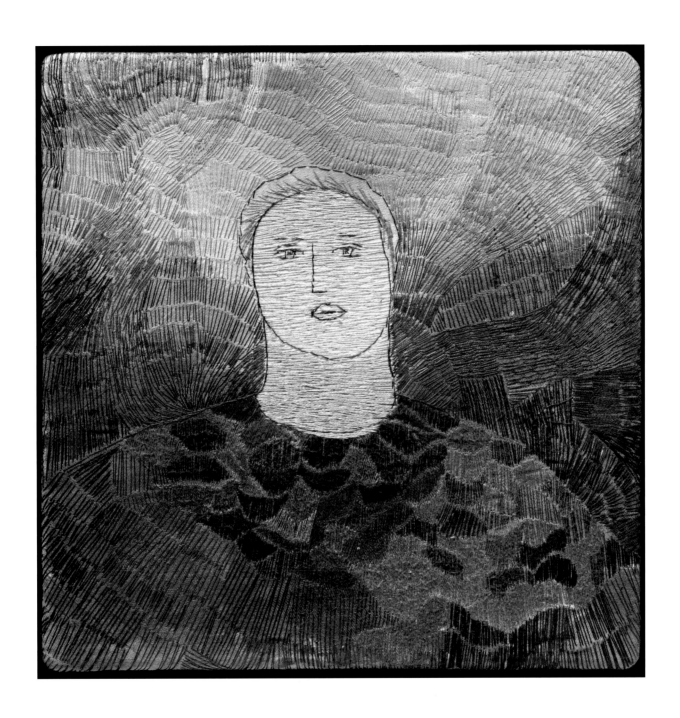

PAMELA HARDESTY ▸ Kinsale, County Cork, Ireland

Pamela Hardesty lives and works near the sea at the western edge of Ireland. Composing material, form, color, and light into metaphors for faith; she creates radiant sculptures to illuminate interior spaces. In her hands, unyielding, often harsh materials are knotted into expressions of culture and spirituality, gathering light from here and there to redistribute freely. In Baptism she captures the ritual of the sparkling droplets of holy water.

Well experienced in traditional tapestry and harness loom structures, the artist has embraced the role of physical process as a meditative journey leading toward a work of art. Her installations and exhibition pieces are formed with shards of glass and stone knotted together with wire into multi-layered visions. They enlighten public buildings and sanctuaries across Europe and Scandinavia.

The artist writes, *My art practice responds to my ongoing inner efforts to articulate my Christian faith. I have tried to form a contemporary language of faith, using new, innovative methods and materials in symbolic forms. I am particularly conscious of the role of process, of making, in forming my work, and I see the meticulous, repetitive constructions I use as forms of prayer.*

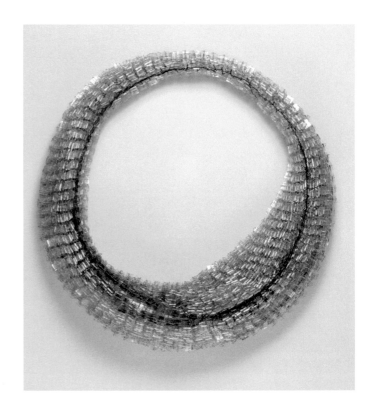

▴**Pamela Hardesty**; *Halo*; Artist's own technique: wrapped, twisted together, and stitched; glass, wire (enameled copper), gold leaf; 20 x 20 x 3" (50 x 50 8cm); photo: Roland Paschoff.

◂*Halo* (detail).

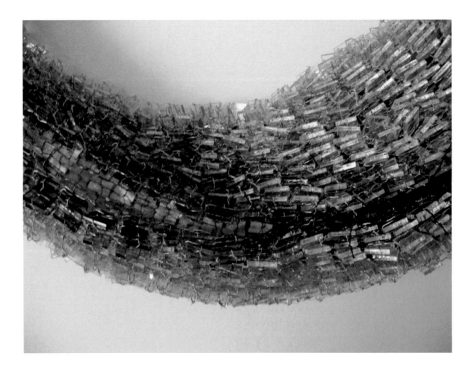

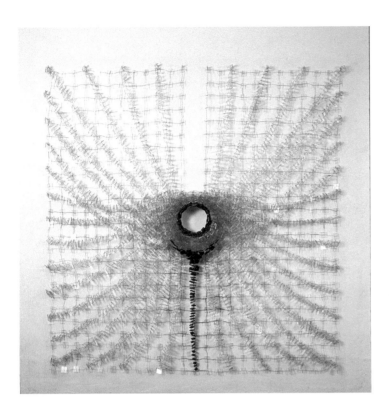

Pamela Hardesty;
Baptism; Artist's own
technique: wrapped,
twisted together, and
stitched; glass (clear
and stained glass),
wire (stainless steel
and enameled copper),
stone; 48 x 48 x 2"
(120 x 120 x 5cm);
photo: John Collins.

Baptism (detail).

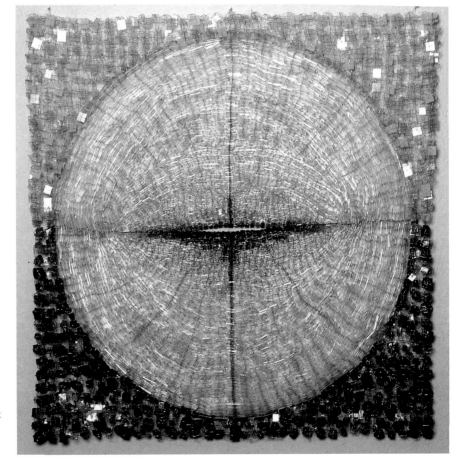

▶Pamela Hardesty; *Sacred Heart: the Water*;
Artist's own technique: wrapped, twisted
together, and stitched; glass (clear and stained
glass); wire (stainless steel and enameled
copper), stone, paper; 40 x 40 x 2" (100 x 100 x
5cm); photo: John Collins.

Sacred Heart: the Water (detail).

MARILYN HENRION ▶ New York, NY USA

They say that every sound ever made is still reverberating through the universe, however quietly and however distant.

Simon Armitage, *Modeling the Universe: Poetry, Science, and The Art of Metaphor.*

Born, bred and living still amidst the vibrancy of New York City's street life and cultural treasures, Marilyn Henrion works at the outer edges of fine art textiles. Having placed her quilted works upon the walls of prestigious public and private collections, she is perhaps best known for confounding her audiences with cheeky geometric metaphors poised to escape the medium's two-dimensional confines. Her strokes of colors bend, twist, and distort logic as they dance back and forth to her tune. Carrying this attitude through a succession of well received quilted series; the artist arrives here with a noticeable shift toward pictorial means of expressive content.

Though these series of works began in literal terms, they are still subject to Henrion's quintessential reordering through geometric patterns of hand stitching and surface manipulation. Here the heart and soul of the city speak—not through loud activity but through echoes, glances, and ambiguities. The city's grandest museum on 5th Avenue holds a procession of marble icons whispering their ancient experiences to all passing by. The softer images of the city appear within peeling architectural frames suggesting a series of worn pages from an intimate urban journal. Viewed through the artist's richly applied patina of stitches, the literal becomes an abstract drama. Reverberating in concert are the sights and sounds of both series.

▲**Marilyn Henrion**; *Epikouros (from the Reverberations series)*; digital photography, inkjet printing on fabric, fusing, piecing, hand quilting, trapunto; cotton, silk, polyester batting, silk thread; 12 x 9 x .50" (30 x 22.5 x 1.25cm); photo: D. James Dee.

◀◀**Marilyn Henrion**; *Felicia (from the Reverberations series)*; digital photography, inkjet printing on fabric, fusing, piecing, hand quilting, trapunto; cotton, silk, polyester batting, silk thread; 12 x 9 x .50" (30 x 22.5 x 1.25cm); photo: D. James Dee.

◀**Marilyn Henrion**; *Cassius (from the Reverberations series)*; digital photography, inkjet printing on fabric, fusing, piecing, hand quilting, trapunto; cotton, silk, polyester batting, silk thread; 12 x 9 x .50" (30 x 22.5 x 1.25cm); photo: D. James Dee.

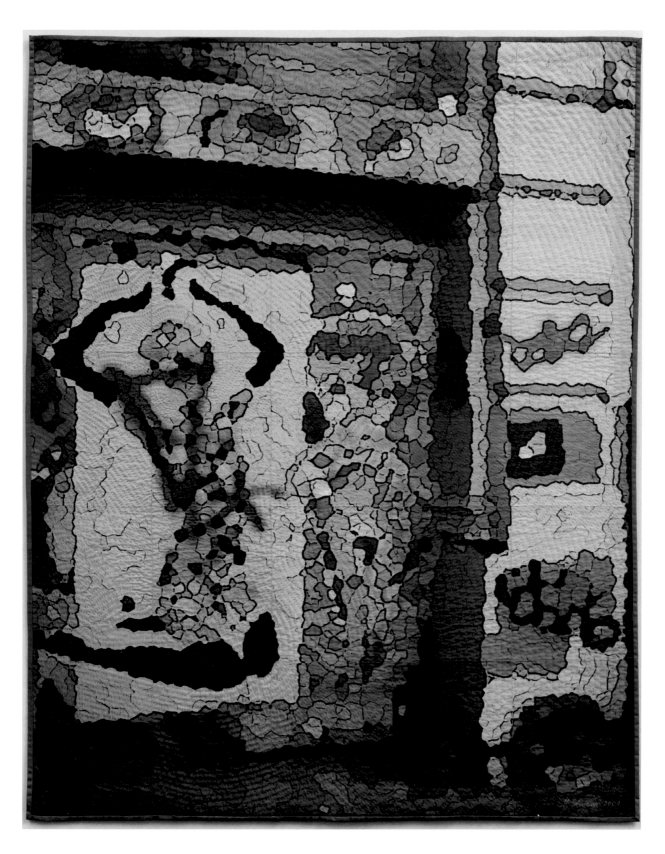

Marilyn Henrion; *Dancer (from the Soft City series)*;
digitally manipulated photography, inkjet printing
on cotton, piecing, hand quilting; cotton fabric,
polyester batting, cotton thread; 50 x 40" (125 x
100cm); photo: D. James Dee.

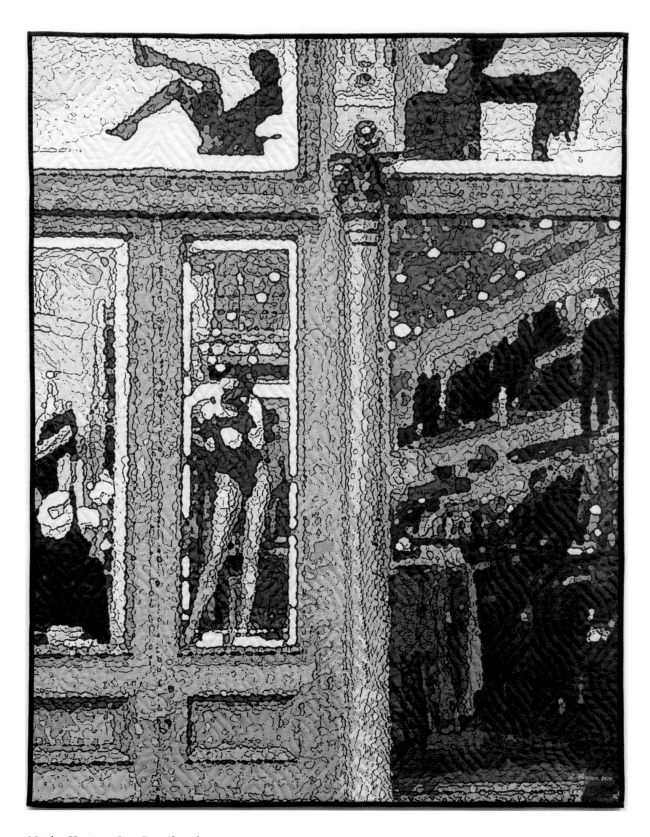

Marilyn Henrion; *Open Door (from the Soft City series)*; digitally manipulated photography, inkjet printing on cotton, hand quilting; cotton fabric, polyester batting, cotton thread; 50 x 40" (125 x 100cm); photo: D. James Dee.

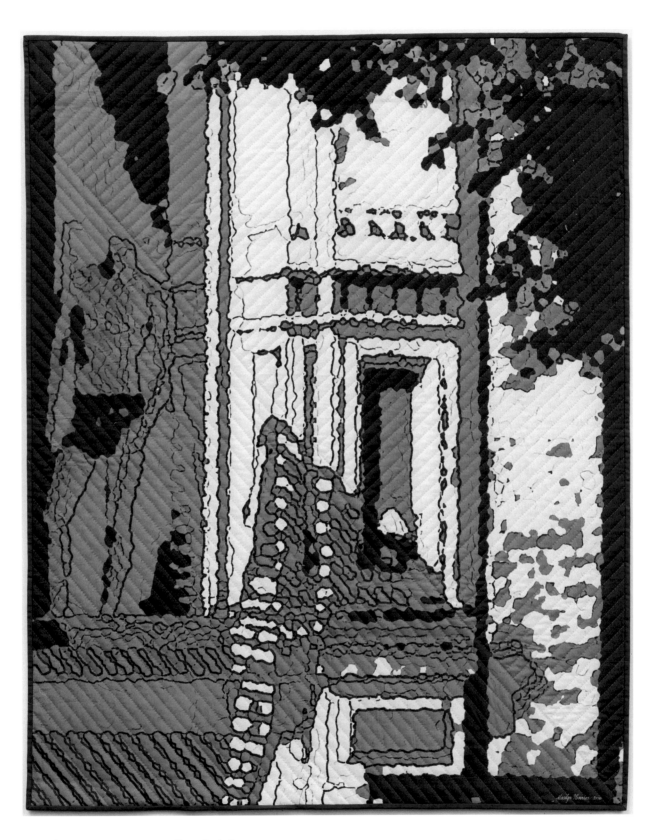

Marilyn Henrion; *Mannequin (from the Soft City series)*; digitally manipulated photography, inkjet printing on cotton, hand quilting; cotton fabric, polyester batting, silk thread; 50 x 40" (125 x 100cm); photo: D. James Dee.

PAT HICKMAN ▸ Haverstraw, New York USA

Snyderman-Works Galleries

In her art, Pat Hickman reflects on time, considering what is meant by the idea of cascading time, a creatively active, accelerated time for exploring and experimenting. With the gift of quiet, focused time in the studio, where there is a slowing down of time, an artist steps outside the urgent pace of daily life to see what can be done. Rusted metal represents changing time, deterioration, history. Bringing metal together with gut (hog casings) allows a transfer with each element receiving an aspect of the other. The gut takes the form of the metal; the rusted metal stains the gut. In playing with these ideas and materials, Hickman explores memory, loss, aging, mortality. Through art she brings to mind these concepts and calls attention to them. Living on the Hudson River, watching its currents, knowing the water is never still is part of this time of imagining.

Pat Hickman is Professor Emeritus of the Art Department, University of Hawaii and President of the Textile Society of America (2008-2010), she was elected a fellow of the American Craft Council in 2005. Her work is in several major collections including the Museum of Art and Design, the Oakland Museum, the Honolulu Academy of Arts, the Hawaii State Art Museum, and the Renwick Gallery, Smithsonian Institution. In Hawaii, Hickman's commission, Nets of Makali'i – Nets of the Pleiades, stands as monumental entrance gates for the Maui Arts and Cultural Center.

▲ **Pat Hickman**; *Eye Chart*; stitching; paper ("to do" lists), waxed linen, and wax; approximately 57 x 84 x 1" (142.5 x 210 x 2.5cm); photo: Troy Ruffles.

▼ *Eye Chart* (detail).

◀ **Pat Hickman**; *Whorl*; sculptural installation; mahogany dyed gut, pins for mounting insects; (size is approximate depending upon installation) 6'9" x 14' x 10" (202.5 x 420 x 25cm); photo: D. James Dee.

▼ *Whorl (detail).*

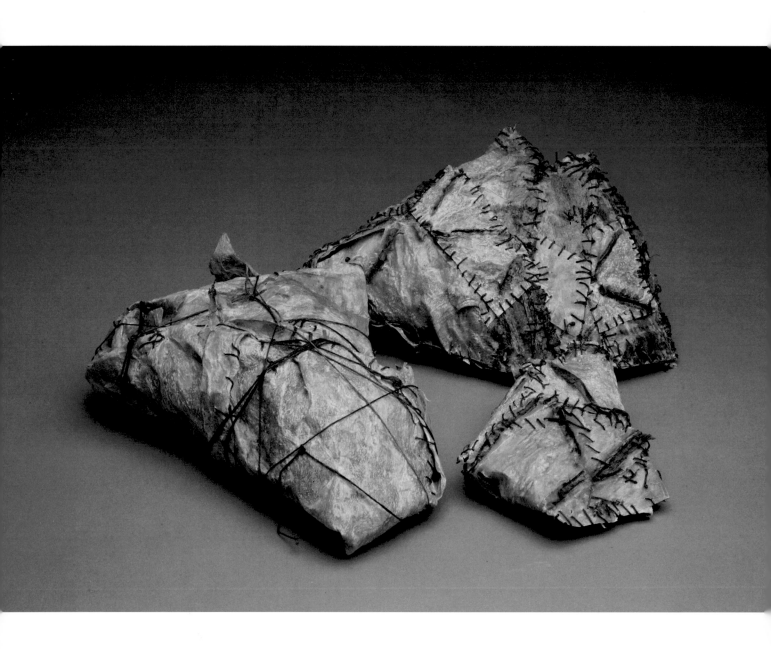

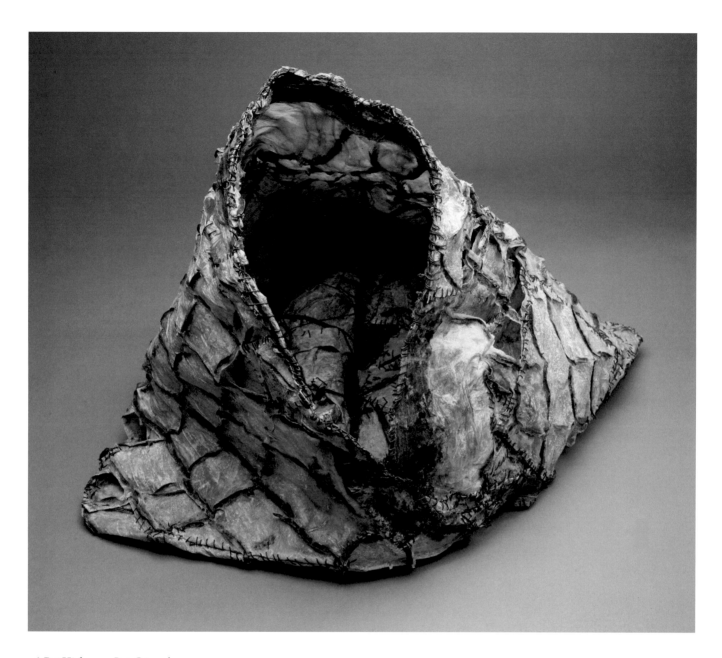

▲**Pat Hickman**; *Post Cot*; sculpture; gut
with rust marks; approximately 15 x 21.5
x 14" (37.5 x 53.75 x 35cm); photo:
George Potanovic, Jr.

◀**Pat Hickman**; *The Things They
Carried*; sculpture; gut with rust marks;
approximately 8 x 7 x 3" (20 x 17.5 x
7.5cm); photo: George Potanovic, Jr.

FERNE JACOBS ▶ Los Angeles, California USA

Nancy Margolis Gallery

Ferne Jacobs emerged as a prominent fiber artist from the international movement of the 1960s and '70s. Inspired by Lenore Tawney, Jacobs ventured forth to study with Peter Collingwood, Dominic di Mare, Olga de Amaral and others whose work framed the critique of fiber art for several decades. Though her art career began with painting, she became fascinated with the processes of looms and weaving. Once mastered, she sought to burst forth from the rectangular limitations of the loom and its soft results. In a direction that would combine weaving with her three-dimensional impulses, she experimented with basketry techniques which quickly evolved into free-form sculpture.

Her organically composed structures are distinguished by a strong presence of ancient cultures drawn forth by intuitive hands. Beginning with the simplest element—a thread, one seemingly infinite line—the artist lives in the moment with the form emerging at her fingertips. Their ongoing dialogue influences the work until it becomes itself. The process continues from one piece to the next, always different from the last but with a body that could only have been sculpted with the nurturing touch of a consummate artist coiling her thread into a never ending story.

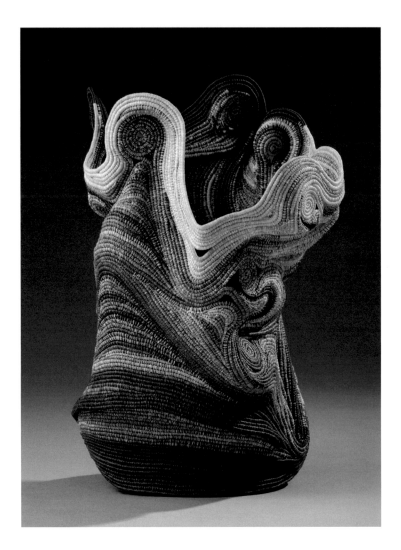

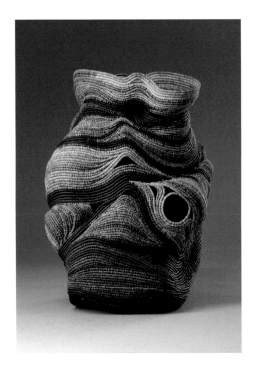

▲**Ferne Jacobs**; *Floating World*; coiled; waxed linen thread; 18 x 13.5 x 11.5" (45 x 33.75 x 28.75cm); photo: Susan Einstein.

◀**Ferne Jacobs**; *Puzzle*; coiled; waxed linen thread; 23.5 x 20 x 13" (58.75 x 50 x 32.5cm); photo: Susan Einstein.

▶**Ferne Jacobs**; *Wind*; coiled; waxed linen thread; 15.5 x 11 x 9" (38.75 x 27.5 x 22.5cm); photo: Susan Einstein.

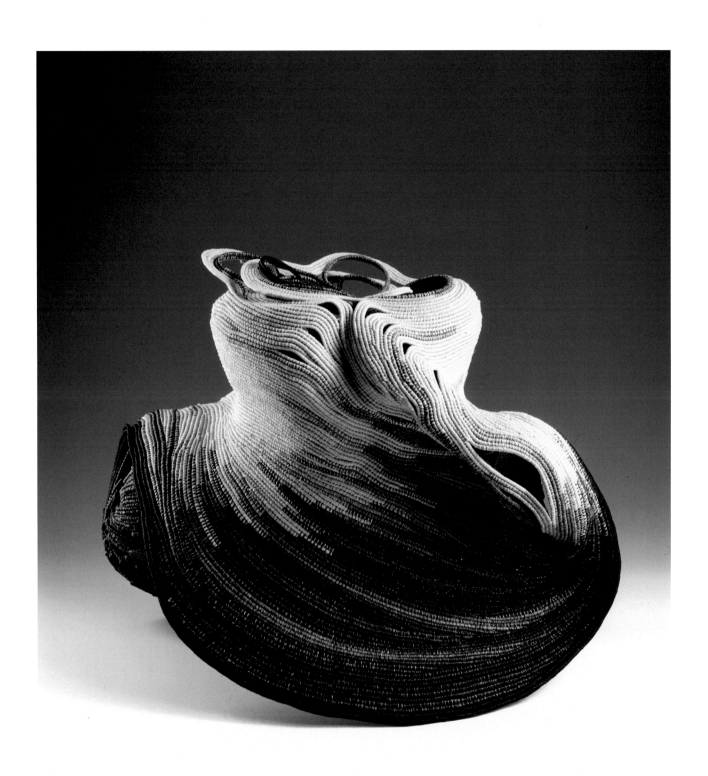

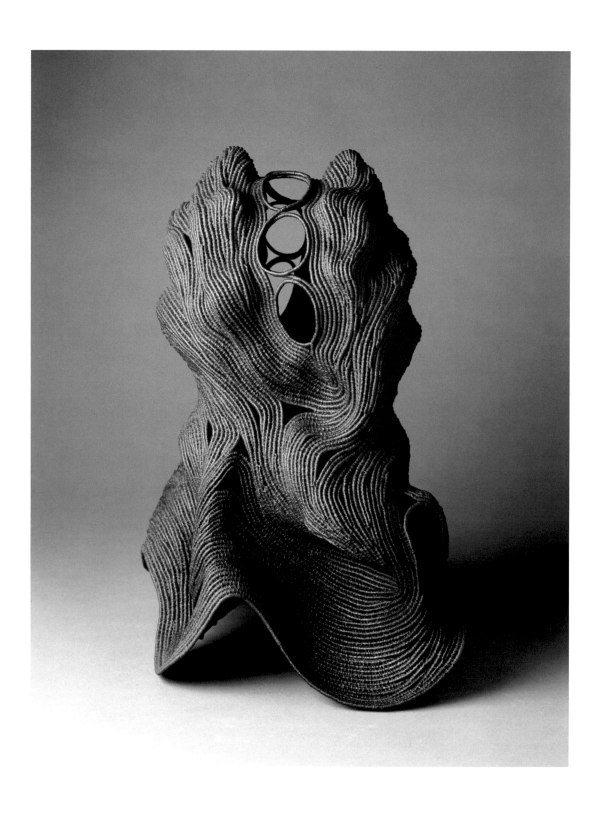

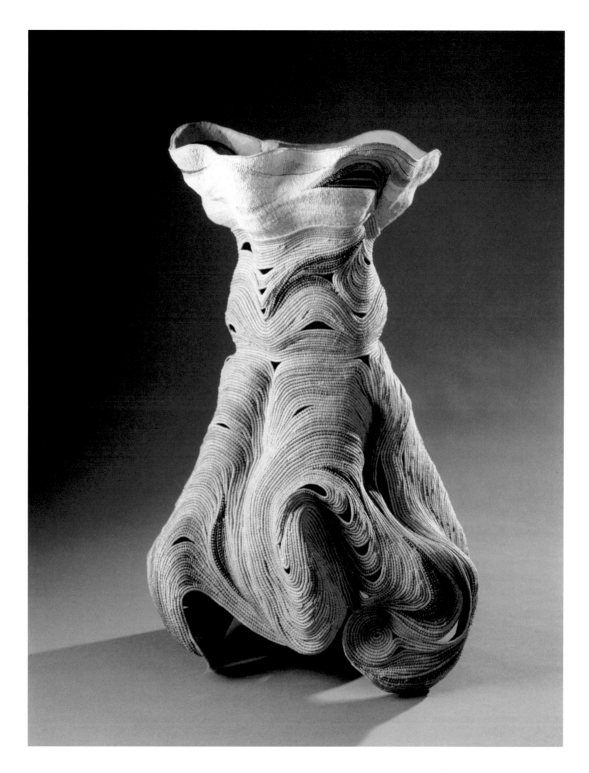

▲ **Ferne Jacobs**; *Tides*; coiled; waxed
linen thread; 26 x 17 x 17" (65 x 42.5 x
42.5cm); photo: Susan Einstein.

◀**Ferne Jacobs**; *Open Heart*; coiled; waxed
linen thread; 16.5 x 12 x 9" (41.25 x 30 x
22.5cm); photo: Susan Einstein.

JUDITH JAMES ▸ Lincoln, Nebraska USA

Snyderman-Works Galleries

Alluding to communication and even poetry in her textile constructions, Judith James first sets forth a material language. Her intricately prepared fabrics are informed by the out-of-focus patterns of Japanese shibori, African adire cloth, and other early resist dying methods. Stitch marks and serendipitous results provide the artist with a cloth of substantial character to embroider, print again or layer amongst other soft traces.

Fabric has been my means of expression ever since I was a young child. I made it the focus of my professional business life for nearly twenty-five years, and now it's the focus of my creative life. It interacts with all of my senses, so it's not only its tactile appeal that entices me to return again and again, but also the expressive magic that it promises.

Judith James

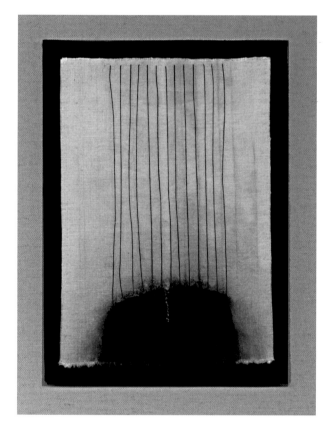

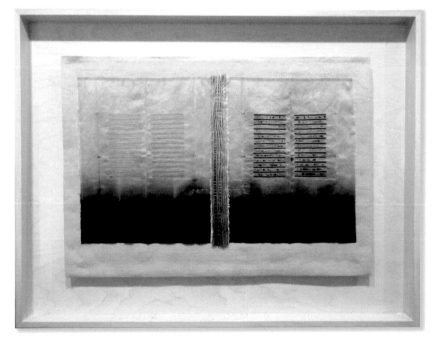

▴**Judith James**; *High Wire*; resist discharge, dye, stitching; cotton and silk; 10 x 7.25" (25 x 18cm).

◂**Judith James**; *Erasure*; stitched resist discharge, stitching; cotton and silk; 17 x 24.5" (42.5 x 61.5cm).

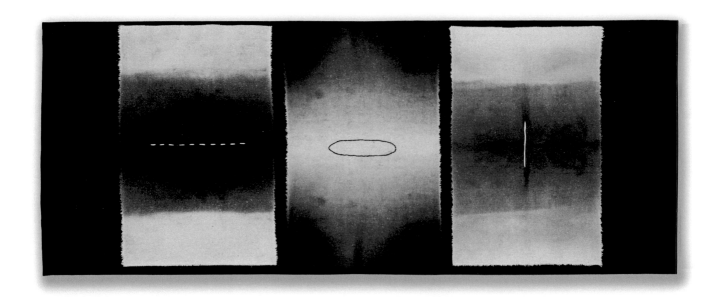

Judith James; *Landscape*; resist discharge, dye, stitching; cotton and silk; 10 x 27" (25 x 67.5cm).

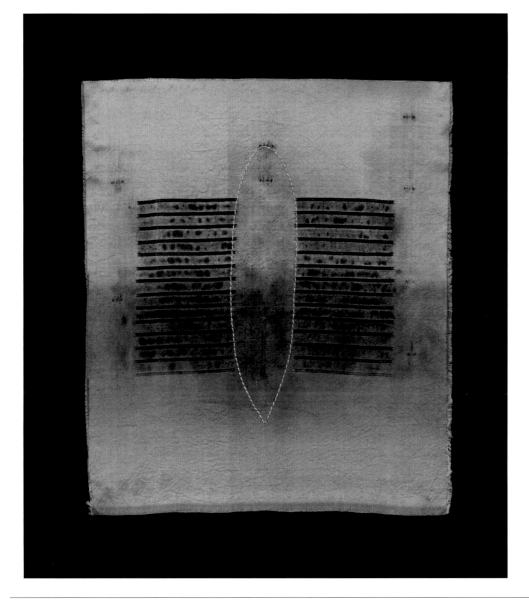

Judith James; *Bookmark*; stitched resist discharge, stitching; cotton and silk; 11.5 x 10" (28 x 25cm).

MICHAEL JAMES ▸ Lincoln, Nebraska USA

Modern Arts Midwest

Pattern has been the constant element in my work, going back more than thirty years. I use pattern as a metaphor for the complex systems that work through our world: physical systems, emotional systems, psychological systems, etc. Pattern is a metaphor for the order implicit in these systems, but the play with pattern, altering and deconstructing it, allows for the likelihood that order will give way to disorder, to the unexpected and the unpredictable. This constant tension between order and disorder is a unifying thread that runs through my work .

I'm also interested in the unseen world that constitutes much of the emotional and psychological spaces that we reside in a good part of the time. Using abstract constructions, sometimes with representational images, or images that occupy that ambiguous realm between the recognizable and the indeterminate, I attempt to give visual form to these metaphysical domains. I'm comfortable in dream spaces and in the malleable and fluid territory of memory, and in my work I try to reach into these psychic domains. I hope that the work evokes in the viewer some experience of these worlds held just below the outward surface of things.

Michael James, January 2010

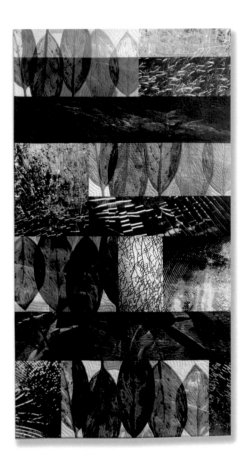

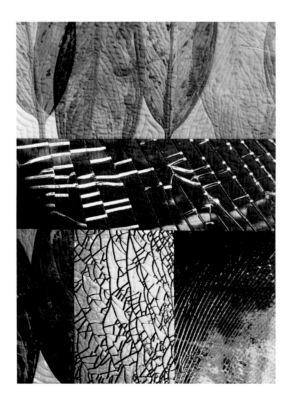

▲**Michael James**; *The Geometric Organization of Nature*; machine pieced and machine quilted; digitally-developed and digitally-printed cotton, reactive dyes; 36.75 x 67.75" (91.5 x 167.5cm); photo: Larry Gavel.

◂*The Geometric Organization of Nature* (detail).

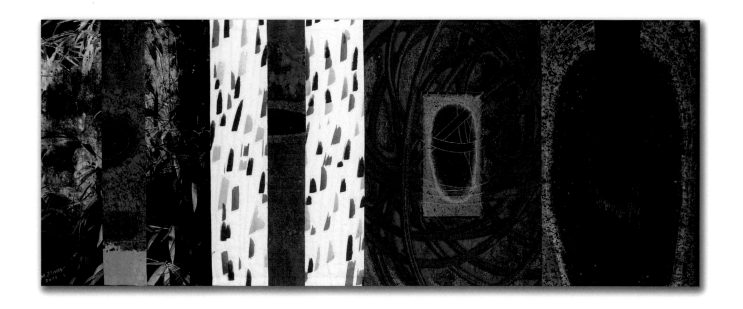

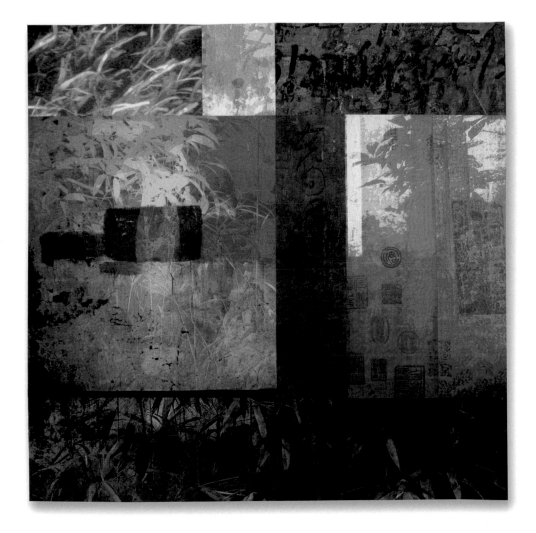

Michael James; *Four Stages in Picturing Imagination*; machine pieced and machine quilted; digitally-developed and digitally-printed cotton, reactive dyes; 17.25 x 43.25" (43 x 107.5cm); photo: Larry Gavel.

Michael James; *The Concept of Qi*; machine pieced and machine quilted; digitally-developed and digitally-printed cotton, reactive dyes; 50.5 x 52" (126.25 x 130cm); photo: Larry Gavel.

MARIA JOHANSSON ▸ Göteborg, Sweden

Though educated in and still a resident of Göteborg, Sweden, Maria Johansson has exhibited her weavings not only at the Rhösska Museet there but also at the Musée Jean Lurçat in Angers, France, The International Triennial of Tapestry in Lodz, Poland and the Deutsches Textilmuseum in Krefeld, Germany. As our modern world becomes more accessible, an international community of fiber artists extends the prestigious legacy of artistic invention in mediums with deep cultural connotations. Through a common visual language, practitioners in the field enrich exhibitions, conferences, and galleries with their global perspective.

Johansson's weavings explore whispers between the lines she draws on her loom, much as a poet's words sketch lightly and indistinctly. Weaving on a specially built tapestry loom allowing two separate and distinct layers of threads upon which to compose, this artist orchestrates a complex three-dimensional concert of voices viewed at once in perfect harmony. A technological, yet physically supple, light source illuminates from within the textile structure. As in a medieval manuscript, illumination here serves to intensify the viewer's perceptions of the creator's meaning.

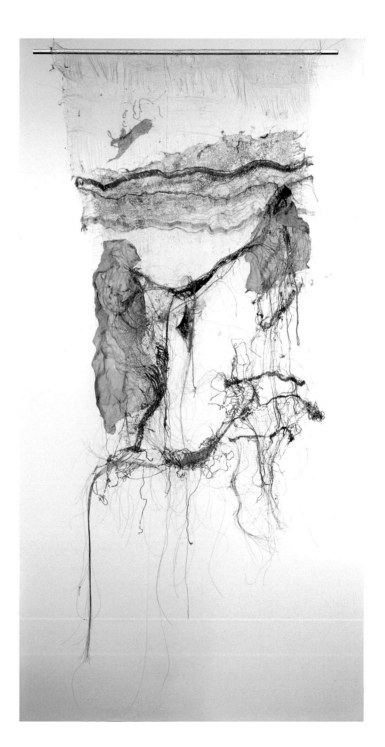

Maria Johansson; *Heart and Lung*; handweaving and papermaking; silk, nylon, handmade paper from flax; 24 x 48" (60 x 120cm); photo: Bo Kågerud.

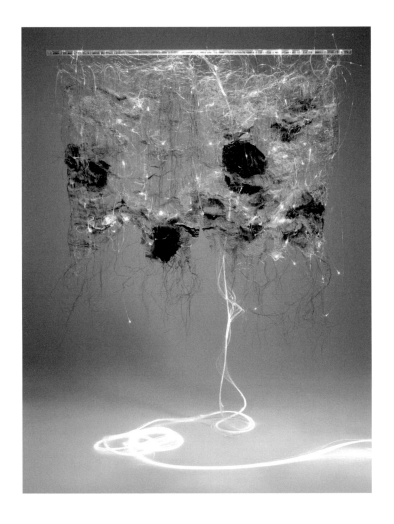

Maria Johansson; *Threads of Light*; double weave in a tapestry loom; silk, nylon, fiber optics, metal threads; 60 x 52" (150 x 130cm); photo: Bo Kågerud.

Threads of Light (detail).

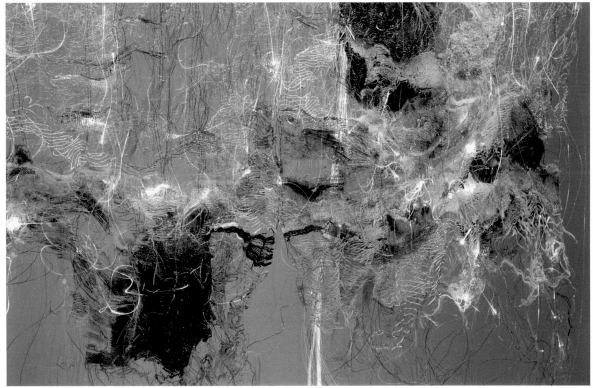

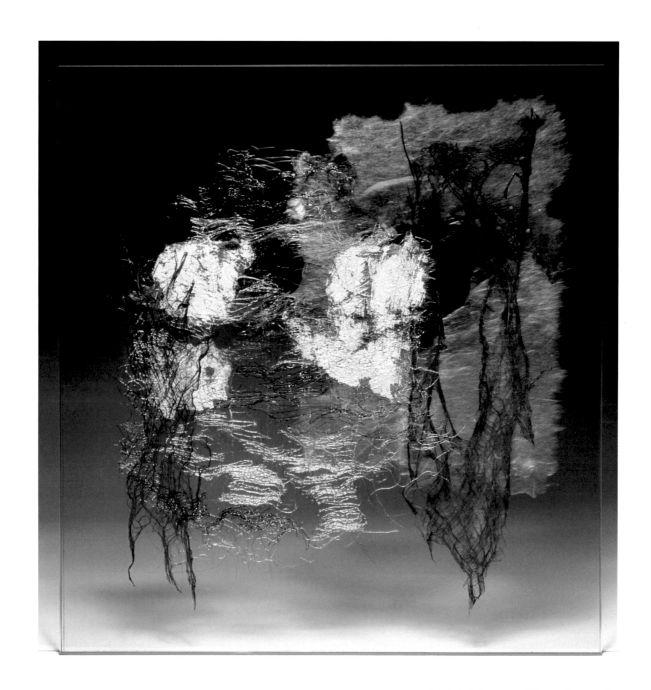

▲**Maria Johansson**; *Weave in laminated glass with blue fiber*; handweaving; silk, nylon, gold leaf, mulberry fiber; 16 x 17" (40 x 42cm); photo: Bo Kågerud.

▶**Maria Johansson**; *Weave in laminated glass*; handweaving; silk, nylon, gold leaf; 12.5 x 16" (32 x 40cm); photo: Bo Kågerud.

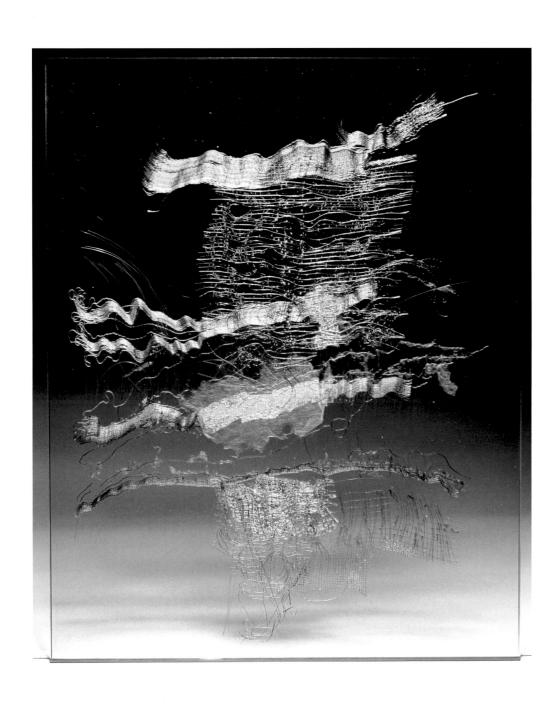

ALLIE KAY ▸ Whitegate, County Clare, Ireland

For many years I have been working to combine words, images, fabrics, surfaces, and textures to create not representational but tactile and emotional reactions to these starting points, both for myself and the viewer. The sources for the works range from the interior self to social and local history to responses to human activities such as war.

Allie Kay

Allie Kay lives in a country with a rich history of practice in all the finest textile arts. Traditional skills such as embroidery, quilting, knitting, and weaving are handed down through generations and taught in schools through the university level. Ireland is also a country rich in literature, poetry, and song. Along with its treasured arts heritage came centuries of hardship and political conflict. Ireland's artists readily appropriate a relevant textile voice for the holistic expression of their complex culture. Just as densely outlined buttonholes speak in visual terms for voices unheard throughout the island's 32 counties, so shall elegantly stitched cloth hold words of farewell yet leave much unsaid.

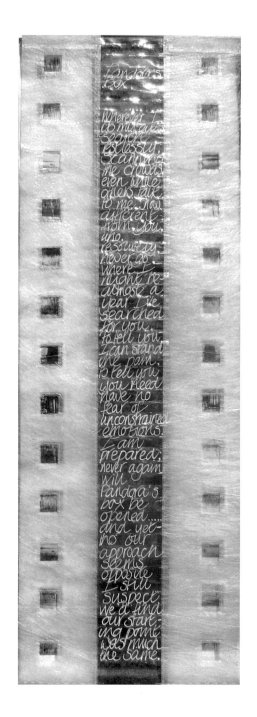

◀**Allie Kay**; *Pandora's Box (one of a series based on a poem of the same name)*; photo prints on acetate, writing, stitching; Tyvek, plastic, acetate, corrector pen; 20 x 60" (51 x 150cm); photo: courtesy of the artist.

▲*Pandora's Box* (detail).

▶**Allie Kay**; 32 Unheard Voices; bound buttonholes in whole cloth; linens and silks; 10 x 7 x 3.5" (25 x 18 x 9cm); photo: courtesy of the artist.

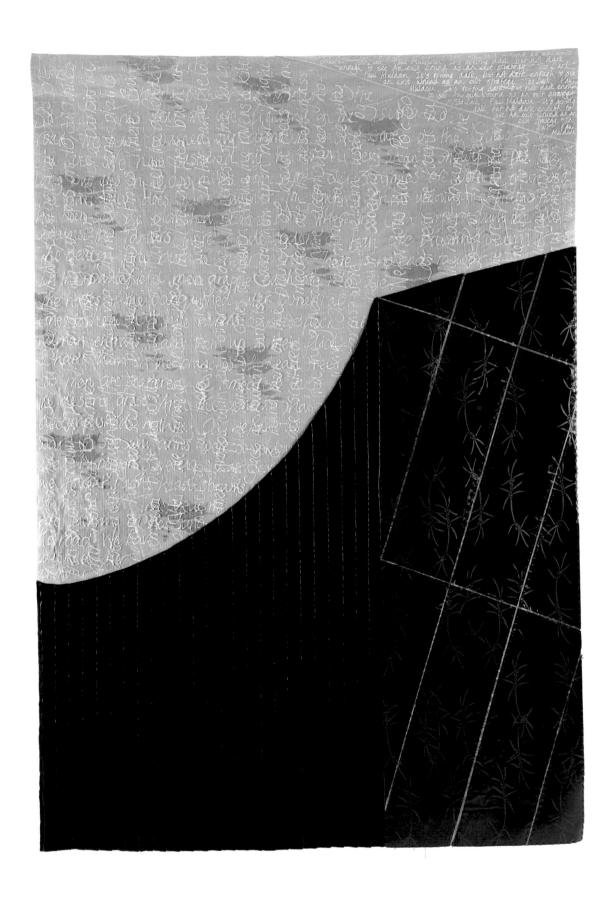

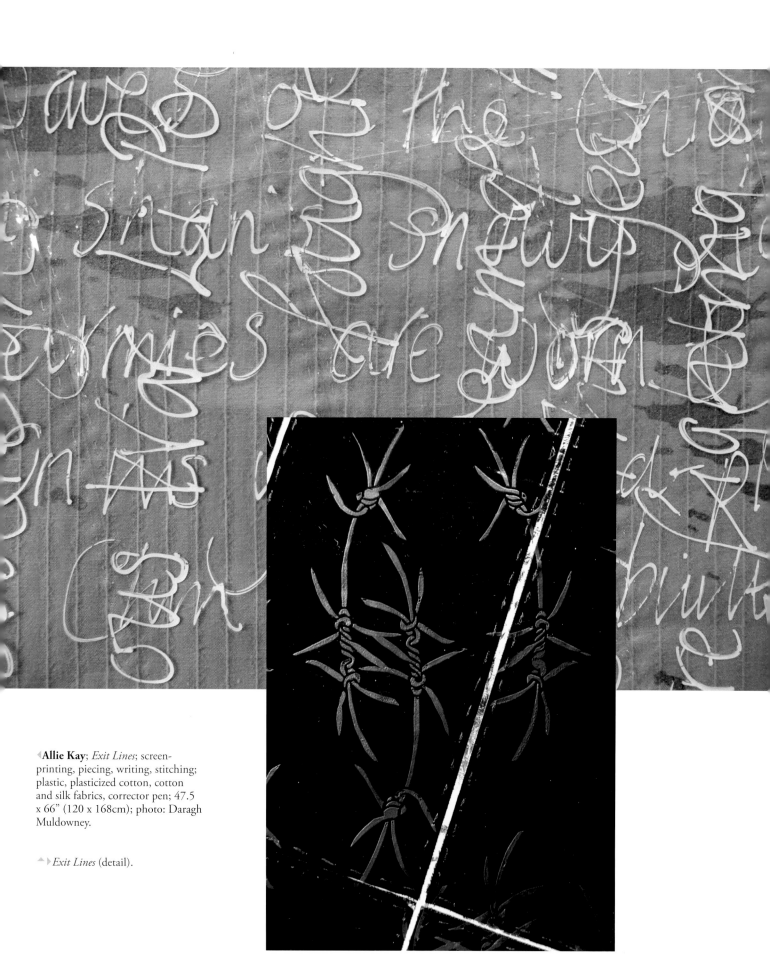

Allie Kay; *Exit Lines*; screen-printing, piecing, writing, stitching; plastic, plasticized cotton, cotton and silk fabrics, corrector pen; 47.5 x 66" (120 x 168cm); photo: Daragh Muldowney.

Exit Lines (detail).

KAY KHAN ▸ Santa Fe, New Mexico USA

Kay Khan's vessels confront 3-dimensional principles of the void within being the true reality of a form. Rather, Khan constructs distinct visual levels in content and form. Quilted labyrinths of intricately constructed and stitched wordplay surround her vessels with hypotheses in the manner of a Greek tragedy but in fleeting impressions of contemporary views. Unlike the Greeks', Khan's images are not merely added to an existing form, they are the form itself. Therefore, by pushing the limits of sculptural abstraction while still suggesting powerful representational associations, Kahn creates singular vessels to contain the human experience of our time.

Kahn's Armor and Façade series explores in the metaphors of cloth and garments the vulnerabilities of modern life. The artist writes: *I wanted to 'armor' modern society. The artworks in the Armor and Façade series are about how we protect ourselves and how we present ourselves. I began with simple ordinary ready-made garments that I then deconstructed; armored with quilting, imagery, and text; and then rebuilt. Garments have their mundane yet necessary purpose to protect us from the elements. But they are obviously more than that in every society. They are our 'decoration'; they express and reflect who we are as individuals and as a culture.*

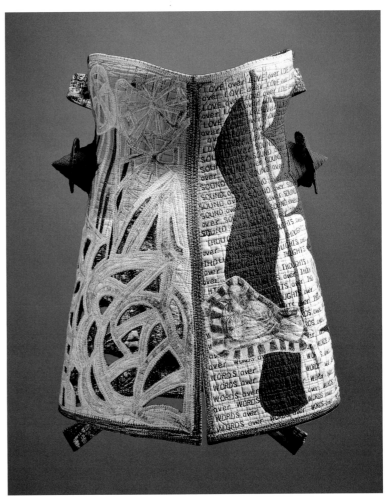

▲**Kay Khan**; *Bird Bodice: Armor and Façade series*; quilted, pieced, appliquéd, hand and machine stitched, drawn, constructed; silk, cotton, paper, thread, ink; 21 x 15 x 14" (52.5 x 37.5 x 35cm); photo: Wendy McEahern.

◂*Bird Bodice: Armor and Façade series*; alternate view.

▸**Kay Khan**; *Boundless: Armor and Façade Series*; man's shirt: deconstructed and "armored" with quilting, text, and imagery quilted, pieced, appliquéd, hand and machine stitched, constructed; silk, cotton; 32 x 23 x 9" (80 x 57.5 x 22.5cm); photo: Wendy McEahern.

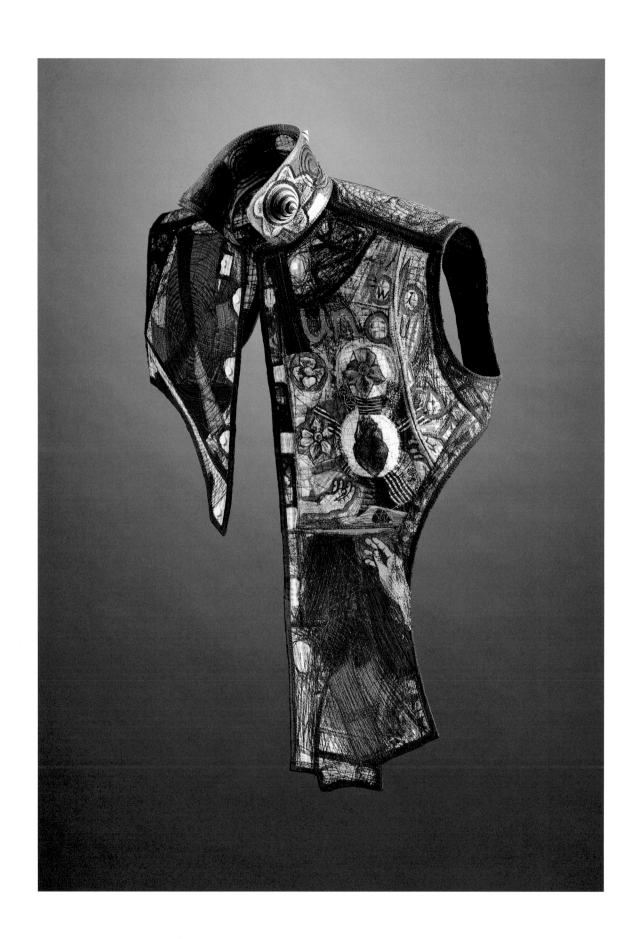

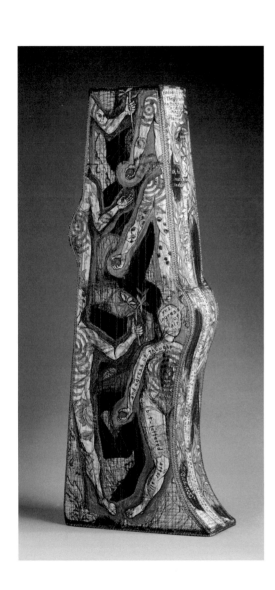

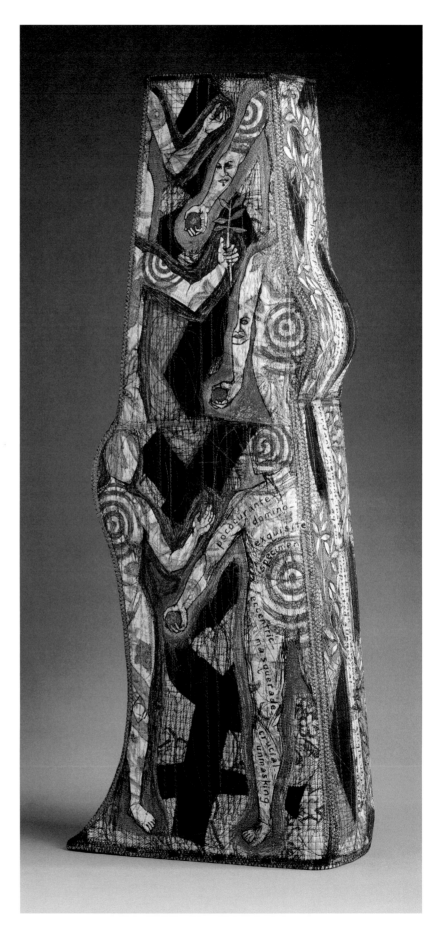

▲ **Kay Khan**; *Unmasking*; quilted, pieced, appliquéd, hand and machine stitched, constructed; silk, cotton, felt, wire; 36 x 14 x 7" (90 x 35 x 17.5cm); photo: Wendy McEahern.

▶ **Kay Khan**; *Unmasking* (alternate view).

▶▶ *Unmasking* (detail).

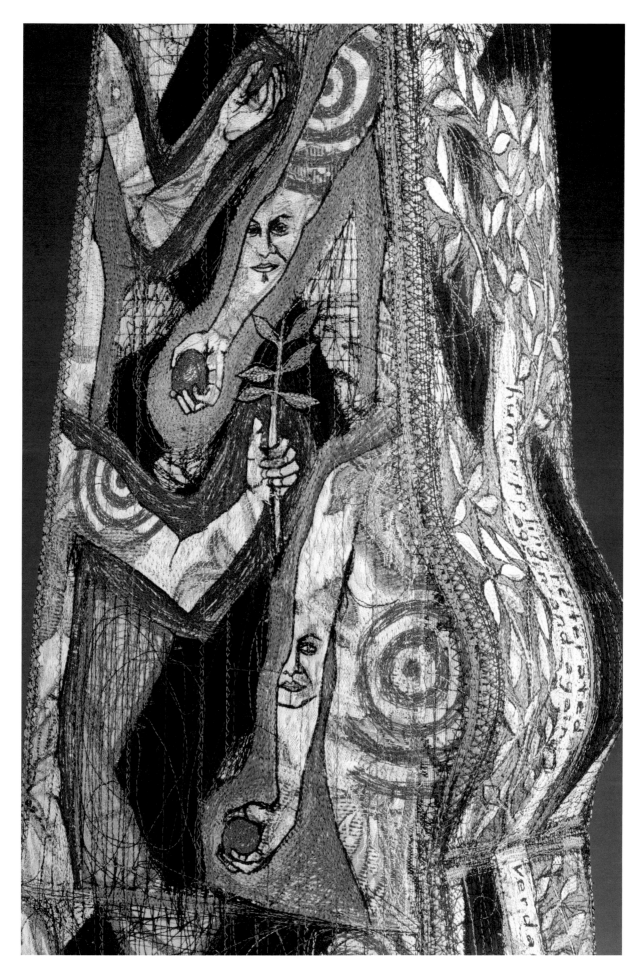

Nancy Koenigsberg ▸ New York, NY USA

browngrotta arts

Vessels and wall pieces by Nancy Koenigsberg seem to glow from within. Reflections animate freely through the crannies of her metal and glass webs. At first glance one recognizes the surface characteristics of industrial materials used widely in the urban architecture of our time. Though architectural in spirit, Koenigsberg's structures suggest volumes not as enclosures but rather as channels for light and air. Organic shapes and textures appropriate light from any source and toss it back with a playful hand. Drawing upon a highly refined functional intuition, the artist crafts mysterious layers of weaving, knotting, and shadows. She was one of only five American artists selected to exhibit in the prestigious 13th International Triennial of Tapestry in Lodz, Poland.

My interest is in creating a sense of weightlessness and luminescence by the manipulation of narrow gauge industrial wire and glass beads. I am exploring the transformation of materials and the contradiction between these elements known for their strength and durability and the delicate forms that are created.

Nancy Koenigsberg

▸▸**Nancy Koenigsberg**; *Bark*; weaving, folding; annealed steel wire; height x diameter 66 x 13" (168 x 33cm); photo: D. James Dee.

▸**Nancy Koenigsberg**; *Sonnets*; knotting; annealed steel wire, lead fishing sinkers; 96 x 22 x 18" (244 x 56 x 46cm); photo: D. James Dee.

▾ *Sonnets* (detail).

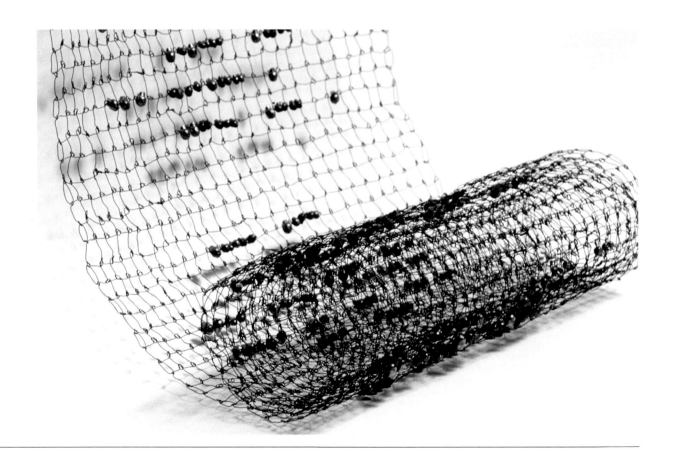

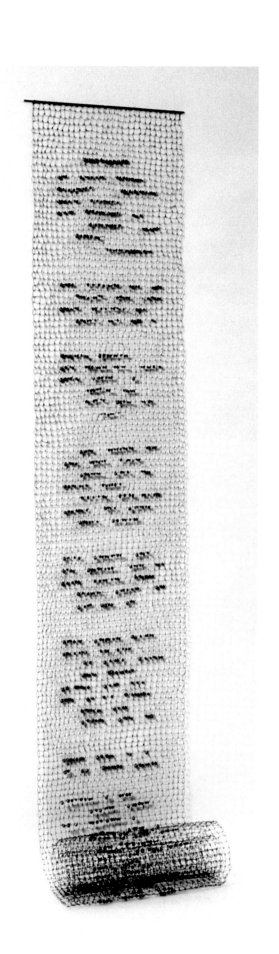

Nancy Koenigsberg; *Briar Patch*; weaving; annealed steel wire; 14 x 14 x 4" (35.5 x 35.5 x 10cm); photo: Cathy Carver.

Nancy Koenigsberg; *Morning Light*; knotting; coated copper wire, glass beads; 78 x 89 x 14" (200 x 225 x 35cm); photo: Cathy Carver.

Morning Light (detail).

HANS KRONDAHL ▸ Malmo, Sweden

After the Second World War, Scandinavian design began to evolve as a unitary manifestation of a sense of form rooted in Nordic cultures. Though national features and individual personalities exist, a Pan-Nordic image is traceable through common ideas of refinement, elegance, and technical perfection. On the heels of the less-idealistic Arts and Crafts movement, Scandinavian design aspired to moral and social values expressed with clarity and strength in pure forms.

Having lived and taught these values over a career spanning the last half of the twentieth century, Professor Hans Krondahl is retired but still a patriarch amongst Sweden's fiber artists. The bold abstractions of *Granada* exemplify the liberation of textile art in the 1960s. An example of this artist's revolutionary ideas was to applying paint directly to cloth. With liberation came travel commissioned by the United Nations. From Java and Africa the artist brought "bark and bast" mediums to his traditional Swedish methods.

Hans Krondahl is recognized internationally as a major force in the world of art textiles. Still living in the country where the old textile skills are part of daily life, his influential, forward-looking approach is apparent on these pages and elsewhere in this book.

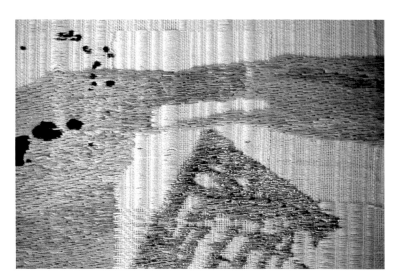

▲**Hans Krondahl**; *Tystnaden (The Silence)*; assistant weaver: Inga Krook; Swedish Dukagång with details in discontinuous brocade; linen, handspun linen, Japanese gold-foil thread; 50 x 68" (125 x 170cm); Röhsska Museet.

◂*Tystnaden (The Silence) detail.*

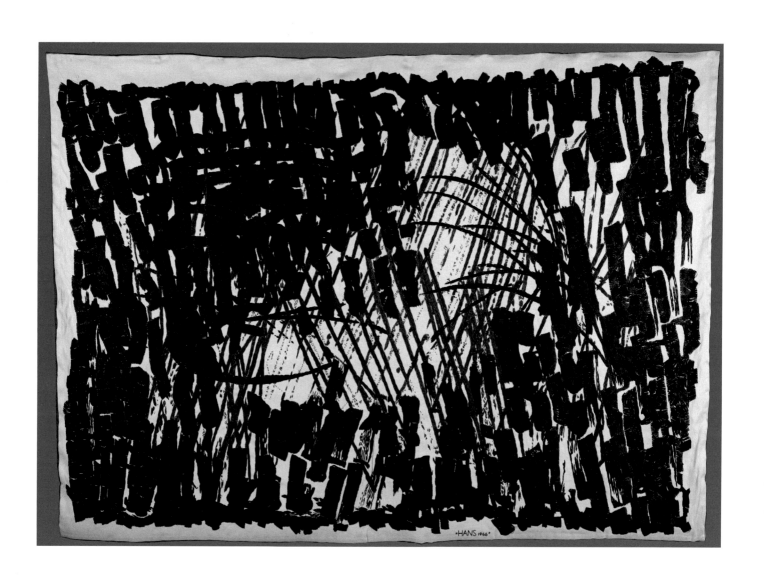

▲ **Hans Krondahl**;
Vintermanöver (Winter movement); hand embroidery on handwoven linen twill fabric; hand-dyed linen thread for the embroidered details; 53 x 74.5" (135 x 190cm); Designarkivet, Nybro.

◄ **Hans Krondahl**;
Granada; appliqué with free embroidery; handwoven fabrics; 56 x 74" (143 x 188cm).

TRACY KRUMM ▸ Kansas City, Missouri USA

Chiaroscuro Contemporary Art

Tracy Krumm's sculptures are informed by the histories of sculpture and women's work. For generations, blacksmithing and crochet have been viewed as gender-specific. Yet this artist does more than display virtuosity with both processes; she confronts and questions issues of balance, power, social class, relationships and conventional notions of beauty. Her physical components are endowed with specific aesthetics and historical connotations though deeper meanings remain open to interpretation. The artist's diaphanous textiles—while crocheted in lighter metals—appear to influence and even sway the sculptural impact of the heavy metal armatures they touch.

My approach to art-making intertwines process and product to integrate remnants of time, culture, personal history and environment. This engages me in a continually evolving dialogue with research on feminism, social practice, popular culture, and the exploration of how the transcendental possibilities of repetitive processes lead to and influence creative experience. These sculptures also speak about the history of craft in their attention to detail, and about how structural and material explorations serve my ability to accommodate and transform the physical and conceptual substance of my work.

Tracy Krumm

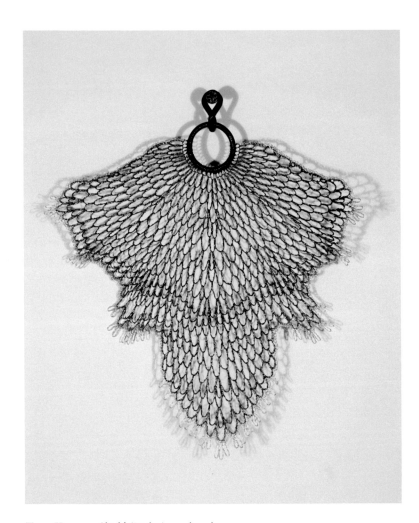

Tracy Krumm; *Shield (Dickey)*; crocheted and fabricated metal; copper and fine silver wire, forged steel, found objects, patina, resin, lacquer; 17 x 15 x 4" (42.5 x 37.5 x 10cm); photo: courtesy of the artist.

▲**Tracy Krumm**; *Rolled Squares*; crocheted and fabricated metal; brass and nickel wire, forged steel, found objects, patina, resin, lacquer; 19.5 x 28 x 9" (48 x 70 x 22.5cm); photo: courtesy of the artist.

◄*Rolled Squares* (detail).

▶**Tracy Krumm**; *Cones (Three)*; crocheted and fabricated metal; bronze and nickel wire, forged steel, found objects, patina, resin, pigment, lacquer; 25 x 5.5 x 11" (62.5 x 13.5 x 27.5cm); photo: courtesy of the artist.

▼ *Cones (Three)* detail.

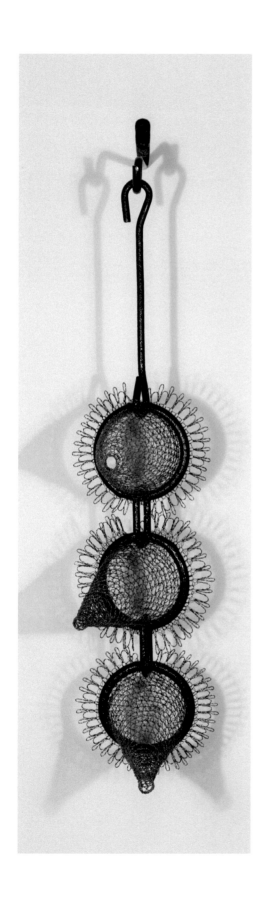

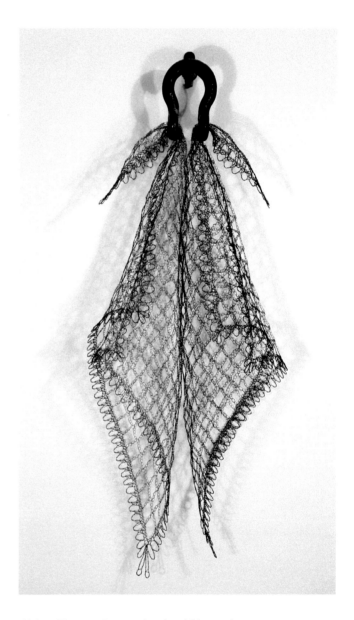

Tracy Krumm; *Pair*; crocheted and fabricated metal; copper and brass wire, forged steel, found objects, patina, lacquer; 29 x 11 x 17" (72.5 x 27.5 x 42.5cm); photo: courtesy of the artist.

Ewa Latkowska-Żychska ▸ Warsaw, Poland

There is a feeling of dread of all the fish,
which disappear in a flash,
 There is an awareness of grace inherent in
peacocks' feathers—lined with fear and passion
of cock crest.
 There is a dark precipice of hunger,
which has to be appeased before it *lights up*
a thought.

Ewa Latkowska-Żychska, from her
volume *Unpainted Poems*.

Born and educated in Poland in the midst of an influential fiber arts movement in post-war Eastern Europe, Ewa Latkowska-Zychska has achieved international recognition. She and her generation continue to elevate the practice of textile art to a point well beyond craft traditions and into the arena of fine art. Contradicting earlier trends toward copying paintings or other media in fiber, Polish artists were amongst the first to begin a work of art with fiber and explore its expressive range. The prestigious Triennial exhibitions in Lodz, Poland, confirm fiber artists from around the world as a force not to be ignored by the art world.

Continuing the assertion of fiber as a starting point, Latkowska-Zychska's compositions in plant materials narrate an internal dialogue with the natural world and all that might impact it. Bending paper and textile matter to her will, the artist's personal intervention in nature gives form, content, and reverence to the poetry of our earth. The colors and fibers of her world view coordinate toward a mutual purpose—as with the natural rhythms of nature.

Ewa Latkowska-Żychska; *With Redness* (page from a book); hand-made paper, eastern style; plant materials; 18.5 x 12" (46 x 30cm); photo: Piotr Mastalerz.

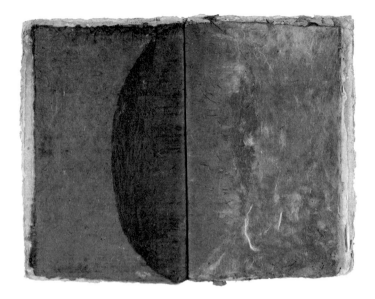

Ewa Latkowska-Żychska; *Creation of the World* (pages from a book); hand-made paper, eastern style; plant materials; 18.5 x 24" (46 x 60cm); photo: Piotr Mastalerz.

Ewa Latkowska-Żychska; *One Way*; hand-made paper, eastern style; plant materials; 18.5 x 12" (46 x 30cm); photo: Piotr Mastalerz.

Ewa Latkowska-Żychska; *…and the whole Universe*; hand-made paper, personal technique; plant materials; 112 x 120" (280 x 300cm); photo: Ewa Latkowska-Zychska.

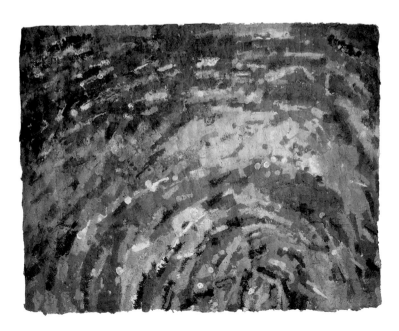

Ed Bing Lee ▸ Philadelphia, Pennsylvania USA

Snyderman-Works Galleries

The Chawan is the bowl used in the tea ceremony which is most familiar to modern audiences in the highly stylized ritual practiced in Japan. The Chawan is used in the preparation of the powdered tea which is whisked into a foamy brew to be shared by all the guests. The significance of the bowl is that it is more than a vessel of convenience as are all the other utensils employed in the tea ceremony. The design, color, and shape of the bowl, often treasured antiques, were intentionally selected to compliment the occasion and the tastes of the different guests. Comments on the beauty and uniqueness of the bowl became a point of departure for conversation.

The limitation of size and the repetition of the form offered the opportunity to reexamine the knotting process. The clove hitch remains the principal knot used in most of the pieces but the use of different materials, such as paper, ribbons, and shoe laces require adjustments both in design and technique. Although there is a basic similarity in all the pieces, the desire to give each its own personality was an important goal. Looking back on this series, my primary concern has been the aesthetic expression eliminating any consideration for functional aspect of the bowl. I fear what remains is a new creature and my departure from the traditions of the Chawan is after all not so radical.

Ed Bing Lee

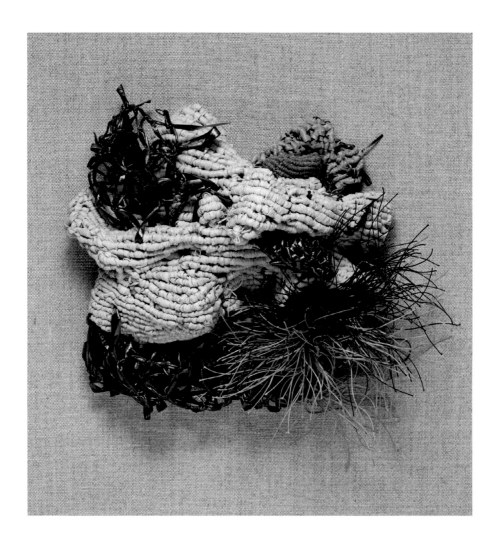

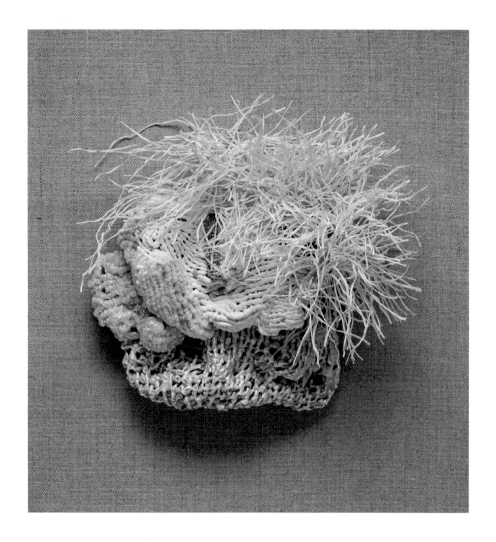

▲ **Ed Bing Lee**; *Pettamellera from the
Earthcrust series*; clove hitch, Gordian knot;
raffia, pearlized ribbon with metal thread,
waxed linen; 6 x 7 x 3" (15 x 17.5 x 7.5cm);
photo: Ken Yanoviak.

◄**Ed Bing Lee**; *Zoisite from the Earthcrust
series*; clove hitch, Gordian knot, netting;
raffia, cotton floss, ribbon, waxed linen; 6 x
7 x 2.5" (15 x 17.5 x 6.25cm); photo: Ken
Yanoviak.

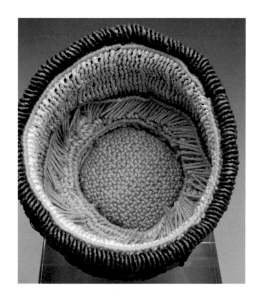

▸**Ed Bing Lee**; *Chawan: Roots, Floats, Cloud Dragon, Polar Bear, Olive, Bramble, Gold Cup, Temoku II*; knotted, mainly clove hitch and its variations; mixed: ribbons, raffia, cotton floss, linen, waxed linen; each bowl is approximately 5 x 5 x 5" (12.5 x 12.5 x 12.5cm); photo: Ken Yanoviak.

◂▾*Chawan*; (details).

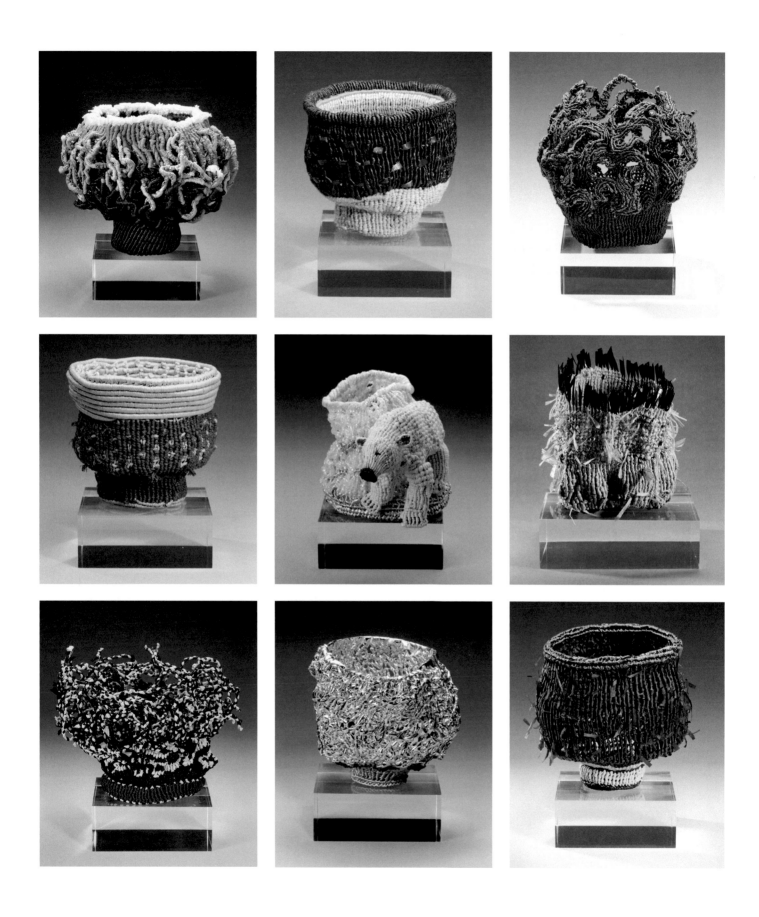

JACQUELINE RUSH LEE ▸ Kailua, Hawaii, USA

Snyderman-Works Galleries

As one who loves books, and the imaginative worlds to which book contents lure their readers, I am drawn to the physicality of the book, as familiar object, medium, and archetypal form.

Jacquelyn Rush Lee

In the not-too-distant future, the material existence of the books loved by Jacquelyn Rush Lee and many others could follow a trail of endangered species into the cyber-annals of this century. Applying her love of books and her vast imagination to battered discards bearing the scars of human handling, this artist invents materials, process, and content. Her hand-painted small-scale sculptures Devotional Series have been transformed from rejects sourced from library sales and book graveyards. Page by page, the form and text of each book is altered. Inner passages become engulfed yet still exist within the sculpture. Marginal notes remain.

Working mainly with the pure components of a book, Lee's hands follow others' who have handled its pages. Old books, made qualitatively different, hold contemporary narratives born of a distressed past and threatened future. Molded and preserved in sculptural form, Lee's books emerge no longer as vehicles of information but as vessels of meaning.

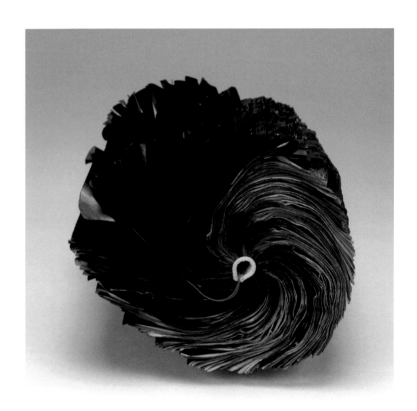

Jacqueline Rush Lee; *Peacock: from the Devotion Series*; manipulated book, hand-painted inks; altered book using only the scrambled components of the book (book, inks, book marks, book head bands); 5 x 6 x 6" (12.5 x 15 x 15cm); photo: Paul Kodama.

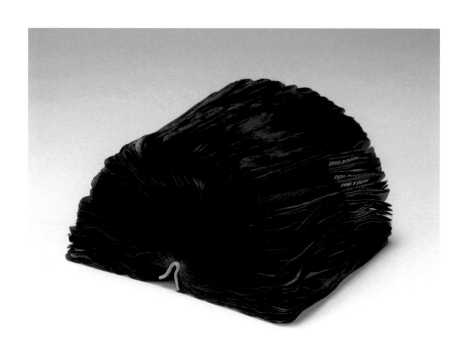

Jacqueline Rush Lee; *Flutter: from the Devotion Series*; manipulated book, hand-painted inks; altered book using only the components of the book (book, inks, book marks,); 3.5 x 6 x 5" (8 x 15 x 12.5cm); photo: Paul Kodama.

Flutter (detail).

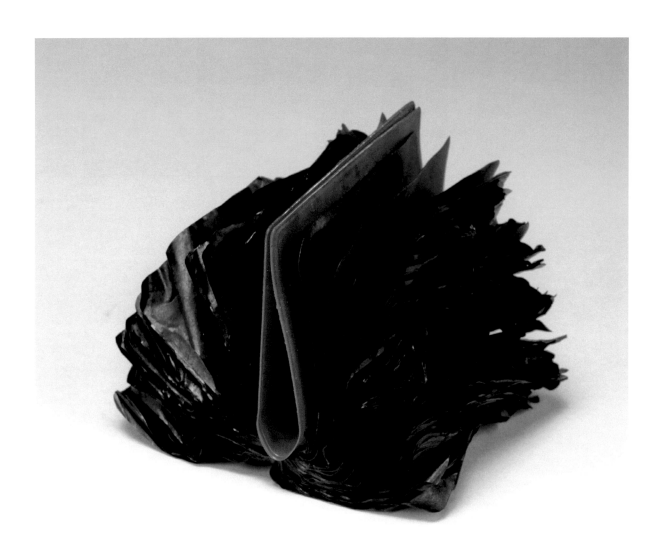

▲**Jacqueline Rush Lee**; *Nee: Little Red Book from the Devotion Series*; manipulated book, hand-painted inks; altered book using only the components of the book (book, inks, book marks); 4 x 3.5 x 3" (10 x 8 x 7.5cm); photo: Paul Kodama.

▶**Jacqueline Rush Lee**; *Anthologia: from the Devotion Series*; used, assembled books, hand-painted and sanded, burnished inks, bookmarks, archival glue; altered books using only the components of the book (book, inks, book marks, book head bands); 9 x 9 x 6" (22.5 x 22.5 x 15cm); photo: Paul Kodama.

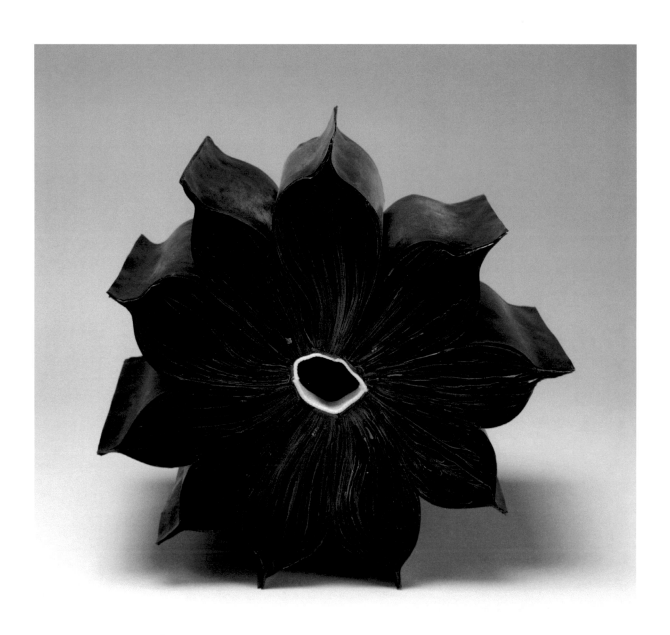

LORE KADDEN LINDENFELD ▸ Princeton, New Jersey USA
1921-2010

In my recent work I have been intrigued with the potential of transforming and reinventing visual images of natural forms through the merging of graphic elements with fiber techniques.

As a basis for seeing the relationships of colors and shapes I am returning to my studies of design as a student at Black Mountain College. In my weavings I was concerned with the shaping of pliable materials, resulting in designs characteristic for the potentials of the loom, or changing the surface to create another dimension.

A change from weaving came about when I returned from a stay in Japan. I became fascinated with the way natural objects were carefully selected and observed. To capture this spirit I made fiber compositions. In a series called "Japanese Diary" I used nylon netting for shading of color, and also used some graphic accents, somewhat tentatively. Since then I have looked more closely at the physical world around me, and now search for images that I can translate into fiber pieces.

During summers in Vermont I walk through groves of woods. The branches cross over, intertwine, touch, forming ever-changing patterns that have captured my imagination. I realized that drawing would give me a feeling of echoing that rhythm, and by merging graphics with stitching and layering of materials I could form images of things seen and experienced, combining the real with the imagined.

It seems that I have come full circle, rediscovering the elements of drawing, color, and design in a newly conceived constellation.

Lore Kadden Lindenfeld, 2007

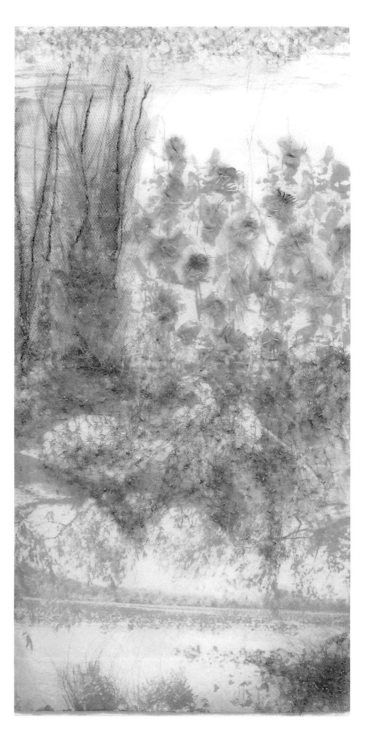

Lore Kadden Lindenfeld;
Marshland; photography, stitching, drawing, fiber collage; Pellon, Japanese paper, nylon netting, thread, ink; 16 x 8" (40 x 20 cm); photo: Peter Lindenfeld.

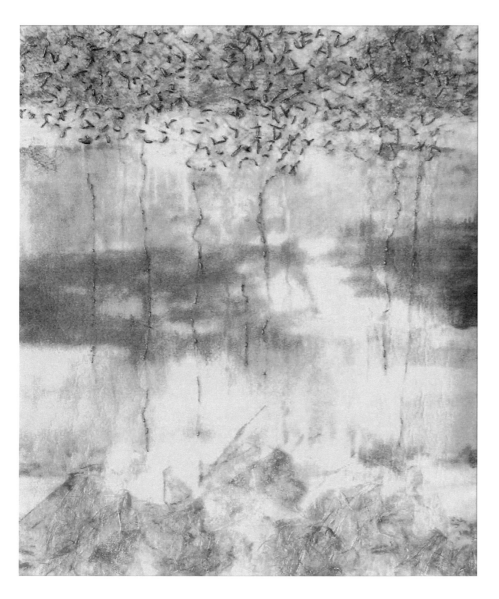

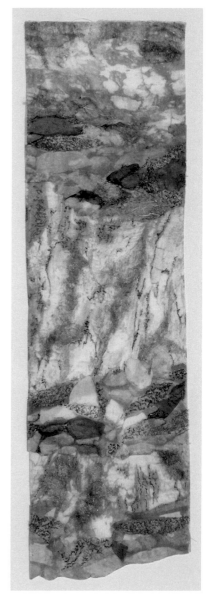

▲**Lore Kadden Lindenfeld**;
Reflection; photography, drawing,
stitching, fiber collage; Pellon,
thread, netting ink; 9 x 8" (22.5 x
20cm); photo: Peter Lindenfeld.

▶**Lore Kadden Lindenfeld**; *Wall*;
photography, stitching, drawing,
fiber collage; Pellon, thread, ink;
17.5 x 6" (43 x 15cm); photo: Peter
Lindenfeld.

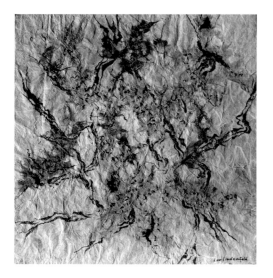

◀**Lore Kadden Lindenfeld**; *Wind
and Tree*; drawing, stitching, fiber
collage; Japanese paper, thread,
ink; 13 x12" (32.5 x 30cm); photo:
Peter Lindenfeld.

PATRICIA MALARCHER ▸ Englewood, New Jersey USA

Never intending to create mere passive aesthetic enjoyment, Patricia Malarcher challenges the audience to consider her art on multiple levels. From within her underlying disciplines of quilting, collage or surface designed textiles a unique abstract idiom radiates with psychic energy. Materials appear for which there is neither precedent nor tradition. Images of coded implication reveal themselves. Compartmentalized structures, seemingly isolated, share discrete elements. Caught in a loose web of cultural data, a viewer shifts to and fro between acts of recognition and the Art of the piece.

Working primarily with fabrics and pliable plastics Malarcher adds additional voices in the form of scraps of art reproductions, shredded documents or urban detritus. In *Homage to Jean Lurçat,* Malarcher honors the esteemed twentieth-century tapestry designer with a sculpture of woven visual and verbal information about him. In addition to her career as an internationally exhibited artist, Patricia Malarcher is also a prominent critic, curator, lecturer, and Editor of the *Surface Design Journal.*

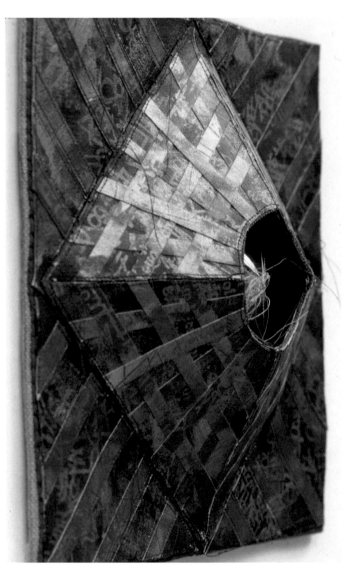

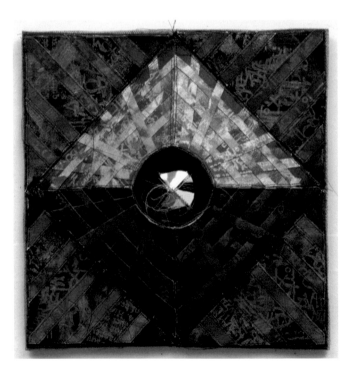

◂**Patricia Malarcher**; *Orifice*; painted canvas, Mylar, thread; 12 x 12 x 2.5" (30 x 30 x 6.25cm); photo: D. James Dee.

▴ *Orifice* (side view).

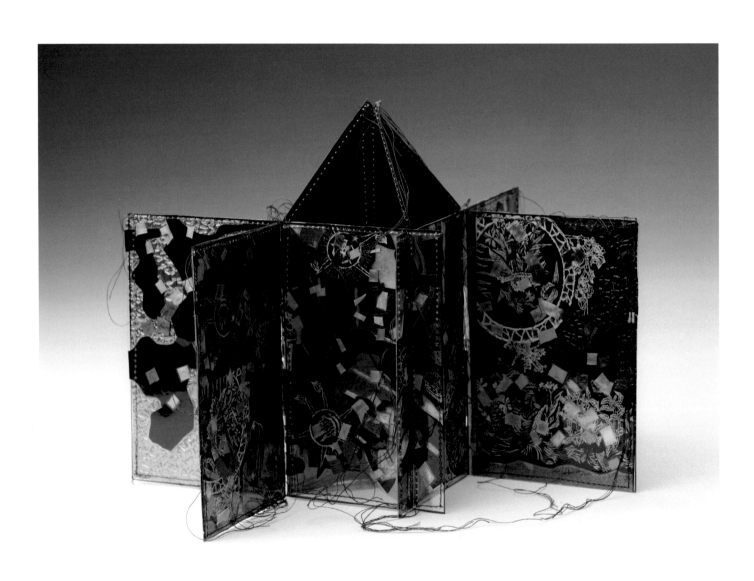

[▲]**Patricia Malarcher**; *Pages from a Book of Hours;* Mylar, fabric, paint mixed media collage; six units, each 9 x 9" (22.5 x 22.5cm); photo: D. James Dee.

[◄]**Patricia Malarcher**; *Homage to Jean Lurçat;* detached encyclopedia pages, interwoven with strips of photocopied images; remaining pages from the book, rebound; laminated plastic, paper, thread, machine stitching; overall dimensions variable depending on installation, laminated structure: 8.5 x 10 x 5.5" (21.25 x 25 x 13.75cm); photo: D. James Dee.

Seamus McGuinness ▸ Ballyvaughan, County Clare, Ireland

The installation 21g (21 grams) originally consisted of 92 white shirt fragments, mainly collars torn from the garment's body. Each fragment weighs 21g, the mythical decline in body weight at the precise moment of death; each represents a young male between 15-25 years of age who died by suicide in Ireland in 2003.

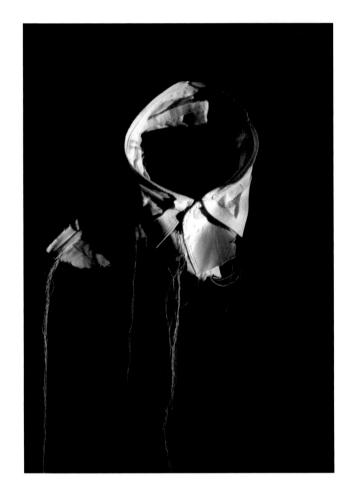

The fragments, suspended in space, occupy the "absent body." Each is sculpted to suggest human form. The raw edges created by physically ripping the fragment from the main shirt body reflect the internal agony of the victims and underpin the ripping apart of the lives of the deceased's loved ones. The shirts were randomly taken from charity shops to emphasise the randomness of suicide, which can afflict people from all social strata and environments. White collar shirts symbolise the pressure on the modern male to succeed and conform, often at personal cost. Each fragment was individually moulded reflecting its refusal to conform to a uniform shape. The placement of the fragments is intentionally at various heights suggesting the person absent but undeniably they were a collective community—in absence.

When I originally made this work, my inquiry was the relationship between cloth and gender in the making of object-based art works in which cloth was both the driving concept and the material. I was critically evaluating my own personal involvement as a male artist in working with the medium. My choice of subject was informed by the stark statistical evidence in suicidal death in Ireland. In 2003, statistics show that in the age bracket 15-25 years there were 110 deaths by suicide, 92 male, 18 female. I became interested in developing working practices that would revisit the history of cloth to open up a space for addressing the young male suicide in visual and material form. Reiterated in different forms in different locations, 21g was and continues to be a social and cultural probe, interrogating gender differences in suicidal deaths in Ireland.

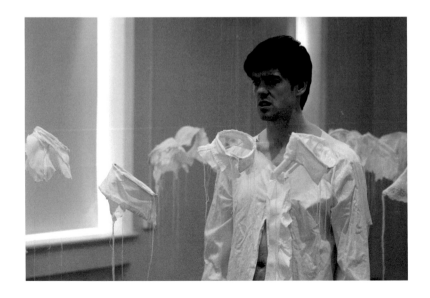

Seamus McGuinness

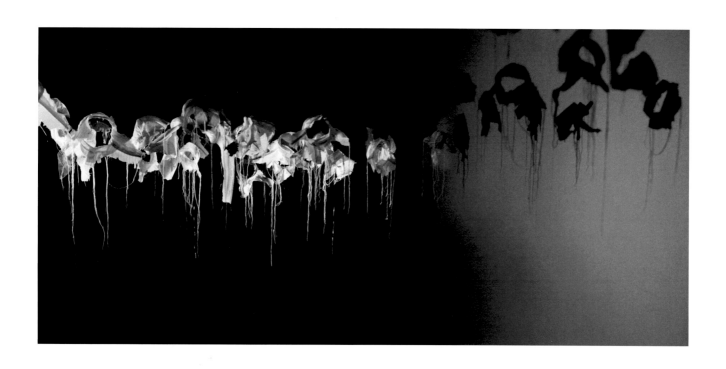

(All) **Seamus McGuinness**; *21g (4 perspectives)*; large scale sculptural installation designed to include opera performance, has been adapted to galleries of various dimensions; 92 white shirt fragments suspended in space; photos: courtesy of the artist.

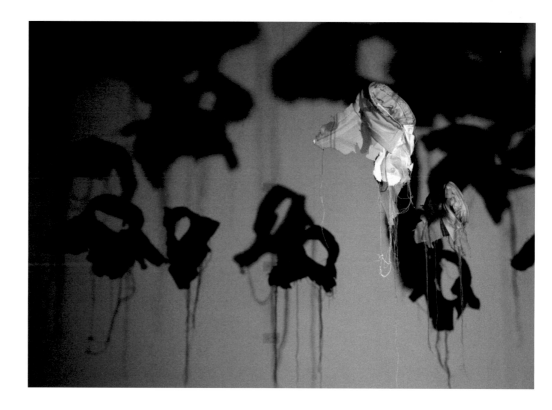

NANCY MIDDLEBROOK ▸ Philadelphia, Pennsylvania USA

Snyderman-Works Galleries

The double cloth method, which has inspired Nancy for more than fifteen years, has been used with great innovation in many places, especially by those who were part of the rich textile culture of the Pre-Colombians and by early Chinese weavers. It was later of great interest to a number of modern textile artists including Anni Albers (Bauhaus) and the legendary American weaver, Richard Landis. Nancy is now making a contribution to this legacy through her luminous compositions of highly saturated color and strong optical mixing. In comparison to the more sedate and regulated color fields of Albers and Landis, Middlebrook has developed her own modestly scaled but vibrant woven geometries in a different way. That is, her weavings appear to be miniaturized abstract landscapes, where we see through a complex patterned ground to the sky beyond. She utilizes an active and constantly fluctuating geometric matrix as a foreground and window, then draws us through to shimmering but quiet atmospheres. In almost every one of her double cloth weavings, Middlebrook gives us this undulating patterned grid in the front with a variegated brightly colored sky in the distance, with its acid blues and greens and golds appearing lunar and otherworldly.

Warren Seelig: Distinguished Professor,
Fiber & Mixed Media, University of the Arts,
Philadelphia, May 2007

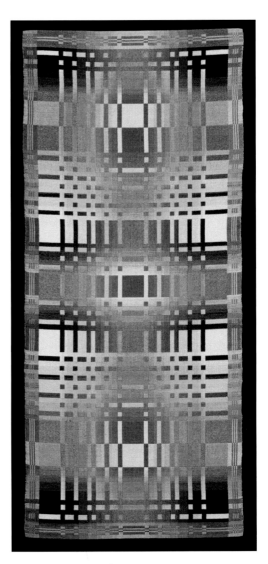

▲**Nancy Middlebrook**; *Color Chords #4*; handwoven; hand-dyed cotton; 28 x 12" (70 x 30cm); photo: Ken Yanoviak.

◂*Color Chords #4* (detail).

▸**Nancy Middlebrook**; *Cinco de Mayo*; handwoven; hand-dyed cotton; 30 x 29" (75 x 72.5cm); photo: Ken Yanoviak.

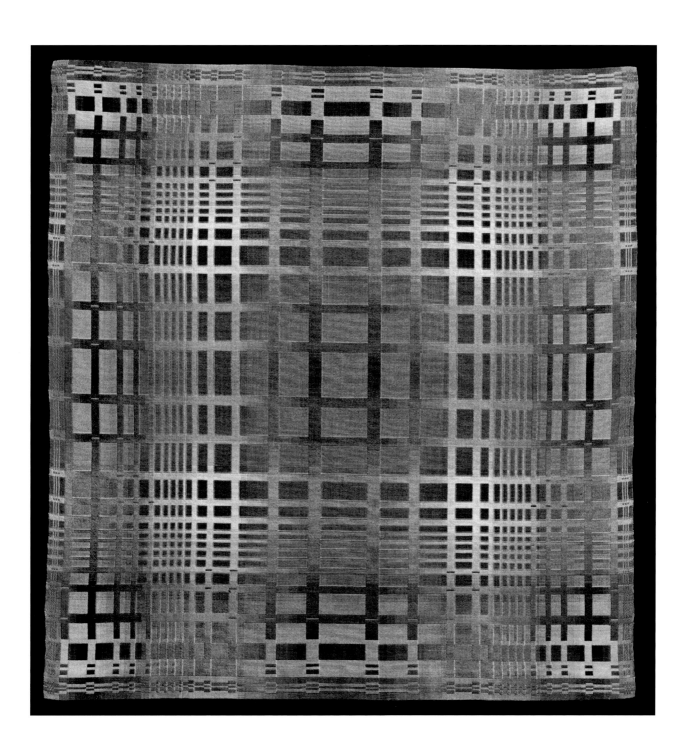

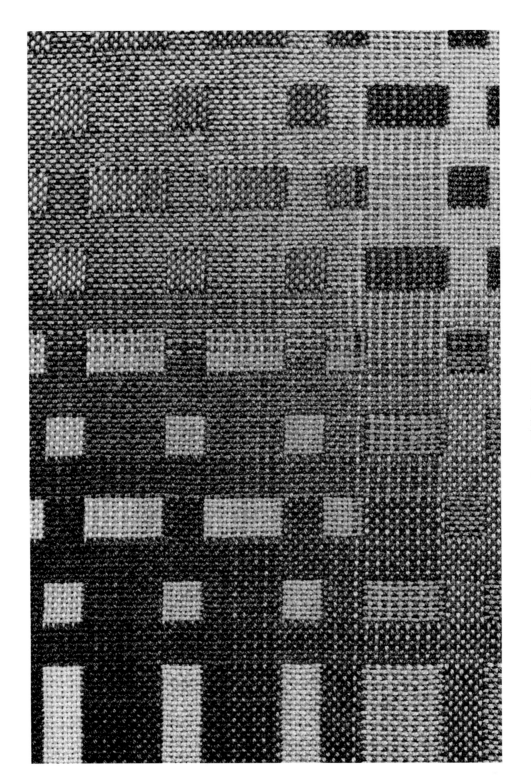

▶**Nancy Middlebrook**;
Color Chords #2;
handwoven; hand-dyed
cotton; 28 x 12" (70
x 30cm); photo: Ken
Yanoviak.

◀*Color Chords #2* (detail).

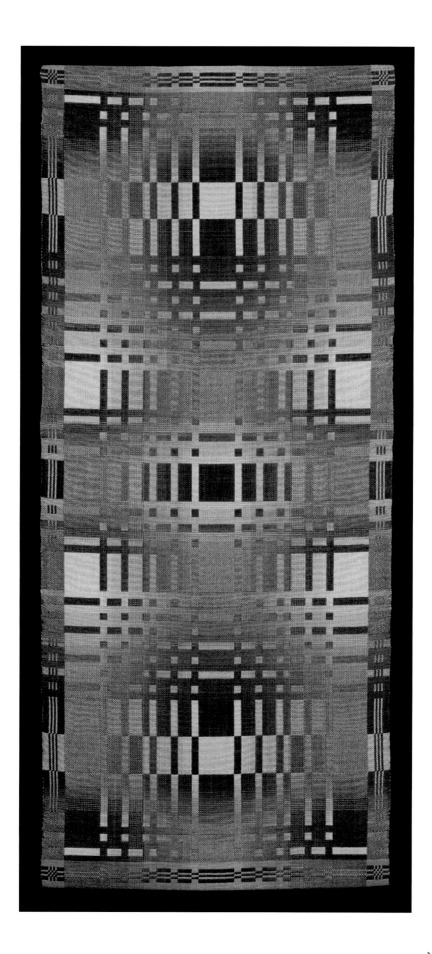

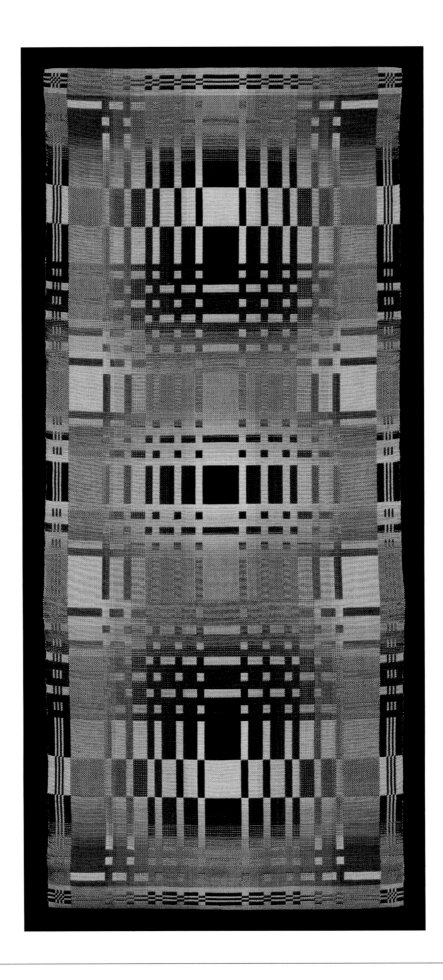

Nancy Middlebrook;
Color Chords #6;
handwoven; hand-dyed
cotton; 28 x 12" (70
x 30cm); photo: Ken
Yanoviak.

▶ *Color Chords #6* (detail).

NORMA MINKOWITZ ▸ Westport, Connecticut USA

browngrotta arts

The immediacy of the content in Norma Minkowitz's sculptures disrupts any childhood memory of crochet as poetic embellishment for prosaic textiles. In a powerful inversion of crochet's traditional meanings, the artist at once seduces and stuns her audience. Her sculpted forms hover at a tense point between realism and abstraction. They bear the obvious touch of human hands but even more so the humanity of the maker. In complex lace-like patterning referring to a love of both crochet and drawing are reflections of contemporary society expressed through the artist's whisper-soft visual vocabulary. Aptly examined through her ever sympathetic materials may be childhood anxieties, fear—real or imagined, symbols of extremes in fortune or politics, even unspeakable acts committed on blindfolded victims in full view of a horrified world. Working in a medium too often taken for granted or dismissed as women's work, Minkowitz penetrates to unusual depths its expressive range and layers of metaphors.

▸**Norma Minkowitz**; *Boy in a Tree*; crochet, painting; fiber, wood, resin, paint, wire; 29 x 11 x 11.5" (72.5 x 27.5cm); photo: Joseph Kugielsky.

▾**Norma Minkowitz**; *Collected*; crochet, knitting, painting; fiber, paint, wire; 79.5 x 55 x 8.5" (198.75 x 137.5 x 21cm); photo: Richard Bergen.

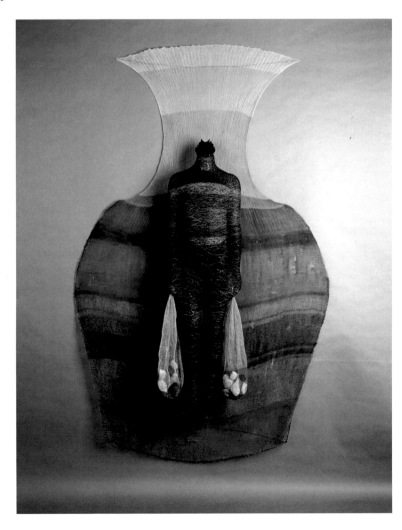

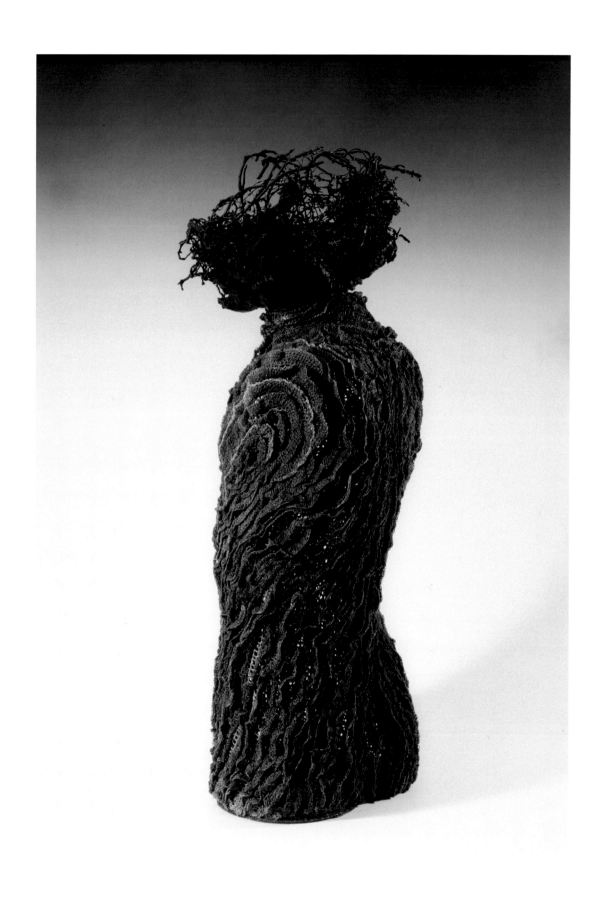

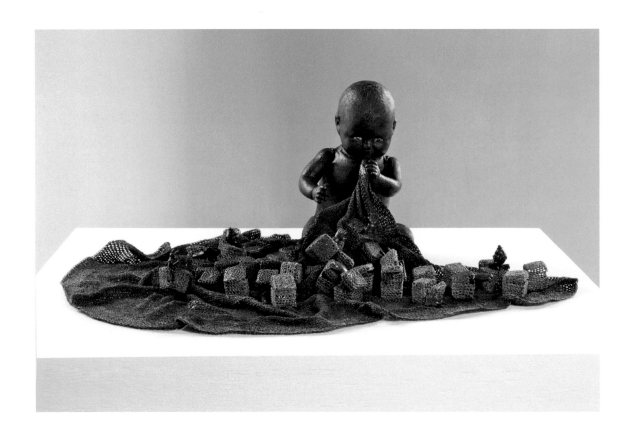

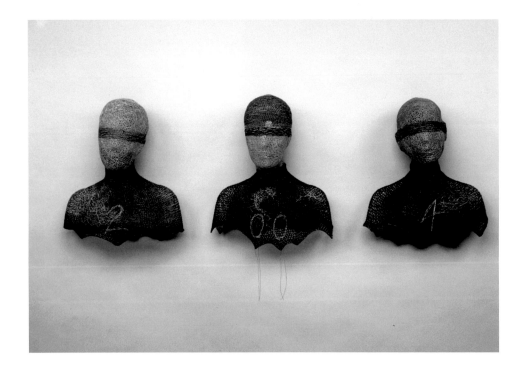

Norma Minkowitz; *Child of the Night*; fiber and mixed media; 12 x 32 x 22" (30.5 x 81.25 x 56cm); photo: courtesy of browngrotta arts, copyright © 2009 Tom Grotta.

◀ Norma Minkowitz; *2004*; crochet, painting; fiber, paint, wire, resin; 18 x 55 x 8.5" (45 x 137.5 x 21cm); photo: Richard Bergen.

▶ Norma Minkowitz; *Sisters*; crochet, painting; fiber, buttons, wood, paint, resin, chair; 43 x 21 x 19" (107.5 x 52.5 x 47.5cm); photo: Joseph Kugielsky.

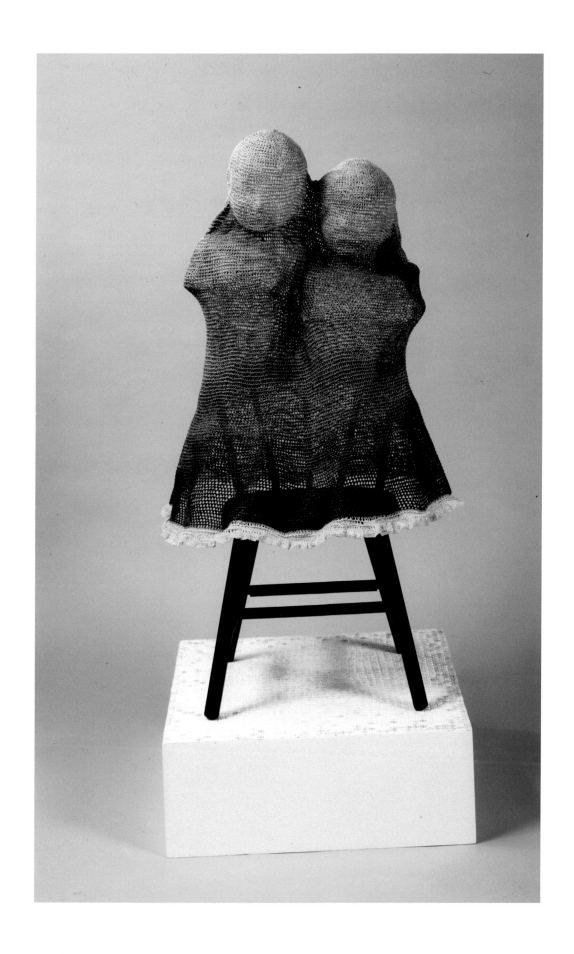

DEBORA MUHL ▸ Whitsett, North Carolina USA

Debora Muhl elevates traditional coiling skills and uncommon materials into lyrical vessels collected by museums such as The Museum of Decorative Arts in Paris and The Museum of Fine Arts in Boston. Maine sweet grass is hand gathered by Native Americans for their own ceremonial use as well as for the enjoyment of the artist who makes these sculptures and those who collect them. Would that it were possible to make these pages as fragrant as the sculptures!

Neither static in their posture nor predictable in any aspect, Muhl's vessels suggest fleeting moments in time not unlike the musical phrases that inspire her. Yet, each sculpture remains grounded within the artist's distinctive visual language refined through human experience with the logical properties of her natural materials.

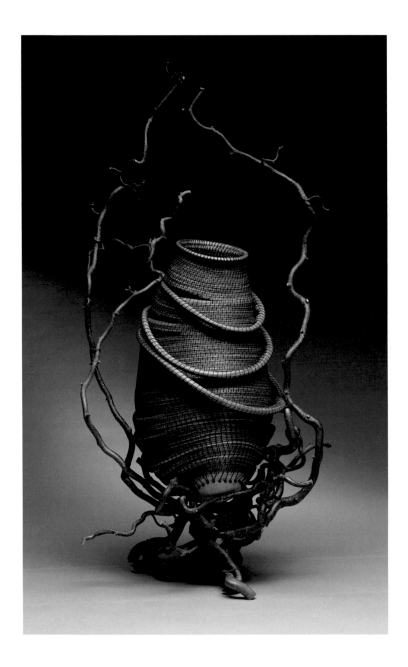

Debora Muhl; *Red Saturn #1225*;
sculptural coiling; sweet grass, gourd,
rayon ribbon, waxed Irish linen, carnelian
beads, branches (Harry Lauder's Walking
Stick); 17 x 9.5 x 9.5" (42.5 x 23.75 x
23.75cm) without branches; photo: John
Sterling Ruth.

Debora Muhl; *Untitled #1220*;
sculptural coiling; sweet grass, rayon
ribbon, waxed Irish linen; 7.5 x 17 x
14" (18.75 x 42.5 x 35cm); photo: John
Sterling Ruth.

Debora Muhl; *Blue Fish #1280*;
sculptural coiling; sweet grass, gourd,
nylon/polyester ribbon, waxed Irish linen,
blue goldstone beads; 8 x 14 x 11" (20 x
35 x 27.5cm); photo: John Sterling Ruth.

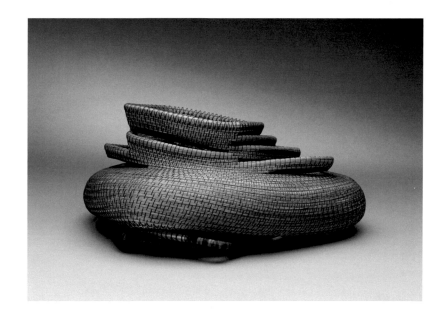

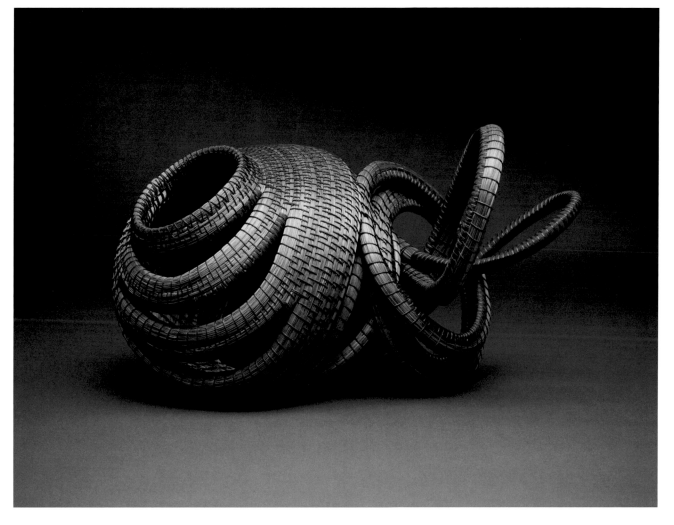

Debora Muhl; *Chaos #1310*;
sculptural coiling; sweet grass,
nylon/polyester ribbon, waxed Irish
linen; 12 x 17 x 14" (30 x 42.5 x
35cm); photo: John Sterling Ruth.

Debora Muhl; *Blue Majesty
#1306*; sculptural coiling; sweet
grass, nylon ribbon, waxed Irish
linen; 13 x 12 x 12" (32.5 x 30 x
30cm); photo: John Sterling Ruth.

BIRGITTA NORDSTRÖM ▸ Hönö, Sweden

Birgitta Nordström's exhibition opening in Stockholm.

In the Swedish language we often use textile metaphors to describe a lifetime. Here the weaving process has a deep symbolism for life itself. Livets vav translated means the cloth of life or life as a weave. The terms life and weave are interchangeable. The weaving of cloth has multiple interdependent stages of production. Step by step, hour by hour, repetitive, reflective moments and occasional entangled and broken threads like life itself.

In the book of Isaiah: Chapter 38 a weaving metaphor describes the end of life:

Like a shepherd's tent my house has been pulled down and taken from me.

Like a weaver I have rolled up my life; he has cut me off from the loom.

Birgitta Nordström

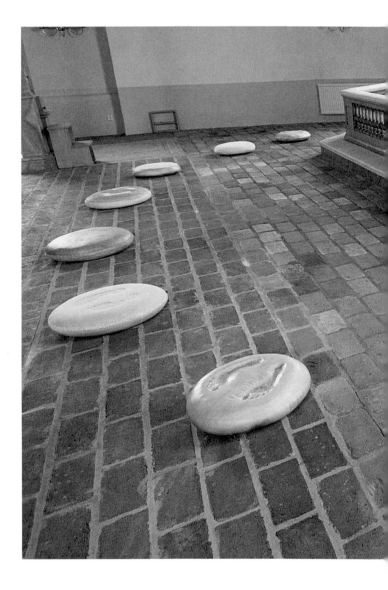

▴ **Birgitta Nordström**; *Friends Feet: from the installation The Sixth Sense at Husby Church, Sweden, consisting of nine pillows with footprints honoring deceased friends*; mixed media, embroidery; linen, wool, reindeer skin; each piece: 18" (45cm) in diameter x 6" (15cm) high; photo: Peder Hildor.

▸*Friends Feet* (details).

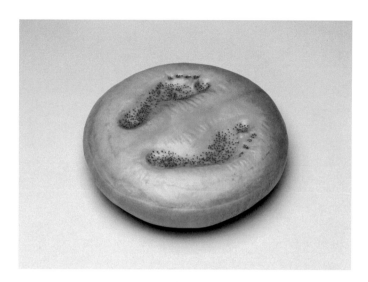

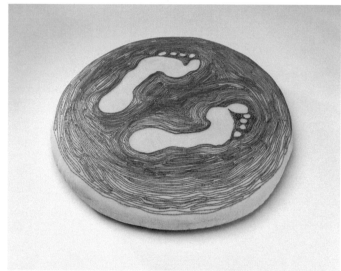

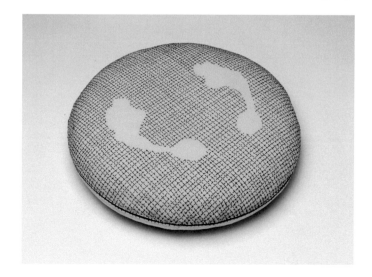

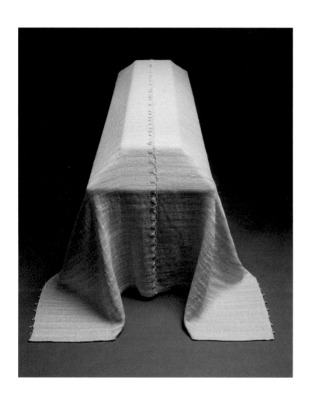

Birgitta Nordström;
Comfort Blanket; double weave;
linen, wool, stainless steel; 84
x 150" (210 x 375cm); photo:
Peder Hildor.

Comfort Blanket (details).

Birgitta Nordström;
Belongings For The Last Journey;
weaving and embroidery;
linen, wool, wax; 8 pieces, each
18 x 18 x 6" (45 x 45 x 15cm);
photo: Per Magnus Ström.

KATHRYN PANNEPACKER ▸ Philadelphia, Pennsylvania USA

Kathryn Pannepacker has transformed the *City of Brotherly Love* with all manner of art in textiles. A stunning example of her commitment to public art in her home city is a 7 x 500' painted mural, *Wall of Rugs: The Global Language of Textiles*. All those passing by are invited to pause and appreciate her intricately painted procession of traditional handcrafted rug patterns and colors, accurately researched and related to the ancestral homelands of Philadelphia residents. On a formerly mundane fence, one can discover one's own textile heritage with no admission charge. The artist is also a teacher who conveys the joy of weaving in many ways, not least is her weaving workshop at homeless shelters.

Pannepacker's formal education in French tapestry making methods is apparent in *Two Children on Unicycles*. Expressed herein is a masterful command of her creative voice applied to the expressions of a complex medium. Early French tapestries were copies of easel paintings by artists of the time. In an ironic inversion of the traditional treatments of both mediums, a large scale painted mural of *Two Children on Unicycles* squeals with joy in the voice of tapestry as Philadelphia's children pass by.

Though Kathryn exhibits nationally and internationally and has placed her art in private and public collections, she is committed to the transformative power of art in people's lives and the sustainability of such transformation by involving the community.

Peace, Shalom and repeated.

Kathryn Pannepacker

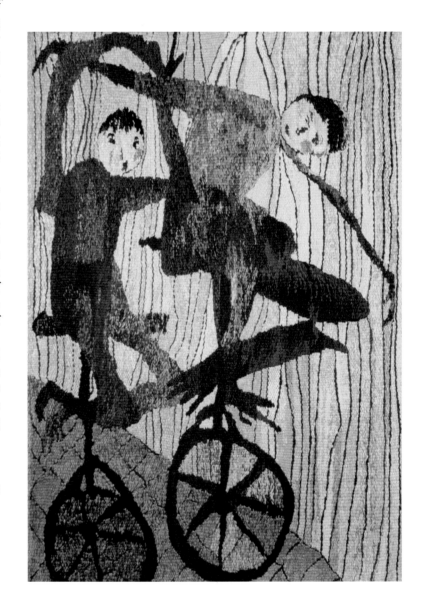

▸ **Kathryn Pannepacker**; *Pay Attention*; hand-stitched with wax encaustic; cloth, thread, hoop, wax; 8" in diameter (20cm); photo: courtesy of the artist.

▸▸ **Kathryn Pannepacker**; *Art Trick*; hand-stitched with wax encaustic; cloth, thread, hoop, wax; 8" in diameter (20cm); photo: courtesy of the artist.

▸▸▸ **Kathryn Pannepacker**; *Een-ie mean-ie*; hand-stitched with wax encaustic; cloth, thread, hoop, wax; 8" in diameter (20cm); photo: courtesy of the artist.

◀**Kathryn Pannepacker**; *Two Children on Unicycles*; hand-woven tapestry with mixed fibers; 62 x 42" (155 x 105cm); photo: Karen Mauch.

▲ *Two Children on Unicycles* (detail).

JÓH RICCI ▸ New Oxford, Pennsylvania USA

Snyderman-Works Galleries

With her distinctive pallet of bright and bold hues, Jóh Ricci seizes the true spirit of knotting, an ancient rug-making technique predating even oriental pile structures. Here is art in a textile form born centuries ago as a cultural value but also as a means of communication. Ricci keeps alive the traditions of knotting as her preferred method of building sculptures through the molding and shaping of the common thread. Notably uncommon are the artist's ideas solidly presented with the pointillist marks and shadows of knots joined tightly to each other and to the artist's purpose. That purpose is well served expressing this artist's interests and values.

Thanks to art, instead of seeing a single world, our own, we see it multiply until we have before us as many worlds as there are original artists.

Marcel Proust

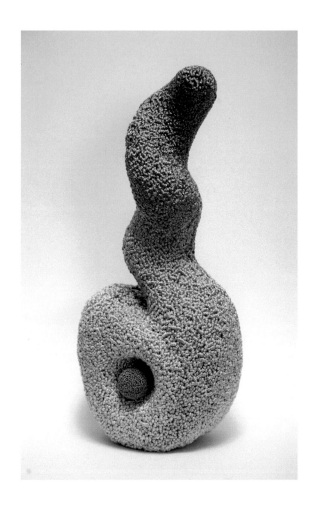

▴**Jóh Ricci**; *Subtle Movement*; knotting; nylon, artist-dyed nylon; 12.25 x 5.5 x 4.5" (31 x 13 x 11cm); photo: Fred Fowler.

◂**Jóh Ricci**; *Autumnal Equinox*; knotting; nylon, artist-dyed nylon; 13.5 x 6 x 4" (33 x 15 x 10cm); photo: Fred Fowler.

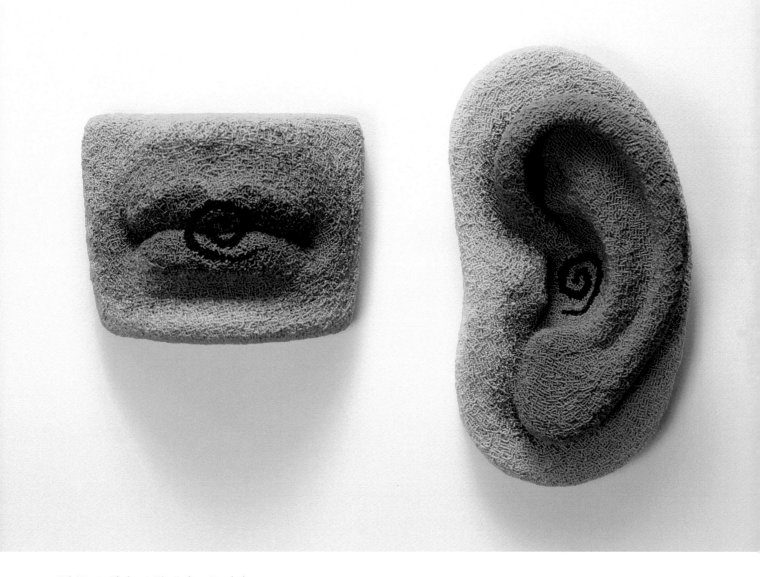

Jóh Ricci; *Chakra 5: The Right to Speak the Truth, The Right to Hear the Truth*; knotting; nylon and artist-dyed nylon; 5 x 6.75 x 4.5" (12.5 x 17 x 11.25cm), 10.25 x 5.25 x 4.25" (26 x 13 x 11cm); photo: Fred Fowler.

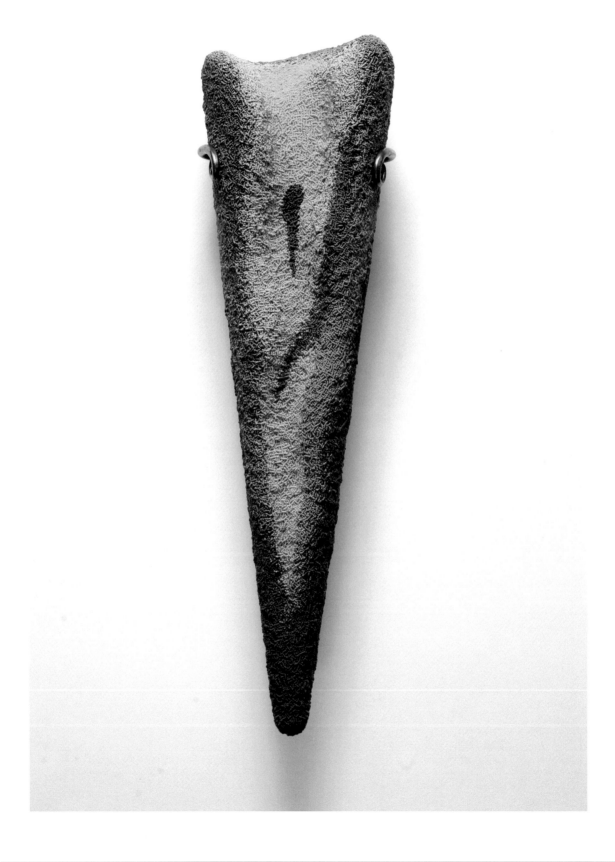

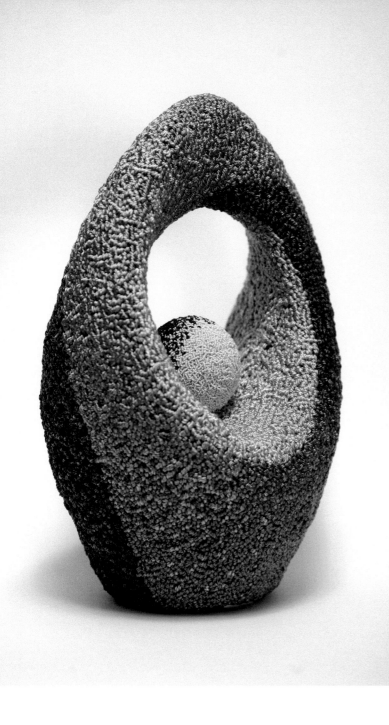

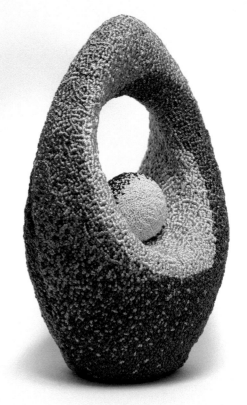

◀ **Jóh Ricci**; *Spirit Rising*; knotting; nylon and artist-dyed nylon; 18 x 5 x 4.25" (45 x 12.5 x 11cm); photo: Fred Fowler.

▲ **Jóh Ricci**; *Waves of Emotion*; knotting; artist-dyed nylon; 10.25 x 7.75 x 5.75" (25.5 x 18.5 x 14.75cm); photo: Fred Fowler.

▶ *Waves of Emotion (alternate view).*

YAMAGUCHI RYUUN ▶ Oita Prefecture, Japan

TAI Gallery/Textile Arts

Frankly speaking, I never thought of the possibility of being an artist until I apprenticed with the first Living National Treasure in bamboo arts, Shono Shounsai. His example deeply inspired me to express myself. Even now, it is a great struggle for me with each new piece. I feel the beauty of the flowers. I feel the beauty of the water flow. I try to bring that flow into my pattern. At first I was very surprised that people wanted to collect my work in the West, but now it has given me more confidence as an artist.

Yamaguchi Ryuun

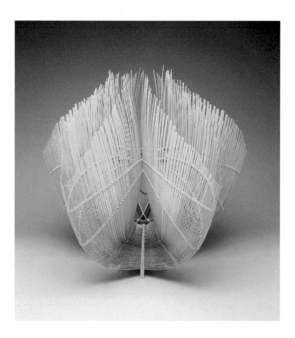

▶**Yamaguchi Ryuun**; *Waves*; technique: kushime-ami, mutsume-kasane-ami; material: madake, rattan; 26 x 19.5 x 23.5" (65 x 48.75 x 58.75cm); photo: Gary Mankus.

◀**Yamaguchi Ryuun**; *Fire*; technique: kasane-ami; material: madake, rattan; 22 x 21" x 21" (55 x 52.5 x 52.5cm); photo: Gary Mankus.

▼**Yamaguchi Ryuun**; *Blossoms Dancing with the Wind*; technique: uzu, kasane-ami; material: Madake; 31" (diameter) x 8" (high), (77.5 x 20cm); photo: Gary Mankus.

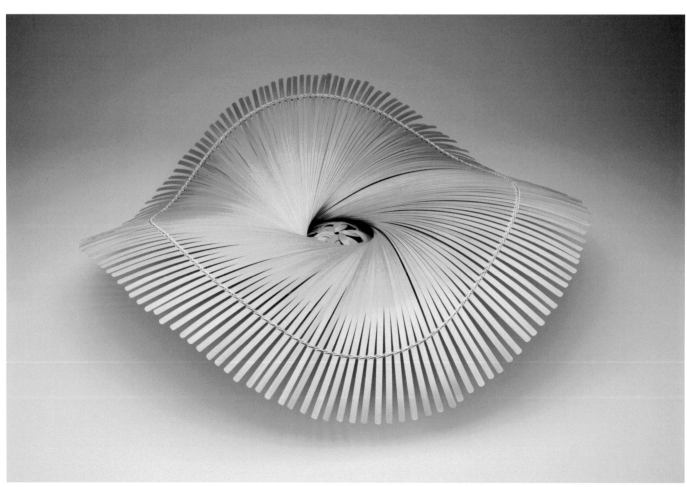

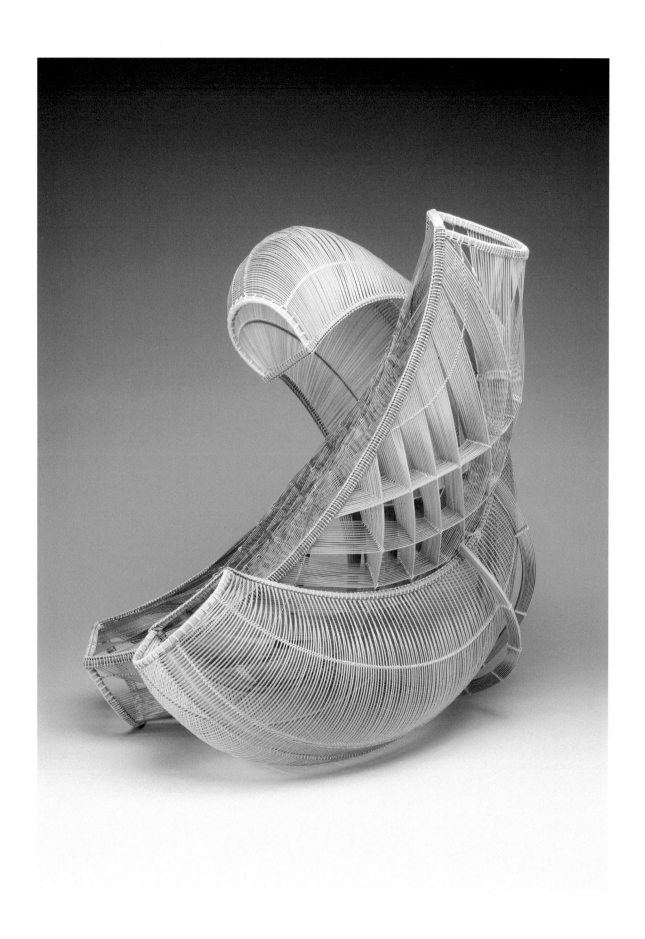

JOY SAVILLE ▸ Princeton, New Jersey USA

Snyderman-Works Galleries

Having attained a high level of success with her intricate compositions, Joy Saville has never been tempted to fall back on technical virtuosity as the premise for continued creative inquiry. Rather she has delved ever deeper into uncomfortable internal places seeking further insights to bring forth in thousands of tiny bits of cloth.

Earlier pieces take the viewer through mysterious outdoor trails of light, shadow and colors perceived in shimmering expressions. The artist's pathways shimmer still today with all the visual powers of an inner world—wholly acknowledged in her distinctive but never predictable rhythms.

To be an artist is not a matter of making paintings or objects at all. What we are really dealing with is our state of consciousness and the shape of our perception. Any tool you use is legitimate. The key to the tool is whether it has the dimensions to deal with what have become your questions. I consider art as thought form more than anything else.

Robert Irwin

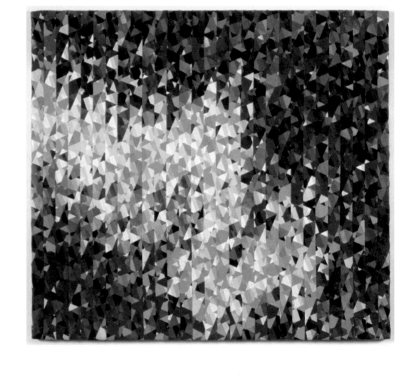

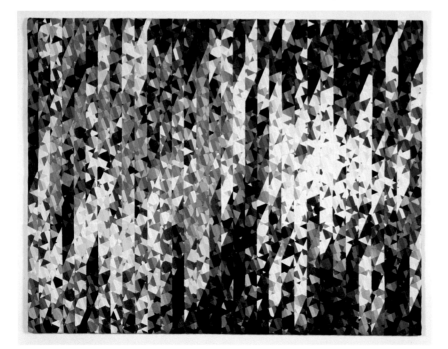

▲ **Joy Saville**; *River's End*; pieced, stitched, constructed, mounted on hidden frame; cotton, linen, silk; 58 x 64 x 1" (145 x 160 x 2.5cm); photo: William Taylor.

▸ **Joy Saville**; *Silent Scream*; pieced, stitched, constructed; cotton, linen, silk; 48 x 30" (120 x 75cm); photo: William Taylor.

◂ **Joy Saville**; *Dogwood*; pieced, stitched, constructed, mounted on hidden frame; cotton, linen, silk; 62 x 79 x 1" (155 x 197.5 x 2.5cm); photo: William Taylor.

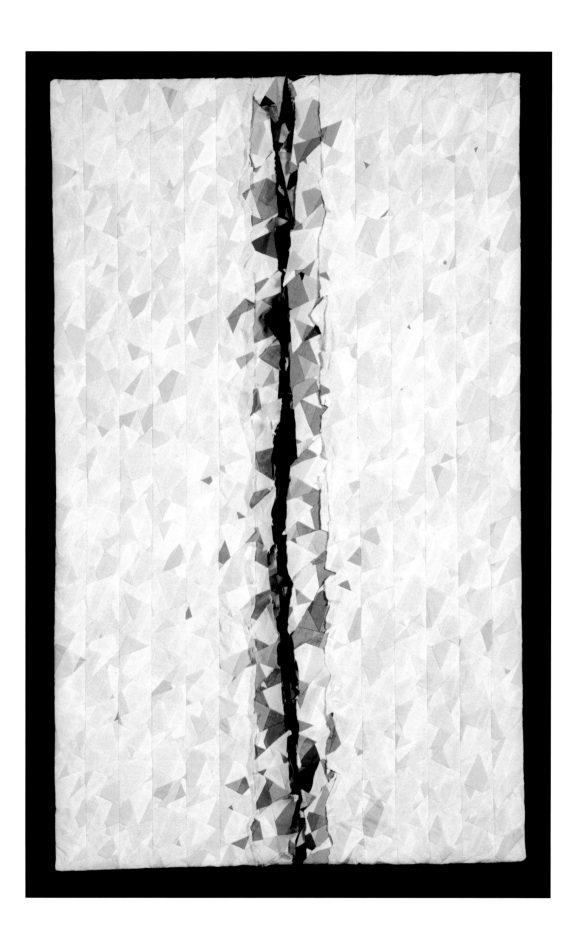

CYNTHIA SCHIRA ▸ Westport, New York USA

Snyderman-Works Galleries

For more than 40 years, Cynthia Schira has been exhibiting her fiber art in international exhibitions in Switzerland, Lithuania, Turkey, Japan, the Nordic countries, and elsewhere in the world. Along this prestigious route, which includes America's finest in the fiber arts movement beginning in the mid-twentieth-century, examples of her art have been acquired by The Art Institute of Chicago, The Metropolitan Museum of Art, The Museum of Fine Arts in Boston, The Renwick Gallery (National Museum of American Art, Smithsonian, Washington, DC) and the DeYoung Museum, San Francisco to name a few. The coveted Louis Comfort Tiffany Award might be mentioned amongst her honors and grants.

Viewed here, the artist refers to a rich range of experiences in her life, on her drawing board and at her loom. Schira weaves together fragments of images born of the life; expressed through the cloth. With her assured hands and keen perceptions, a range of cultural traditions and their discernible marks are made manifest in woven threads intentionally bold and provocative.

In damask cloth woven on a jacquard loom, Schira commands one of the most complex of all textile structures. Her seemingly unbounded strokes of thread, examine visual notations of music, culture, ciphers or language. The end result is a rare synthesis of well-ordered articulation within the clear rhythms of the loom.

Cynthia Schira; *Windows*; jacquard woven with appliquéd lines and forms; cotton with mixed fibers and ribbons; 24 x 72" (60 x 180cm); photo: Neal Keach.

Cynthia Schira; *Source Code*; jacquard woven (damask weave); cotton; 10 x 5 x 2' (300 x 150 x 60cm); photo: Neal Keach.

Cynthia Schira; *Variations*; jacquard woven (damask weave); cotton; 48 x 59" (120 x 147.5cm); photo: Neal Keach.

ELIZABETH TALFORD SCOTT ▸ Baltimore, Maryland USA

Elizabeth Talford Scott and
Joyce J. Scott

Stitched within the quilts of Elizabeth Talford Scott are traces of her early years as the sixth of fourteen children in a family of sharecroppers from America's deep south. Of necessity, her early quilted efforts were bartered away for overalls and other basic needs. Would that those who acquired the early handwork of this visionary artist might appreciate her remarkable accomplishments and honors today including a Lifetime Achievement Award from the Women's Caucus for Art. No longer mere trading currency, Elizabeth Scott's quilts have found their way into private collections as well as exhibitions in prestigious museums such as the Metropolitan Museum of Art, The Studio Museum of Harlem, and the Smithsonian Institute.

Though she clearly inspired her daughter, artist Joyce J. Scott, the two have absorbed from each other as well as from the wider world, especially their shared African and African American heritage. Just as each brilliant fabric scrap carried special meanings in Elizabeth's life, so have the precious beads, buttons, stones, and shells embedded in her stitched mosaics. Obvious amongst her references to history are profound messages for us to value and nurture social harmony and community. From a wise and gifted woman, decades of quilts exist today as enchantment, inspiration, and *personal hieroglyphics* as Joyce calls them.

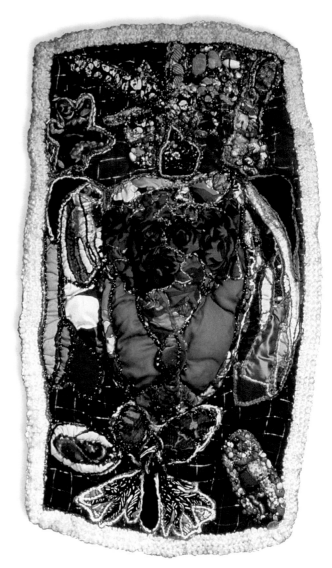

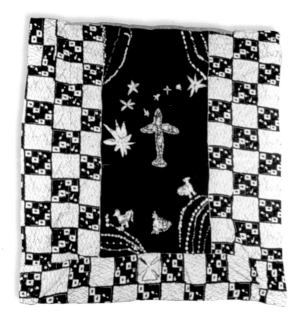

▴**Elizabeth Talford Scott**; *Underwater*; fabric with mixed media; 38 x 22" (95 x 55cm); photo: courtesy of Snyderman-Works Galleries.

▸**Elizabeth Talford Scott**; *Joyce's Quilt*; fabric with mixed media; 63 x 61" (157.5 x 152.5cm); photo: courtesy of Snyderman-Works Galleries.

◂**Elizabeth Talford Scott**; *Both Sides Now*; fabric with mixed media; 78 x 60" (195 x 150cm); photo: courtesy of Snyderman-Works Galleries.

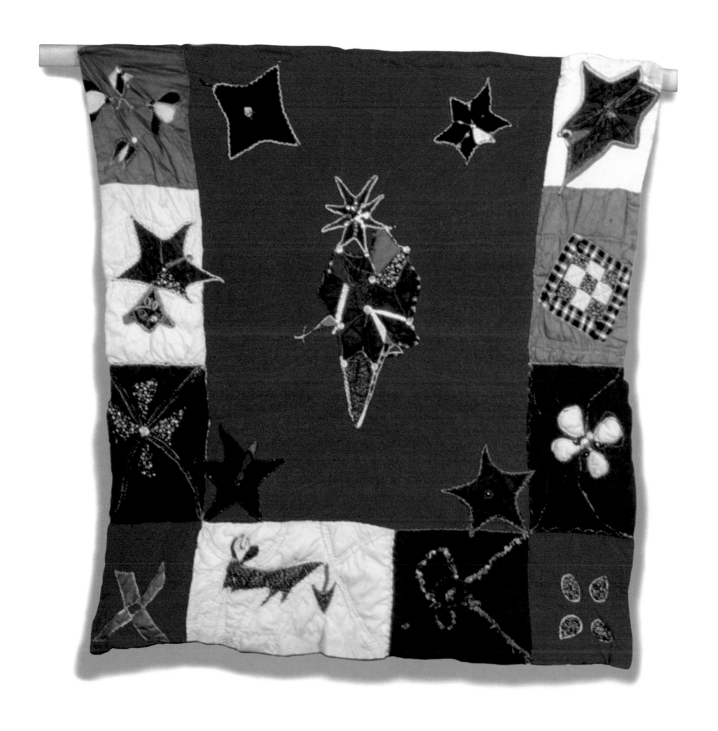

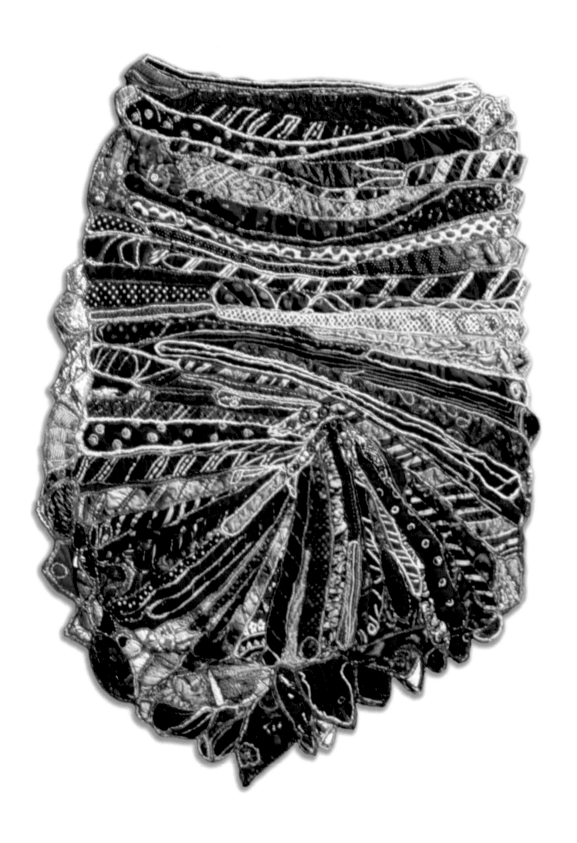

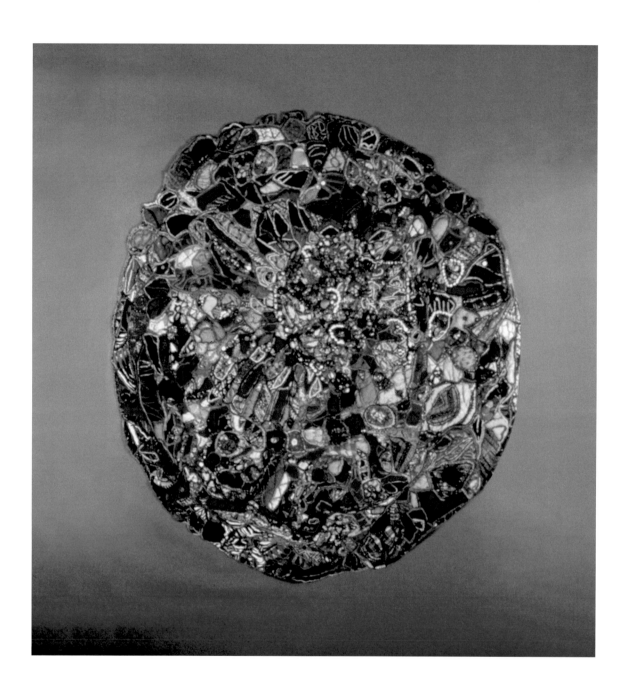

▲**Elizabeth Talford Scott**; *Flower Garden*
#2; fabric with mixed media; 72" diameter
(180cm); photo: courtesy of Snyderman-Works
Galleries.

◀**Elizabeth Talford Scott**; *Tie Quilt*; fabric
with mixed media; 66 x 57" (164 x 142.5cm);
photo: courtesy of Snyderman-Works Galleries.

JOYCE J. SCOTT ▸ Baltimore, Maryland USA

Goya Contemporary

Snyderman-Works Galleries

Born in Baltimore, 1948, Joyce J. Scott is arguably the most significant and influential living female artist working in Baltimore today. Sculptor, printmaker, installation artist, performer, quilter, storyteller, and educator, Joyce J. Scott draws from influences as wide ranging as her media: from African and Native American experiences to art history, television, popular American culture, religious traditions, politics, and contemporary urban street customs. Renowned for her meticulous craftsmanship and biting social commentary relating to issues of racism, violence, sexism, morality, stereotypes, and other forms of social injustice, Scott's catalytic power for change is supported by her keen application of humor. For more than four decades, this multifaceted and provocative artist has created complex objects of exceptional skill, beauty, and sophistication that double as a social mirror.

The daughter of nationally acclaimed fiber artist Elizabeth Talford Scott, Joyce's education in object making began at a remarkably young age. Today she is included in the collections of the Baltimore Museum of Art, Brooklyn Museum of Art, Corning Museum of Glass, Metropolitan Museum of Art, Mint Museum of Art, Mobile Museum of Art, Museum of Glass in Washington, Museum of Art and Design in NY. Museum of Fine Arts in Houston, National Museum of American Art, Smithsonian Institution in D.C., and the Philadelphia Museum of Art.

Scott has been the recipient of myriad commissions, grants, residencies, and prestigious honors from institutions such as the National Endowment for the Arts, the Louis Comfort Tiffany Foundation, Anonymous Was a Woman, and the American Craft Council. In 1996, Scott was nominated for a National Living Treasure Award, and in 2010, she will be presented with a lifetime achievement award from the Women's Caucus for the Arts.

Amy Eva Raehse, Executive Director, Goya Contemporary, Baltimore Maryland

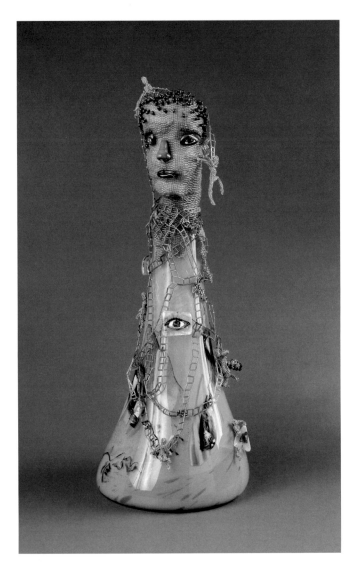

Joyce J. Scott; *Celadon II*; beadwork; mixed media; 22 x 8 x 9" (55 x 20 x 22.5cm); photo: courtesy of Snyderman-Works Galleries.

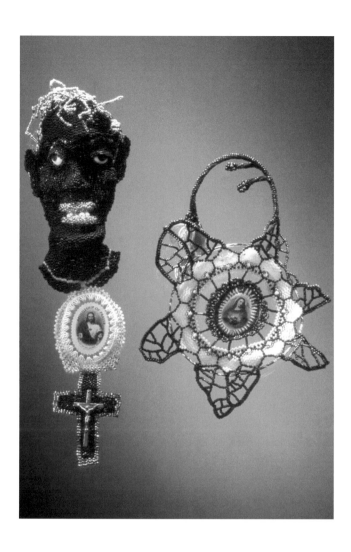

Joyce J. Scott; *Devotee*; beadwork; mixed media: beads, paper, prayer card, metal cross, pendants; 14.5 x 11.5 x 2" (36.25 x 28.75 x 5cm); photo: courtesy of Snyderman-Works Galleries.

Joyce J. Scott; *Vaulted*; beadwork; mixed media; 27 x 9 x 6" (67.5 x 22.5 x 15cm); photo: courtesy of Snyderman-Works Galleries.

Joyce J. Scott; *The Heart is a Lonely Hunter II*; beadwork; mixed media; 52.5 x 36 x 36" (131.25 x 90 x 90cm); photo: courtesy of Snyderman-Works Galleries.

WARREN SEELIG ▸ Rockland, Maine USA

Snyderman-Works Galleries

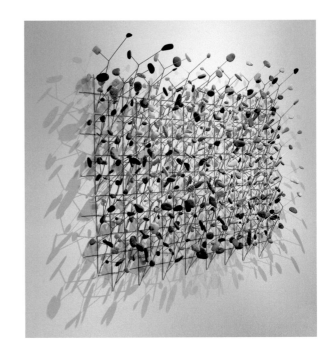

The Shadowfields of this past decade generate a beautifully complex pattern with no clear beginning or end. They imply movement towards infinite space, a place that verges on the sublime. My earliest recognition of this space came during the process of weaving fabric. The intersecting threads appeared animate and alive as they grew into cloth, and, working close in, the field seemed boundless and immense. The Shadowfields embrace this space while at the same time moving away from the more tangible, physical, and material surfaces inherent in textiles. They create contradictory atmospheres of reality and illusion through an expanse of random and uncontrollable accumulated shadows.

Warren Seelig 2010

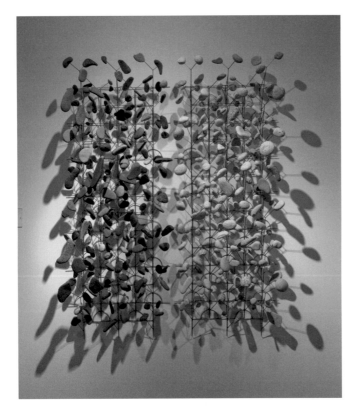

▲**Warren Seelig**; *Shadowfield/ Granite*; silver brazed stainless steel, granite; 46 x 62 x 8" (115 x 155 x 20cm); photo: Jack Ramsdale.

◂**Warren Seelig**; *Twin Trellis/ Shadowfield*; silver brazed stainless steel, granite; 49 x 43 x 6" (122.5 x 107.5 x 15cm); photo: Jack Ramsdale.

▸**Warren Seelig**; *Clark Island/ Shadowfield*; silver brazed stainless steel, granite; 40 x 190 x 8" (100 x 475 x 20cm); photo: Jack Ramsdale.

▸▸*Clark Island/ Shadowfield* (detail).

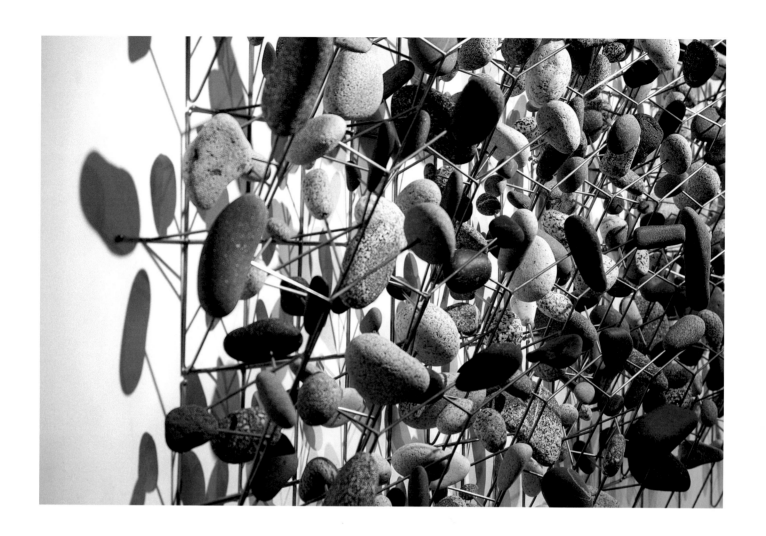

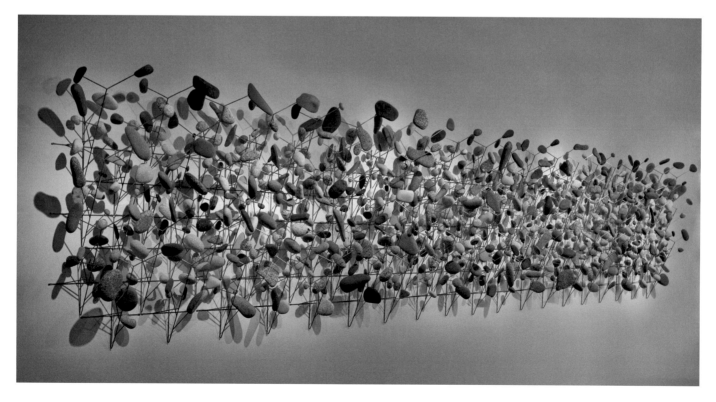

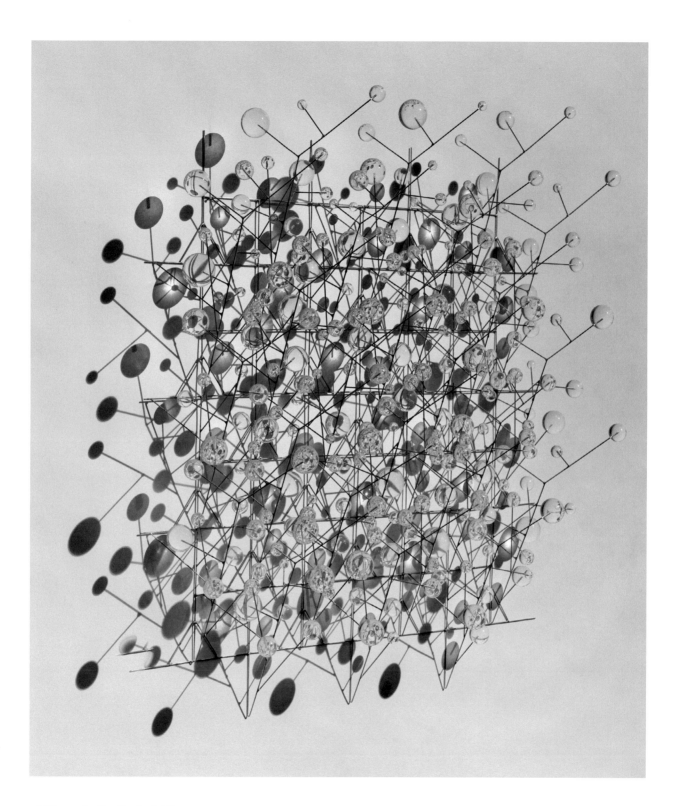

▲**Warren Seelig**; *Shadowfield/*
Crystal; silver brazed stainless
steel, Lucite balls; 24 x 24 x 3.5"
(60 x 60 x 8.75cm); photo: Jack
Ramsdale.

◄*Shadowfield/ Crystal* (detail).

HONDA SYORYU ▸ Oita Prefecture, Japan
TAI Gallery / Textile Arts

Honda Syoryu began his career studying bamboo basket making for flower arranging but the limitations of this centuries-old genre constrained his creativity. An innovator, he crafts dramatic, undulating sculptures that demonstrate his fascination with line, volume, and space. Seamless lengths of braided bamboo, dyed in warm shades of tobacco, gold, and bronze, resemble leather or metal. The artist is a master at tight ajiro plaiting, a technique he has adapted from generations of Japanese bamboo box makers.

A finalist for the Cotsen Bamboo Prize in 2000, 2002, and 2004, Honda's work is now part of the permanent collections of the Museum of Arts and Design in New York City, San Francisco Asian Art Museum, Boston Museum of Fine Arts, Mint Museum, and the Ruth and Sherman Lee Institute for Japanese Art .

Courtesy of TAI Gallery/
Textile Arts

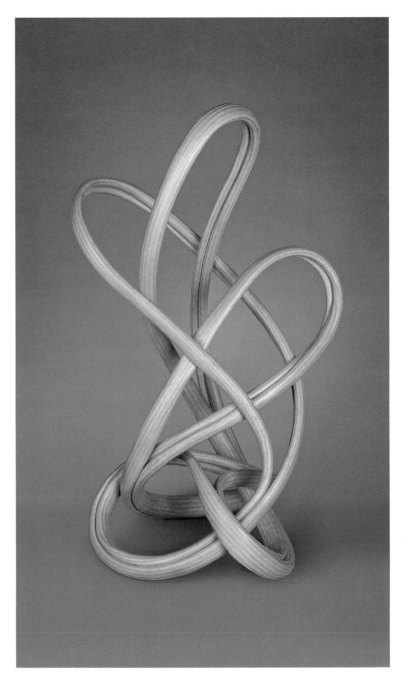

Honda Syoryu; *Reincarnation*; technique: ajiro-ami; material: madake; 33.5 x 19 x 18" (83.75 x 47.5 x 45cm); photo: Gary Mankus.

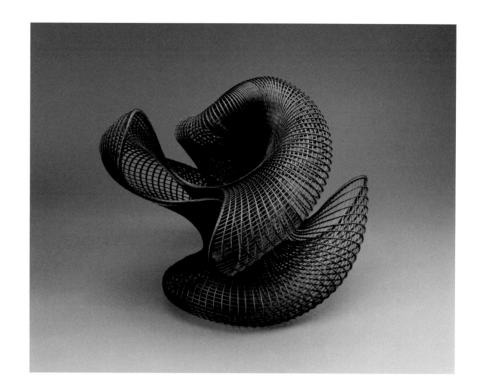

Honda Syoryu; *Revolution*; technique: nawame; material: madake, rattan; 15.5 x 22.5 x 19" (38.75 x 56.25 x 47.5 cm); photo: Gary Mankus.

Honda Syoryu; *Time Undulation*; technique: kushime-ami; material: madake;19 x 28 x 17" (47.5 x 70 x 42.5cm); photo: Gary Mankus.

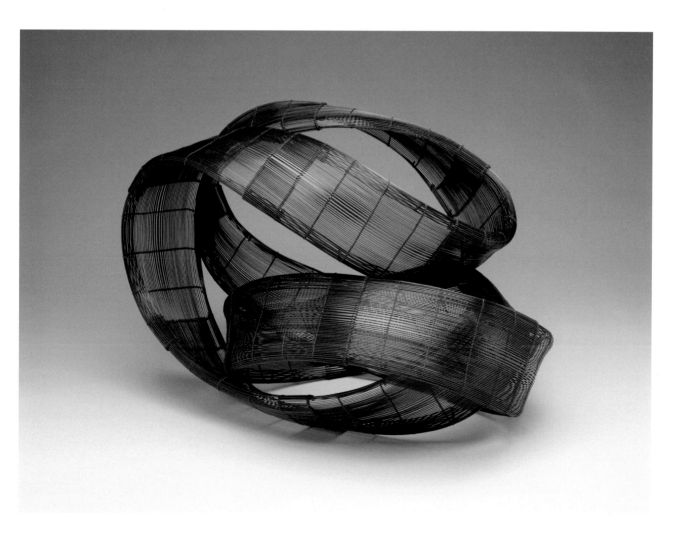

LISBETH TOLSTRUP ▸ Copenhagen, Denmark

Noted artist, designer, and critic Lisbeth Tolstrup refers to sculptural works in fiber media as, *. . .windows into the wizard's workshop where fibres are prepared, and challenged to fulfill those goals the artist sets.* Tolstrup in her writer's mode draws from fluency in both Danish and English. In her artist's mode she connects through a visual language that confronts the lavish and colorful Nordic textile traditions.

Tolstrup's outdoor installation in Rauma, Finland, *In the Shades of a Memory*, refers to two points of view in working with textiles. One is poetic and connected to the domestic use of textiles in everyday households. Sheets, tablecloths, and clothing are universally recognized throughout the world as once having been handmade. Today, those textiles are seldom handcrafted. More likely they are purchased and discarded with little thought about their meaning in one's life. Each textile in the Rauma project has a history in someone's life prior to its appropriation as Tolstrup's second point of view in working with textiles. In Rauma, the artist created an environment of experience in a clearly defined outdoor space. Yet even here is the mark of a poet in her placement of brilliant colors at rhythmic intervals in absolute harmony with the forces receiving them. Her second series Mythical Mini Textiles refers to the secrets and mysteries of fiber art *wizards.*

In my country textile art experienced a huge influence from artists from all over the world taking part in the biennials in Lausanne (1962-1996) and later in the Nordic Textile Triennials (1976-1996). Here we never really experienced the struggle between tapestry and fiber art as it has been described elsewhere, possibly because many artists experimented on both sides of that particular border.

Lisbeth Tolstrup

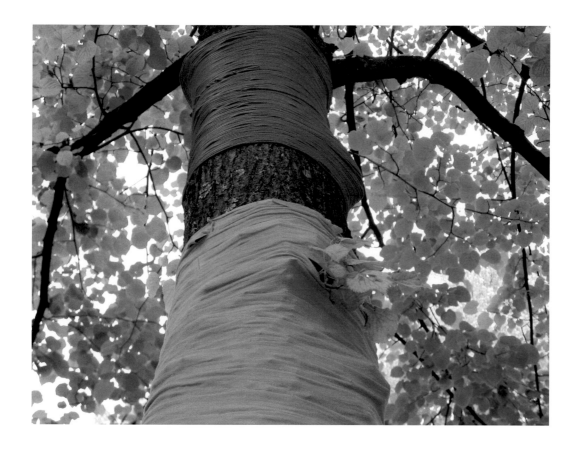

▲**Lisbeth Tolstrup**; *The Rauma Project, 2006*; Textile installation in a public park in the city of Rauma, Finland. Made on invitation from Rauma city council, department of culture on occasion of the annual Lace Week; tearing fabric into strips, binding, sewing, composing strips, and strings into dialogue; (200 x 200M); photo: Lars Pryds.

◀▶ *The Rauma Project (*alternate view).

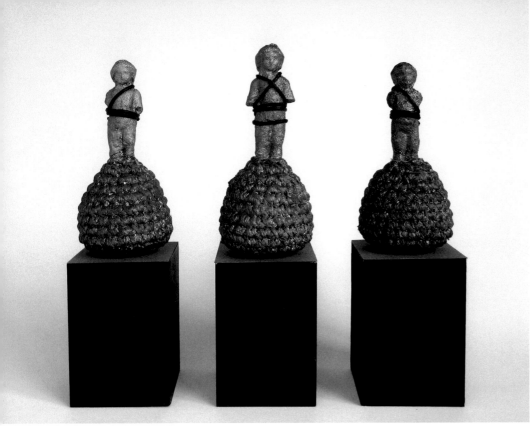

Lisbeth Tolstrup; *Mythical figures: Three Imaginary Guards Watching the Secrets of Textiles*; crochet, gluing, dyeing, mummification; guards: antique porcelain dolls mummified in cotton and bronze, bases: silk, cotton, and flax; each statue (including podium) 9.5 x 5.5 x 5.5" (24 x 14 x 14cm); photo: Lars Pryds.

Lisbeth Tolstrup; *Mythical Figures: An Imaginary Guard Being Guarded by Two Mythical Figures: An Egyptian Cat and a Prehistoric Antelope*; crochet, gluing, dyeing, mummification; porcelain figures mummified in cotton and bronze, wood, silk, cotton, flax; Cat: 7.5 x 5.5 x 5.5" (18 x 14 x 14cm), Guard: 9.5 x 5.5 x 5.5" (24 x 14 x 14cm), Antelope: 8 x 5.5 x 5.5" (20 x 14 x 14cm); photo: Lars Pryds.

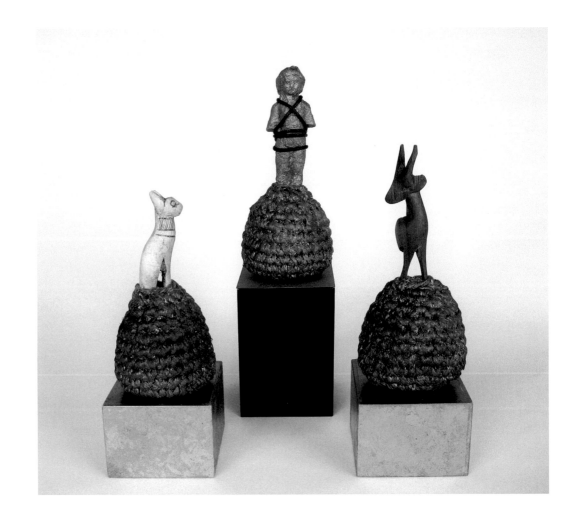

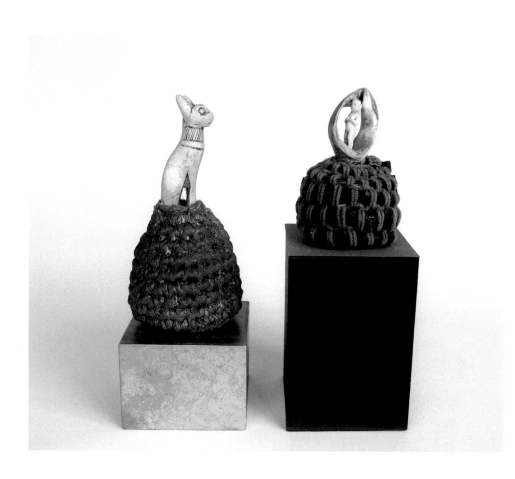

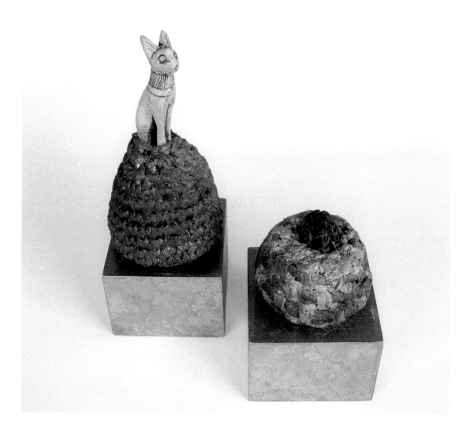

▲ **Lisbeth Tolstrup**; *Mythical figures: A Mythical Cat Meets Venus in a Seashell*; crochet, gluing, dyeing, filling; porcelain figures, silk, cotton, flax; guards: antique porcelain dolls mummified in cotton and bronze, bases: silk, cotton, flax, rubber; Cat: 7.25 x 5.5 x 5.5" (18 x 14 x 14cm), Venus: 7.75 x 5.5 x 5.5" (19 x 15 x 15cm); photo: Lars Pryds.

◄ **Lisbeth Tolstrup**; *Mythical Figures: An Egyptian Cat Watches the Mythical Jar of Fertility*; crochet, gluing, dyeing, filling; porcelain figure, silk, cotton, flax, copper, clay; Cat: 7.25 x 5.5 x 5.5" (18 x 14 x 14cm), Jar: 4 x 5.5 x 5.5" (10 x 14 x 14cm); photo: Lars Pryds.

BETTY VERA ▸ Woodstock, New York USA

Sigrid Freundorfer Fine Art, LLC

Why weave? Building an image thread by thread is unlike any other art making process; the completed work has a richness and depth not achieved by applying pigment to a surface. When woven, image and physical structure are one. My work examines the nature and tangibility of reality, blurring boundaries between what can and cannot be seen. Intentionally ambiguous forms materialize and then dissolve into elusive impressions—traces, residues, and afterimages rather than tactile objects; space suggested but not defined.

At a time of economic and environmental upheaval, with creativity and cultural identity virtually destroyed by global commercial interests, people are being forced to re-examine their lives in relation to this kind of pervasive greed and depersonalization. Consumerist values no longer satisfy. Mass society allows no privacy, but at the same time it does not promote meaningful connections between individuals. My work is an invitation to shed the superficiality, noise, and visual clutter of contemporary society in order to connect meaningfully with the true self and to appreciate the underlying solitude, deep silence, and fleeting nature of human existence.

Betty Vera

⏶ **Betty Vera**; *Oxygen Loops*; Jacquard tapestry; cotton; 77 x 46" (195.5 x 117cm); photo: Nancy S. Donskoj.

◂ *Oxygen Loops* (detail).

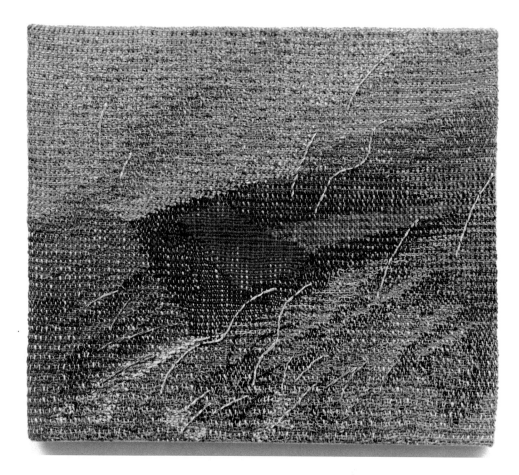

Betty Vera; *Toward a Quiet Place*; warp painted tapestry; cotton; 14 x 16" (35.5 x 40.5cm); photo: D. James Dee.

▼ *Toward a Quiet Place* (detail).

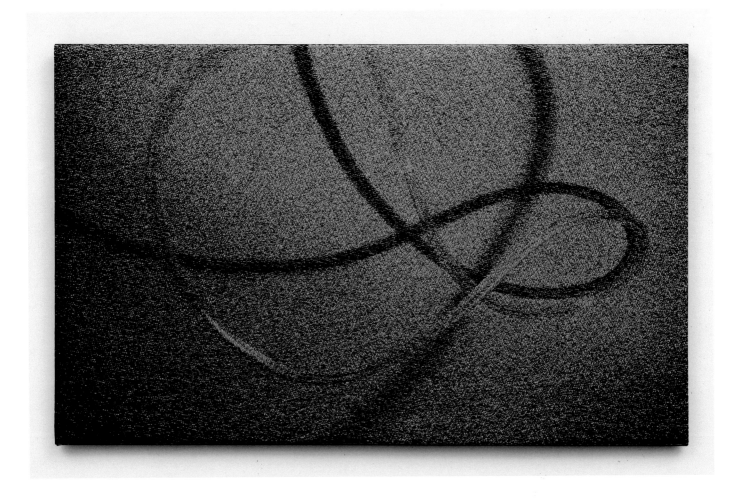

▲**Betty Vera**; *Arabesque*; Jacquard damask; cotton and rayon; 27 x 44" (68.5 x 111.75cm); photo: D. James Dee.

▶**Betty Vera**; *Enso*; Jacquard tapestry; cotton; 85 x 46" (216 x 117cm); photo: Nancy S. Donskoj.

▶▶*Enso* (detail).

CAROL D. WESTFALL ▶ Jersey City, New Jersey USA

I have built a multi-layered bed of colored polyester fabrics onto which I have stitched various synthetic threads to create the look of a cascade of water as in a "waterfall". Using the same synthetic threads, I then used French knots at the base of the "waterfall" to replicate the look of bubbling water at the base of the "falls".

There have been reports that a few of our southwestern states began to run out of water several years ago. They now have to buy the water which their citizens use. As development continues, the need for pure, clean water is growing and the actual amount available at any price is shrinking. In one Midwestern state, the drinking water is used by successive communities as one moves down the flowing river. The closer you are to the source, the less your water has been used and cleaned and returned to the river. Clean, pure water is becoming as precious as gold or silver and this "Cascade Series" seeks to remind us of how wise use of this resource is so important to all of us.

<div align="right">

Carol D. Westfall, 2010.

</div>

In an age when man has forgotten his origins and is blind even to his most essential needs for survival, water along with other resources has become the victim of his indifference.

<div align="right">

Rachel Carlson

</div>

▲ *Cascade I* (detail).

◀ *Cascade VI;* (detail).

▼ *Cascade VI;* 4.5 x 26.75" (11.25 x 67.25cm).

 Carol Westfall; *Cascade IV*; all pieces in this series: stitchery; sandwiched vari-colored polyester layers; 7.5 x 42.25" (18.25 x 106cm).

▲▲ *Cascade V*; 4.5 x 27" (11.25 x 67.5cm).

▲ *Cascade I*; 7.5 x 30" (18.25 x 75cm).

◀ *Cascade II*; 7.5 x 30.5" (18.25 x 76.25cm).

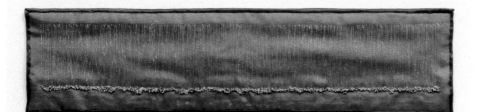

KINUYO YOSHIMIZU ▸ Kyoto, Japan

Kinuyo Yoshimizu leads us into times and places in a directly expressive manner by shifting tapestry away from its traditional narrative role into engaging the viewer's own perspective with her art. A *Scarlet Time* is universal to people everywhere. In the manner of abstract expressionism, her grand scale works fill one's entire field of vision with a grand concept. Her works incite immediate feelings as well as deeper thought.

> *Spring, summer, fall and winter revolve*
> *Coming into buds, flowers bloom and bear fruit*
> *The sun shines, winds blow and rain falls*
> *And again*
> *Spring, summer, fall and winter revolve*
> *By giving all our love we succeed in life*
> *Time passes and we pour out our love*
> *All our love succeed in life*
> *Using thread I play in time*

Kinuyo Yoshimizu

▸▸**Kinuyo Yoshimizu**; *In Woods*; tapestry; wool, acrylic; 40 x 200" (100 x 500cm).

▸**Kinuyo Yoshimizu**; *Time*; tapestry; silk, linen, mitsumata plant, acrylic; 72 x 152 x 3.5" (180 x 380 x 8cm).

▾**Kinuyo Yoshimizu**; *Progress of Time*; tapestry; silk, wool, acrylic; 40 x 80" (100 x 200cm).

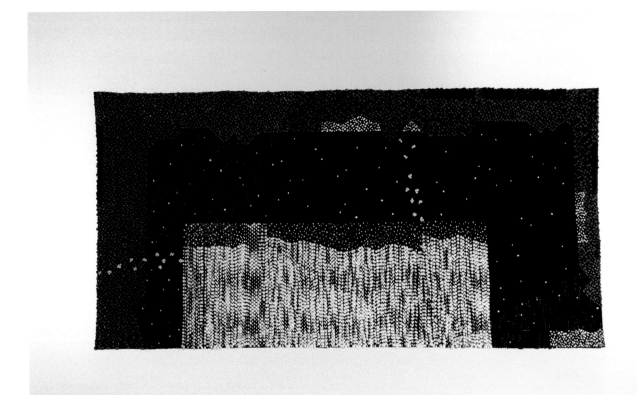

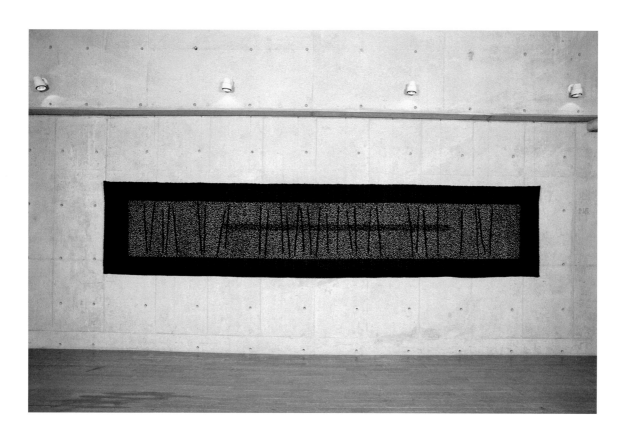

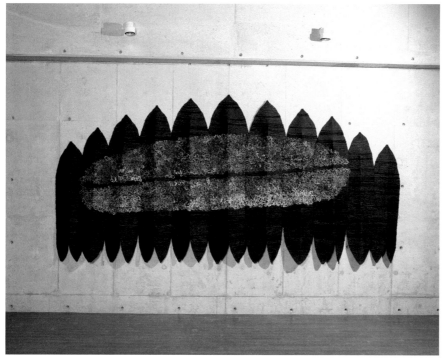

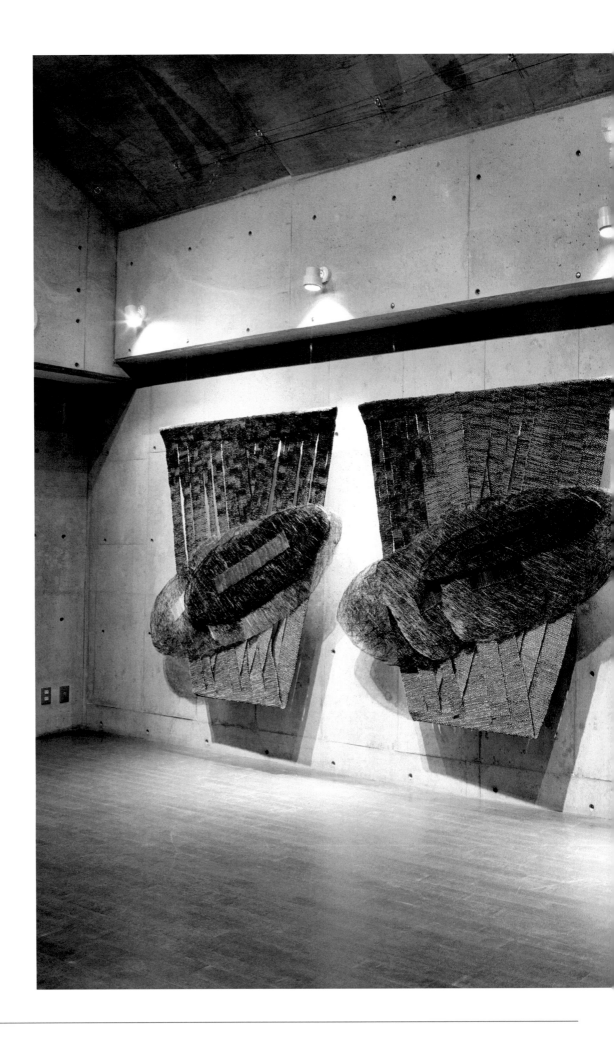

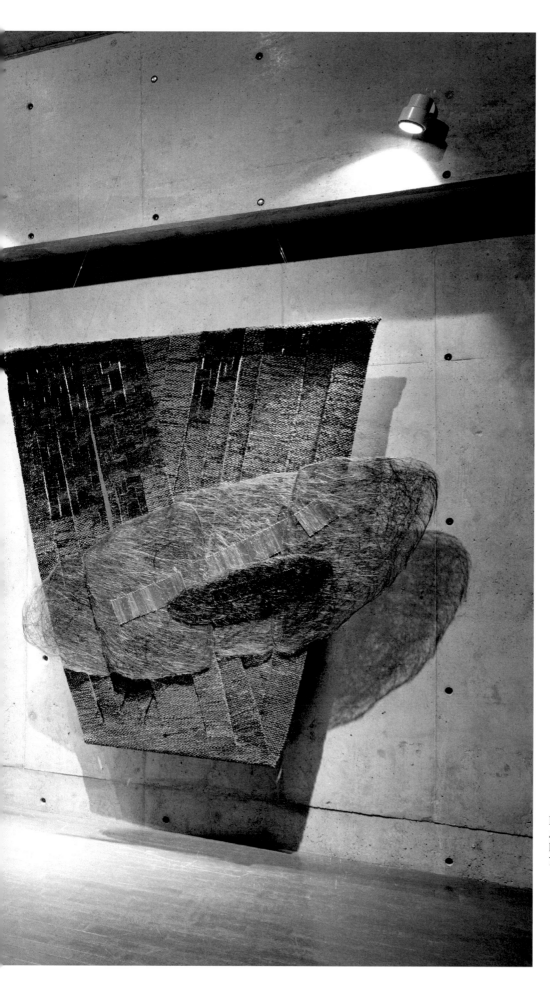

Kinuyo Yoshimizu;
Scarlet Time; tapestry; silk,
linen, acrylic; each piece
72 x 64" (180 x 160cm).

Arnett, William, Paul Arnett, Joanne Cubbs, and E. W. Metcalf. *Gee's Bend: the Architecture of the Quilt*. Atlanta, GA: Tinwood, 2006.

Auther, Elissa. *String, Felt, Thread: the Hierarchy of Art and Craft in American Art*. Minneapolis: University of Minnesota, 2010.

Boman, Monica, Roger G. Tanner, and Bertil Lundgren. *Design in Sweden*. Stockholm, Sweden: Swedish Institute, 1985.

Chicago, Judy, and Donald Woodman. *The Dinner Party from Creation to Preservation*. London: Merrell, 2007.

Chicago, Judy. *Holocaust Project: from Darkness into Light*. New York, N.Y., U.S.A.: Penguin, 1993.

Clarke, Sarah E. Braddock., Marie O'Mahony, and Sarah E. Braddock. Clarke. *Techno Textiles 2*. London: Thames & Hudson, 2006.

Coffland, Robert T., and Donald Bartlett Doe. *Hin: the Quiet Beauty of Japanese Bamboo Art*. Chicago: Art Media Resources, 2006.

Jacqueline Rush Lee; *The Devotion Series:* altered books; book, inks, book marks; photo: Paul Kodama.

Coffland, Robert T., Pat Pollard, and Art Streiber. *Contemporary Japanese Bamboo Arts*. Chicago, IL: Art Media Resources, 1999.

Colchester, Chloë. *Textiles Today: a Global Survey of Trends and Traditions*. London: Thames & Hudson, 2009.

Constantine, Mildred, and Jack Lenor Larsen. *Beyond Craft; the Art Fabric*. New York: Van Nostrand Reinhold, 1972.

Cotsen, Lloyd, Robert T. Coffland, and Pat Pollard. *The Bamboo Basket Art of Higashi Takesonosai*. Los Angeles: Cotsen Occasional Papers, 2002.

Gilsdorf, Bean. "Sticks and Stones: Craft's Identity Battle with Art and Itself." *Surface Design* Spring 2010: Page 49.

Harris, Patricia, David Lyon, Patricia Malarcher, and Michael James. *Michael James: Studio Quilts*. Neuchâtel, Switzerland: Éditions Victor Attinger, 1995. (and Whetstone Hill Publications, Swansea, MA.)

Hix, H. L., and Foreword by Gerhardt Knodel. *Kyoung Ae Cho*. Vol. 17. Brighton, UK: Telos, 2003. Portfolio.

Jefferies, Janis. *Reinventing Textiles: Gender and Identity*. Telos, 2001.

Koumis, Matthew. *Art Textiles of the World: Japan : Volume 2*. Winchester, England: Telos Art, 2002.

Koumis, Matthew. *Art Textiles of the World: Scandinavia, Volume 2*. Bristol: Telos Art, 2005.

Koumis, Matthew. *Art Textiles of the World, USA*. Winchester, England: Telos, 2000.

Koumis, Matthew. *Great Britain*. Brighton, Eng.: Telos Art, 2006.

Krondahl, Hans, Mailis Stensman, Tonie Lewenhaupt, and Göran Söderlund. *Hans Krondahl: Textila Verk*. Stockholm: Carlssons i Samarbete Med Prins Eugens Waldemarsudde, 2009.

Lambert, Patricia, Barbara Staepelaere, and Mary G. Fry. *Color and Fiber*. West Chester, Pa.: Schiffer Pub., 1986.

Lee, Mi-Kyoung. *Art Textiles of the World: Korea*. Brighton, England: Telos, 2005.

Lenkowsky, Kate. *Contemporary Quilt Art: an Introduction and Guide*. Bloomington: Indiana UP, 2008.

Mayer-Thurman, Christa C. *Textiles in the Art Institute of Chicago*. Chicago, Ill.: Art Institute of Chicago, 1992.

McFadden, David Revere, Jane Adlin, and Kathleen Whitney. *Norma Minkowitz*. Vol. 35. Brighton, UK: Telos, 2004. Portfolio.

McFadden, David Revere, Jennifer Scanlan, and Jennifer Steifle Edwards. *Radical Lace & Subversive Knitting*. New York: Museum of Arts and Design, 2007.

Michel, Karen. *Green Guide for Artists: Nontoxic Recipes, Green Art Ideas, & Resources for the Eco-Conscious Artist*. Beverly, MA: Quarry, 2009.

Monem, Nadine Käthe. *Contemporary Textiles: the Fabric of Fine Art*. London: Black Dog Publ., 2008.

Moorman, Theo. *Weaving as an Art Form: a Personal Statement*. Atglen, Pa.: Schiffer Pub., 1975.

Poutasuo, Tuula. *Tekstiilin Taidetta Suomesta = Textile Art in Finland*. Hamina, Finland: AKATIMI in Cooperation with Textile Artists in Finland TEXO Ry, 2001.

Rossbach, Ed. *The Nature of Basketry*. West Chester, Pa.: Schiffer Pub., 1986.

Rossol, Monona. *The Artist's Complete Health and Safety Guide*. 3rd Edition ed. New York: Allworth, 2001.

Russell, Carol K. *Tapestry Handbook: The Next Generation*. Atglen, PA: Schiffer Pub., 2007. .

Schoeser, Mary. *World Textiles a Concise History*. London: Thames & Hudson, 2003.

Sharrad, Paul, and Anne Collett. *Reinventing Textiles: Volume 3 : Postcolonialism and Creativity*. Brighton, UK: Telos, 2004.

Shaw, Robert. *The Art Quilt*. New York: Hugh Lauter Levin Associates, 1997.

Thomas, Michel, Christine Mainguy, and Sophie Pommier. *Textile Art*. New York: Rizzoli, 1985.

Timmer, Dery. *Art Textiles of the World: The Netherlands*. England: Telos Art, 2002.

Ullrich, Polly. *Material Difference: Soft Sculpture and Wall Works*. Western Springs, IL: Friends of Fiber Art International, 2006.

Weltge-Wortmann, Sigrid, *Bauhaus Textiles: Women Artists and the Weaving Workshop*. New York: Thames and Hudson, 1998.

Artists' Websites

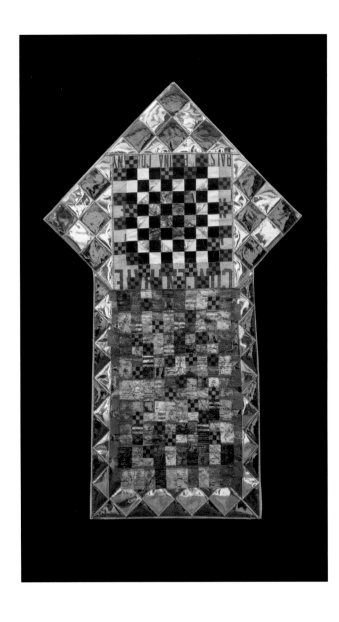

Patricia Malarcher; *Diary*; 52 x
32" (130 x 80cm); Mylar, fabric,
recycled upholstery samples and
feed sack, screen and transfer
printing; photo: D. James Dee.

EXHIBITIONS

Arte & Arte
www.miniartextil.it

Biennale internationale di lin de Portneuf
www.biennaledulin.ca

Craft Boston
http://craftboston.org/springindex.asp

Fiberart International
http://fiberartinternational.org

International Triennial of Tapestry; Centralne Muzeum Włókiennictwa
www.muzeumwlokiennictwa.pl/aktualna-edycja/?lang=en

Kaunas Art Biennial
www.bienale.lt

Lausanne to Beijing
www.chinafiberart.com.cn/4th-english.html#

Quilt National
www.dairybarn.org/quilt

Quilt Nihon Exhibition
www.jhia.org/English

Rijswijk Textile Biennial
www.museumryswyk.nl/htb2009/uk/index.html

Smithsonian Craft Show
www.smithsoniancraftshow.org

SOFA, Chicago, NYC, Santa Fe
www.sofaexpo.com

The Nitten
www.nitten.or.jp/english/index.html

Snyderman-Works Galleries Biennial: http://www.snyderman-works.com/snyderman/current/2010/biennial

Triennale internationale des mini-textiles
www.musees.angers.fr/les-musees/musee-jean-lurcat-et-de-la-tapisserie-contemporaine

Venice Biennale
www.labiennale.org/en/Home.html

APPENDIX

Joy Saville; *Event Horizon*; pieced, stitched, constructed, mounted on hidden frame; cotton, linen, silk; 77 x 56 x 1" (192.5 x 140 x 2.5cm); photo: Ross/Taylor.

GALLERIES

A.I.R. Gallery: www.airgallery.org
ACA Galleries: www.acagalleries.com
Anderson O'Brien Fine Art: www.aobfineart.com
An Gailearaí: http://www.angailearai.com
Andrea Schwartz Gallery: www.asgallery.com
Art Star Gallery: www.artstarphilly.com
Bellas Artes Gallery: www.bellasartesgallery.com
Betty Dare Art Gallery: www.bettydare.com
Blue Heron Gallery: www.blueherondeerisle.com
Browngrotta Arts: www.browngrotta.com
Center for Book Arts: www.centerforbookarts.org
Cervini Haas Fine Art: www.cervinihaas.com

Chiaroscuro Contemporary Art: www.chiaroscurosantafe.com
Contemporary Applied Arts: www.caa.org.uk
Dairy Barn, Inc.: www.dairybarn.org
del Mano Gallery: www.delmano.com
Duane Reed Gallery: www.duanereedgallery.com
Francis M. Naumann: www.francisnaumann.com
Gagosian Gallery: www.gagosian.com
Galerie Besson: www.galeriebesson.co.uk
Gallery 51: www.gallery51.net
Gallery Gen: www.gallerygen.com
Goya Contemporary: www.goyacontemporary.com
Hibberd McGrath Gallery: www.hibberdmcgrath.com
HV Studio: www.hv-atelje.com
Ironwood Gallery: www.ironwoodgallery.com
Jane Sauer: www.jsauergallery.com
Katie Gingrass Gallery: www.gingrassgallery.com
Konsthal Charlottenborg: www.kunsthalcharlottenborg.dk
Liljevalchs Konsthall: www.liljevalchs.stockholm.se
Melissa Morgan Fine Art: www.melissamorganfineart.com
Mobilia Gallery: www.mobilia-gallery.com
Modern Arts Midwest: www.modernartsmidwest.com
Nancy Margolis Gallery: http://nancymargolisgallery.com
Noho Gallery: www.nohogallery.com
Pacini Lubel Gallery: www.pacinilubel.com
Phoenix Gallery: www.phoenix-gallery.com
Robert Hillestad Textiles Gallery: http://textilegallery.unl.edu
Saatchi Gallery: www.saatchi-gallery.co.uk
Sherry Leedy Contemporary Art: www.sherryleedy.com
Sigrid Freundorfer Fine Art, LLC: www.artnet.com/sigridfreundorfer.html
Snyderman-Works Galleries: www.snyderman-works.com
Some Things Looming: www.somethingslooming.com
TAI Gallery / Textile Arts: www.taigallery.com
Textile Center: www.textilecentermn.org
Tory Folliard Gallery: www.toryfolliard.com
Translations Gallery: www.translationsgallery.com
Triangle Gallery: www.triangle-sf.com
Weaving Southwest: www.weavingsouthwest.com

Marilyn Henrion; *Two Red Doors (from the Soft City series)*; digitally manipulated photography, inkjet printing on cotton, hand quilting; cotton fabric, polyester batting, silk thread; 50 x 40" (125 x 100cm); photo: D. James Dee.

▶Helen Dahlman; *The Financial Pants*; Pants with lines embroidered in silver; fit on a sculptural form; human size; exhibited here in The Palace of Hallwyl, Stockholm, Sweden.

Museums

Albuquerque Museum of Art and History
www.cabq.gov/museum
American Textile History Museum: www.athm.org
Art Institute of Chicago: www.artic.edu
Asian Art Museum of San Francisco: www.asianart.org
Brooklyn Museum of Art: www.brooklynmuseum.org
Bildmuseet: www.bildmuseet.umu.se
Carnegie Museum of Art: http://web.cmoa.org
Central Museum of Textiles: www.muzeumwlokiennictwa.pl
Clark Center for Japanese Art & Culture
www.shermanleeinstitute.org
Cooper-Hewitt, National Design Museum: http://cooperhewitt.org
Craft and Folk Art Museum: www.cafam.org
Cranbrook Art Museum: www.CranbrookArt.edu
Denver Art Museum: www.denverartmuseum.org
Design Museum Designmuseo: www.designmuseum.fi
Fabric Workshop and Museum: www.fabricworkshop.org
Fine Arts Museums of San Francisco: www.famsf.org
Fuller Craft Museum: www.fullercraft.org
Fuouka Art Museum: www.fukuoka-art-museum.jp
Hallwyl Museum (Hallwylska Museet): http://hwy.lsh.se
High Museum of Art: www.high.org

Hunterdon Art Museum: www.hunterdonartmuseum.org
International Quilt Study Center & Museum: www.quiltstudy.org
Kyoto Municipal Museum of Art: www.city.kyoto.jp
LongHouse Reserve: www.longhouse.org
Los Angeles County Museum of Art: www.lacma.org
Lux Center for the Arts: www.luxcenter.org
MAD Museum of Art and Design: www.madmuseum.org
Mass MoCA: www.massmoca.org
Metropolitan Museum of Art: www.metmuseum.org
Minneapolis Institute of Arts: www.artsmia.org
MOMA The Museum of Modern Art: www.moma.org
Musée des Arts décoratifs: www.lesartsdecoratifs.fr/english-439
Musée Jean Lurçat et tapisserie contemporaine
http://musees.angers.fr
Museum of Craft and Folk Art: www.mocfa.org
Museum of Fine Arts, Boston: www.mfa.org
National Museum of Modern Art: www.momat.go.jp
National Museum of Women in the Arts: http://nmwa.org
National Quilt Museum: www.quiltmuseum.org
Nederlands Textielmuseum: www.textielmuseum.nl
Newark Museum: http://www.newarkmuseum.org
Nordic Heritage Museum: www.nordicmuseum.org
Oceanside Museum of Art: www.oma-online.org
Ölands Museum Himmelsberga: www.olandsmuseum.com
Philadelphia Museum of Art: www.philamuseum.org
Princeton University Art Museum: www.princetonartmuseum.org
Prins Eugens Waldemarsudde: www.waldemarsudde.se
Racine Art Museum: www.ramart.org
Renwick Gallery: http://americanart.si.edu
Rhode Island School of Design Museum of Art
www.risdmuseum.org
Rocky Mountain Quilt Museum: https://rmqm.org
Röhsska Museum: www.designmuseum.se
San Jose Museum of Quilts & Textiles: www.sjquiltmuseum.org
SFMOMA (San Francisco Museum of Modern Art)
www.sfmoma.org
Solomon R. Guggenheim Museum: www.guggenheim.org
Suomen käsityön museo (The Finnish Craft Museum)
www.craftmuseum.fi
Stedelijk Museum: www.stedelijk.nl
Textile Museum of Canada: www.textilemuseum.ca
Textielmuseum Netherlands: www.textielmuseum.nl
Textile Museum (TextilMuseet): www.boras.se/textilmuseet
Textile Museum: www.textilemuseum.org
The Getty: www.getty.edu
Ulster Museum: www.nmni.com/um
Whitney Museum of American Art: www.whitney.org

PERIODICALS

Cynthia Schira; *Blackboard*;
Jacquard woven (tapestry
weave); cotton; 64 x 69" (160
x 60cm); photo Neal Keach.

American Craft Magazine
 www.americancraftmag.org

Art in America
 www.artinamericamagazine.com

artforum.com
 http://artforum.com

ARTnews
 http://artnews.com

Circa Art Magazine
 www.recirca.com

Craft Arts International Magazine (AU)
 www.craftarts.com.au

Crafts Magazine - Crafts Council (UK)
 www.craftscouncil.org.uk/crafts-magazine

Embroidery
 http://embroidery.embroiderersguild.com

Fiberarts Magazine
 www.fiberarts.com

Gallery and Studio
 www.galleryandstudiomagazine.com

Norwegian Crafts
 www.norwegiancrafts.no

Selvedge
 www.selvedge.org

Shuttle Spindle & Dyepot (Handweavers Guild of America)
 www.weavespindye.org

Surface Design Journal (Surface Design Association)
 www.surfacedesign.org

Taito (The Finnish Crafts Organization)
 www.taito.fi/en/taito-group/welcome

Textile - The Journal of Cloth and Culture
 www.bergpublishers.com/BergJournals/Textile/tabid/518/
 Default.aspx

Textile Fibre Forum - TAFTA (The Australian Forum for Textile Arts)
 www.tafta.org.au

Textile Forum Magazine (European Textile Network)
 www.etn-net.org

Textilkunst
 www.textilkunst.de

Vavmagasinet
 www.vavmagasinet.se

ADDITIONAL RESOURCE FOR COLLECTORS

Friends of Fiber Art International
www.friendsoffiberart.org

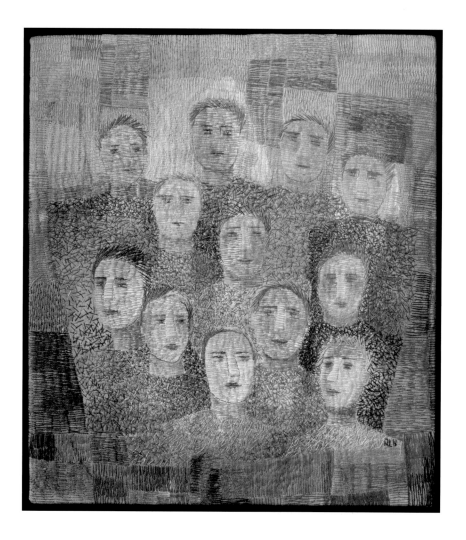

Riitta-Liisa Haavisto; *Rendez-Vous*; hand
stitchery; manipulated paper, paper, paper
yarn, cotton thread; 11.41 x 11.41" (29 x
29cm); photo: Matti Huuhka.